D0972147

International Screen Industries

Series Editors:
Michael Curtin, University of California, Santa Barbara, and Paul McDonald, University of Nottingham

This unique series provides original profiles of film, television and digital media industries in a variety of countries and regions throughout the world. It also analyses how transnational flows of goods, services, talent and capital are shaping the increasingly interconnected global media economy.

Published titles:
The American Television Industry *Michael Curtin and Jane Shattuc*
Arab Television Industries *Marwan M. Kraidy and Joe F. Khalil*
East Asian Screen Industries *Darrell Davis and Emilie Yueh-yu Yeh*
European Film Industries *Anne Jäckel*
European Television Industries *Petros Iosifidis, Jeanette Steemers and Mark Wheeler*
Global Television Marketplace *Timothy Havens*
Video and DVD Industries *Paul McDonald*

Forthcoming:
The Global Videogames Industry *Randy Nichols*
The Indian Film Industry *Nitin Govil and Ranjani Mazumdar*
Latin American Film Industries *Tamara Falicov*
Latin American Television Industries *John Sinclair and Joseph Straubhaar*

Hollywood in the New Millennium

Tino Balio

A BFI book published by Palgrave Macmillan

First published in 2013 by
PALGRAVE MACMILLAN

on behalf of the

BRITISH FILM INSTITUTE
21 Stephen Street, London W1T 1LN
www.bfi.org.uk

There's more to discover about film and television through the BFI.
Our world-renowned archive, cinemas, festivals, films, publications and learning resources are here to inspire you.

Palgrave Macmillan in the UK is an imprint of Macmillan Publishers Limited, registered in England, company number 785998, of Houndmills, Basingstoke, Hampshire RG21 6XS. Palgrave Macmillan in the US is a division of St Martin's Press LLC, 175 Fifth Avenue, New York, NY 10010. Palgrave Macmillan is the global academic imprint of the above companies and has companies and representatives throughout the world. Palgrave® and Macmillan® are registered trademarks in the United States, the United Kingdom, Europe and other countries.

Cover images: (front) *Avatar* (James Cameron, 2009), © 20th Century-Fox Film Corporation/© Dune Entertainment III LLC; (back) *Justice League* (Dan Riba/Butch Lukic/Joaquim dos Santos, 2001–6), Warner Bros. Animation/DC Comics/Warner Bros. Pictures

Set by Cambrian Typesetters, Camberley, Surrey
Printed in China

This book is printed on paper suitable for recycling and made from fully managed and sustained forest sources. Logging, pulping and manufacturing processes are expected to conform to the environmental regulations of the country of origin.

British Library Cataloguing-in-Publication Data
A catalogue record for this book is available from the British Library
A catalog record for this book is available from the Library of Congress
10 9 8 7 6 5 4 3 2 1
22 21 20 19 18 17 16 15 14 13

ISBN 978–1–84457–380–6 (pb)
ISBN 978–1–84457–381–3 (hb)

Contents

Introduction

On 10 January 2000, Time Warner, the venerable entertainment conglomerate, announced that it was merging with AOL, the world's largest internet service provider. AOL purchased Time Warner for $166 billion in stock. Gerald M. Levin, the Time Warner CEO, justified the merger by stating that the internet had begun to 'create unprecedented and instantaneous access to every form of media and to unleash immense possibilities for economic growth, human understanding and creative expression' (Arango, 2010). The merger was considered 'the deal of the century', and climaxed a decade of mergers and acquisitions during which the largest media conglomerates jockeyed for market dominance. In the belief that bigger is better, media moguls asserted there were competitive advantages in marrying content – movies and TV shows – and the means of distributing it to consumers via broadcasting, cable, satellite and broadband. Consequently, every sector of the business was put into play during the 1990s, as media executives pursued the consolidation of all aspects of the business within huge media conglomerates guided by the principle of synergy.

Yet within weeks of the AOL–Time Warner merger, the dot.com bubble burst and internet stocks plummeted. At the time of the merger, AOL Time Warner had a combined market value of $342 billion, placing it among the four largest companies in the USA. AOL Time Warner's worth had been propped up mainly by AOL's inflated stock at the height of the dot.com bubble. By the end of 2002, AOL Time Warner posted a loss of nearly $100 billion, the largest in corporate history. The conglomerate continued on a downward path, eventually losing 83 per cent of its market value. As for AOL itself, the company was a leader of the internet revolution throughout the 1990s, but was slow to take advantage of broadband delivery during the 2000s and lost customers in droves to other internet providers. Linking content and distribution had not delivered the promised synergies. Time Warner removed AOL from its masthead in 2003 and spun off AOL itself from the company in 2009.

Time Warner was not the only media company hit by the bursting of the dot.com bubble. Vivendi Universal Entertainment, the result of a merger of Vivendi, the French telecommunications company, and Seagram's Universal Studios in 2000, posted a $14 billion loss at the close of 2001, the biggest loss in French corporate history. Jean-Marie Messier, who was aspiring to transform

AOL Time Warner

The largest merger in
American history

Vivendi from a French water utility into a global media conglomerate, had acquired stakes in wireless internet and media assets in Europe and wanted Universal's movies and music to distribute across a multitude of platforms worldwide. Like the AOL–Time Warner merger, the expected synergies of convergence did not materialise. The dot.com bubble burst decimated Vivendi's stock, which it had used to finance its buyouts, and the company was put on the block, to be sold to General Electric in 2003.

But the internet had arrived, and its customer reach was so great that no studio could afford not to embrace new media in one form or another. The internet sector had rebounded from the dot.com bubble burst by 2005, which sparked another buying spree as the majors searched for promising internet entertainment and social network sites.

The majors have yet to discover a satisfactory formula to monetise digital media. This failure became acute in 2007, when DVD sales for the first time in eight years began to fall. An industry cash cow since 1999, DVD sales of new releases and library titles had grown to become the largest single source of revenue for the studios, far outstripping theatrical exhibition. 'For a time it seemed as if studios were printing money, with an explosion of DVD sales reaching some $24 billion in 2006,' said Marc Graser. 'Then the business started to shrink, with revenue from DVDs down to $21.6 billion last year [2008], and slumping another 13% this year [2009]' (Graser, 2010a). Sales of Blu-ray discs beginning in 2006 did not stop the decline.

Two of the culprits were Netflix and Redbox. The explosive growth of Netflix's DVD-by-mail and internet streaming services and Redbox's rental kiosks offered cheaper options for watching movies than buying them on DVD. Such options became even more of a draw after the start of the recession in 2008. The downturn in the economy meant that many people had less discretionary money to spend on entertainment. This was especially true with teenagers, the most coveted age cohort of the studios. And there was increased competition for leisure dollars, which had a significant impact on the movie industry. The total domestic box office increased from $7.75 billion in 2000 to a record high of around $10.6 billion in 2009 and 2010. However, admissions – the number of tickets sold – declined from 1.57 billion in 2002 to 1.34 billion in 2010, after fluctuating several times (MPAA, 2010). In need of escape, people were still going to the movies, but not quite as often. Actually, the downturn was worse than the numbers suggested. After adjusting for inflation, the annual

box-office take in the first years of the decade exceeded the 2009 and 2010 fig-
ures. This despite the higher ticket prices exhibitors were charging for the glut
of 3-D films that reached the market beginning in 2009.

In the following pages, I describe how the arrival of the internet, the decline
in DVD sales and changing consumer viewing habits impacted the American
film industry. The time frame is 2000–10. Chapter 1 outlines the round of merg-
ers and acquisitions in the media industry, which began in the 1990s. Going into
the new millennium, the same six media conglomerates, some renamed,
emerged larger and more powerful than ever. But one thing changed; the major
Hollywood film studios now played a relatively minor role in the bottom lines
of their conglomerate parents in terms of revenue. As a result, they were more
beholden than ever to calls for increased profitability from their conglomerate
chiefs and from stockholders. The pressure to increase profits became more
intense when Time Warner and Viacom reversed course by jettisoning distribu-
tion to concentrate on exclusively on content. Distribution entities would come
and go in the era of the internet, but the survivors would always need movies
and television shows to attract customers, the thinking went.

Chapter 2 describes the impact of corporate realignments on Hollywood's
production policies. In building their annual slates, the studios fled to safety by
cutting back on the number of pictures they produced and by relying on big-
budget tentpoles and franchises more than ever to target young people and
families. Superhero movies based on popular comic books and toys and sci-fi
actioners were considered safe bets. Such pictures were instantly recognisable,
easily marketable and exploitable across all divisions of the studio. Moreover,
they were easily expandable into sequels and franchises. Fleeing to safety, the
studios became risk averse. To reduce costs, studios closed underperforming
units, cut salaries, slashed jobs and shot their pictures wherever subsidies could
be found. To further reduce their risks, the majors partnered with private
investors, hedge fund managers and co-producing partners around the world.
Mid-level pictures, which were risky to produce, were consigned mostly to out-
side producing partners. By producing fewer films of their own, the studios
created a buyers' market for talent. Writers were being paid less to develop new
projects and actors and directors, with the exception of the top tiers, were being
offered much smaller fees upfront in return for a bigger cut of the profits. A new
breed of studio chief carried out the mandates from the head offices of the
major conglomerates. This new generation of studio bosses earned its stripes
outside of Hollywood and harboured little sentimental attachment to the
movies.

Chapter 3 surveys the time-tested techniques Hollywood used to distribute
its pictures. It was a mass-marketing approach, which relied on massive TV

advertising and saturation booking to capture the lion's share of the box office quickly to recoup production costs. The strategy had served Hollywood well for decades. The internet provided new possibilities to reach audiences. The studios used the internet in conventional ways at first, by building official websites for their pictures and by dealing with the plethora of emerging fan sites that were undermining their strict control over publicity. Later, the studios embraced social networks such as Facebook and Twitter and the video-sharing site YouTube to generate word of mouth. Dealing with the future, however, posed a challenge. Different age groups used the internet in unexpected ways, and predicting future trends in internet usage was impossible. For the time being, the traditional one-size-fits-all approach to marketing was still effective, but Hollywood is poised for change.

Chapter 4 examines the role exhibitors play in sustaining moviegoing. Today, the exhibition sector in the USA is dominated by five chains. Motion picture theatres traditionally enjoy protected status in the distribution cycle and are the largest revenue source for most new studio releases. In dealing with exhibitors, the standard film rental terms of the major distributors enable them to capture the lion's share of the box office at the beginning of the run as a reward for financing the picture. But, in return, distributors permit exhibitors to deduct their overhead expenses off the top throughout the run. During the 1990s, a growing number of leisure-time alternatives became available to people. Exhibitors responded by upgrading theatres. The free-standing megaplex with stadium seating, ceiling-to-floor screens and creature comforts became the norm by 2000. Because the luxurious megaplexes drew customers away from older mall theatres, the big chains were left with a lot of white elephants. The chains solved their dilemma by declaring bankruptcy, which enabled them to break the leases of their mall theatres and to abandon them altogether. But the bankruptcies left some of the chains vulnerable to takeovers by speculators and led to the consolidation of the sector.

Exhibitors were also challenged by home entertainment options that included high definition television and lush surround sound. To protect their pre-eminent distribution window, theatre chains converted to digital projection. The conversion was an attempt, in part, to neutralise the growing popularity of high-end home entertainment centres. Although digital projection was hyped in the press as a technological revolution, it did not substantially improve the moviegoing experience. However, it did make possible the easy adoption of 3-D, which did, and helped buttress the box office. Since digital projection saved the major studios millions in print distribution costs, distributors agreed to help defray the costs of the conversion by paying the major theatre chains a 'virtual print fee' of around $1,000 per screen for each movie

they distributed digitally to the participating theatres. This accelerated the conversion to digital exhibition, which is quickly becoming the industry standard.

Chapter 5 deals with ancillary markets. After 2007, the challenge for Hollywood was how to make up for declining DVD sales. It faced a dilemma, however; a growing number of people in its core audience wanted to watch movies and TV shows anytime, anywhere and on all devices, while any tampering with the distribution cycle to satisfy that need would incur the wrath of the National Association of Theater Owners, the trade association, which regarded the four-month theatrical window as sacrosanct. Netflix and Redbox offered people cheaper options for viewing movies than buying them on DVD or renting them from video stores. The First Sale Doctrine prevented the majors from doing anything to stop Netflix from renting out new DVDs by mail after their release date, but the majors could weaken Netflix's streaming service by charging more for the streaming rights to newer movies or by withholding new titles from the service altogether. In the case of Redbox, several studios negotiated deals with Redbox in which Redbox agreed to delay the rental of new titles for twenty-eight days after they hit the market in return for a lower wholesale price for the DVDs from the studios. But such manoeuvres did little to restore DVD sales to their former glory. The majors, therefore, pursued other alternatives, the most promising of which was video-on-demand (VOD) over cable. Older titles had long been available on pay-per-view. To generate more revenue from the window, the majors agreed to make new titles available to the cable services the same date they are released to home video. In other words, the majors collapsed the home video and VOD windows. Collapsing or shortening other distribution windows to support premium VOD or digital VOD experiments was not as easy because exhibitors threatened to boycott any new title that was simultaneously playing in another window. The majors stopped tampering with the theatrical window, temporarily, but the cause is far from dead.

Chapter 6 surveys the independent film market. James Schamus, the head of Universal's Focus Feature speciality unit, has characterised the independent market as 'to the rear of the back end' of filmdom (Schamus, 1998, p. 91). Sadly, it is an apt appraisal of a sector of the industry that has been a major source of critics' favourites and award winners. Independent film-making flourished during the 1980s, when premium cable channels like HBO and Showtime, in need of a constant flow of films, instituted the pre-sales agreement, which provided filmmakers with partial financing upfront in return for the pay TV rights. Independent film-making also flourished in the 90s, when the success of Miramax, New Line and Samuel Goldwyn convinced the majors to form speciality units and when talent agents and investors of all stripes scoured Sundance in search of the next crossover hit like *Pulp Fiction*. But afterwards, conditions

changed. To reduce studio overheads, the majors closed underperforming speciality units and invested the savings in blockbusters. Declining DVD sales, once a major source of revenue, hit the indies hard. And with collapse of the financial markets in 2008, the prices being paid for indie product dropped.

Today, the few indie films that receive theatrical distribution play mainly in New York and Los Angeles for short runs. A lucky few also play in the Landmark theatre circuit. A theatrical run, no matter how brief, gives a picture cachet that helps sales in foreign and ancillary markets. To improve conditions, independent film-makers and their supporters have devised innovative ways to reach audiences, witness the marketing efforts of Mark Cuban and Todd Wagner's 2929 Entertainment and IFC Films and the Sundance and Tribeca film festivals.

Concluding the chapter is an overview of the mini-majors, in particular Lions Gate Entertainment, Summit Entertainment and Ryan Kavanaugh's Relativity Media. The independent sector always supported a few such companies, but because they function in the mainstream theatrical market in competition with the majors, they too lead precarious lives.

1

Mergers and Acquisitions: The Quest for Synergy

The American film industry is dominated by six studios – Warner Bros., Walt Disney Pictures, Sony Pictures Entertainment, Paramount Pictures, 20th Century-Fox and Universal Pictures. They produce practically all the top box-office hits, they dominate the playing time of the nation's theatre screens and they account for nearly 80 per cent of the domestic box office every year on average. These studios trace their roots to the silent film era, when the industry became big business, and have remained the major players ever since. But one thing changed; beginning in the 1960s, the majors were either subsumed into burgeoning conglomerates or became conglomerates themselves through diversification. As subsidiaries of giant media concerns, the six major studios account for only a small share of the parent company's total take, around 10–15 per cent (Bart, 2010b). What this means for Hollywood is the principal focus of this book.

GROWTH OF THE DOMESTIC MARKET

To understand the structure of today's Hollywood, one has to go back to the 1980s. The motion picture industry entered a new era of prosperity, the result in part of two new distribution technologies: pay television and home video – each of which extended the market and the revenue stream for feature films. Until then only one ancillary market of consequence existed for feature films – network television. Pay TV came into its own in 1976, when Home Box Office (HBO), a Time Inc. company, leased transponders on RCA's domestic satellite, SATCOM I, and began transmitting uninterrupted, uncut programming to cable systems across the USA. To build its 'premium' service, HBO fought the Federal Communications Commission's (FCC's) restrictions on the cable industry that protected 'free' network television. After winning the right to show recent Hollywood feature films on its service in a timely manner, HBO was joined by other premium services such as Viacom's Showtime to create a second ancillary market for feature films.

Home video also got its start in the 1970s, when two Japanese consumer electronics giants – Sony and Matsushita – introduced videotape recorders on

Studio	Parent Company and Reporting Segments
Warner Bros.	Time Warner Inc. Networks Filmed entertainment Publishing
Walt Disney Pictures	Walt Disney Company Media networks Parks and resorts Studio entertainment Consumer products Interactive media
Sony Pictures Entertainment	Sony Corporation Electronics Games Pictures Financial services Music
Paramount Pictures	Viacom Inc. Media networks Filmed entertainment
20th Century-Fox	News Corp. Filmed entertainment Television Cable network programming Direct broadcast satellite television Magazines and inserts Newspapers and information services Book publishing Other
Universal Pictures	Comcast NBC Universal Broadcast networks Film Cable networks Digital media Parks/resorts

Table 1.1 The Hollywood Majors and Their Parent Companies

competing formats – Betamax and VHS, respectively – which enabled consumers to store and retrieve television programming delivered to their homes. Fearing that the new technology would undermine their control over the availability of feature films, Universal and Disney brought a suit against Sony, charging it with copyright infringement. Instituted in 1976, the 'Betamax case', as it was called, eventually reached the US Supreme Court in 1984. Although the court ruled

against the majors, they nevertheless emerged as winners. By then, the home video market had expanded exponentially. More than six Japanese manufacturers had entered the business, both in their own names and as suppliers of machines to American firms. In the interim, VHS had overtaken Beta as the preferred format for home video. The price of machines dropped and the VCR was fast becoming a ubiquitous home appliance. Although the theatrical box office reached a new high of $5 billion in 1989, the home video market generated twice that. Capitalising on the appeal of their hit pictures and film libraries, the majors devised a way to extract the lion's share of the revenue from their videocassettes: they instituted a two-tier pricing strategy, charging a higher price initially for sales to video stores and a lower price months later for sales to individual consumers. By 1990, home video was generating extraordinary profits for the majors. And because the window could be serviced before pay TV, home video enabled Hollywood to break HBO's hold on the pay TV market.

The public demonstrated its willingness to pay for convenient entertainment in the home. As noted by Warner Communications, 'For the first time in history, the individual member of the audience is sovereign, no longer a passive receiver. With cable television, videotape players, and other electronic accessories the audience has gained control over what it sees and when it sees it; its already widening options will soon be limitless' (Warner Communications, 1980). Home video did not kill the movie theatre as some had predicted; in fact, the number of movie screens and the domestic box take increased substantially during the 1980s. The status of exhibition had actually improved. Pay cable and home video needed feature films, especially hits, which established themselves in one place only, the theatre.

GROWTH OF THE INTERNATIONAL MARKET

The growth of the international market for Hollywood films during the 1980s resulted from the upgrading of motion picture theatres, the emancipation of state-controlled television and the growth of home video. Outside the USA, nearly every market was under screened. Western Europe, for example, had about one third of the screens per capita of the USA, with the same population. And most of its theatres were old and tired. To resuscitate moviegoing, the majors partnered with local investors in the principal markets and went on a building spree to expand and renovate exhibition. International demand for Hollywood films expanded as a result, reaching an historic milestone in 1994; for the first time, foreign sales outpaced domestic.

With the emancipation of state-controlled television, in Western Europe in particular, privately owned commercial interests quickly introduced new satellite and cable services. In the UK, where viewers had long been restricted to two

BBC and two quasi-independent stations, British Satellite Broadcasting and Sky Television introduced nine new pay TV services. In France, Canal Plus, the country's first pay TV service, attracted 3 million subscribers within five years. By 1989, Western European television reached 320 million people and 125 million households (vs 250 million people and 90 million households in the USA) and showed enormous potential for Hollywood entertainment.

The third – and largest – source of new revenue came from home video. The spread of VCRs in Western Europe demonstrated that, given a choice, consumers preferred more variety than their state broadcasting monopolies provided. In 1978, 500,000 VCRs were sold; by 1987, VCR sales topped 40 million, or nearly one third of all households. Consumers not only wanted to time-shift programming to suit their schedules, but also to enjoy different kinds of programming, particularly Hollywood movies.

Today, filmed entertainment is America's second-largest net export. Hollywood's largest markets are Western Europe, the Pacific Rim and Latin America. During the new millennium, theatre admissions in the USA declined. Not so overseas. In 2004, more than 1 billion tickets were sold in the European Union alone, a record. The international box office rose steadily during the decade, reaching a $20 billion benchmark in 2010. In that year, the Motion Picture Association of America (MPAA) reported that 67 per cent of the total box-office revenue collected by the majors came from overseas, and that the percentage was expected to grow.

Hollywood had entered the age of 'globalisation'. As described by Time Warner, the world's largest media and entertainment company, globalisation dictated that the top players in the business develop long-term strategies to build on a strong base of operations at home while achieving 'a major presence in all of the world's important markets' (Time Warner Inc., 1989). Achieving these goals led to a merger movement in Hollywood that has yet to run its course.

The rationale behind the merger movement was a faith in 'synergy', that bigger is better. As touted by business leaders, 'synergy' was a belief that one plus one could equal three. Described another way,

> Synergy is to modern business what alchemy was to the Middle Ages – an arcane process that claims to create riches. Alchemy proposed to turn ordinary metal into gold. Synergy claims to increase profits through corporate collaboration …
> Alchemy was a pseudoscience so compelling that it retained its appeal to kings and princes for centuries. Synergy has the same hold on the capitalist imagination of our time. It's a compelling illustration of the truth that words have the power to blind us. (Fulford, 1995)

It would take a dot.com bubble burst which wiped put billions of dollars in company assets to convince media industry moguls that bigger is not necessarily better.

THE CASE OF TIME WARNER

Time Warner, the long-time industry leader, was the handiwork of Steven J. Ross, one of the first and most energetic advocates of corporate synergy in the media industry. Ross started out in his father-in-law's funeral business in Manhattan, which he parlayed into Kinney National Services, a conglomerate that operated funeral homes, a car rental agency, parking lots and garages, and a building maintenance service. Ross ventured into entertainment in 1967 by purchasing the Ashley Famous talent agency, and then, in 1969, Warner Bros.–Seven Arts, a Toronto-based television syndicator that had recently acquired the ailing Warner Bros. studio. In 1972, he renamed his company Warner Communications (WCI), after selling off the old Kinney business.

By the 1980s, Ross had grown his company into a vertically integrated entertainment conglomerate. The Filmed Entertainment brands included Warner Bros., Warner Bros. Television, Warner Bros. Distributing Corporation and Warner Home Video. Its other brands included Atlantic Records, The Movie Channel, DC Comics, Warner Books and Warner Amex Cable. In addition to owning one of Hollywood's most consistently successful studios, a formidable film and television library, the world's largest record company, WCI, had acquired the distribution systems associated with each of its product lines. Film industry analyst Harold Vogel described the economic benefits of controlling distribution as follows:

> Ownership of entertainment distribution capability is like ownership of a toll road or bridge. No matter how good or bad the software product (i.e., movie, record, book, magazine, TV show, or whatever) is, it must pass over or cross through a distribution pipeline in order to reach the consumer. And like at any toll road or bridge that cannot be circumvented, the distributor is a local monopolist who can extract a relatively high fee for use of his facility. (Vogel, 1989)

In 1988, WCI added considerable muscle to its operations by buying stakes in three important theatre chains that owned 500 screens.

Regarded in the industry as a consummate deal maker, Ross's greatest coup was orchestrating the merger of his company with Time Inc. in 1989 to create Time Warner, the world's largest media company. Time's properties included HBO, the premier pay TV channel, and *Time*, *People*, *Money* and *Sports Illustrated* mass-market magazines. Ross touted the merger 'as essential to the

competitive survival of American enterprise in the emerging global entertainment communications marketplace' (Gold, 1989). In some ways this was a defensive manoeuvre, for he had in mind not only the takeover of 20th Century-Fox by Australia's News Corp., but also the anticipated invasion of Hollywood by Japan's Sony and Matsushita.

FOREIGN INVADERS

The growing demand for filmed entertainment of all kinds worldwide attracted foreign investment in Hollywood. Rupert Murdoch's News Corp. started the trend. The owner of newspapers in Australia and the UK, Murdoch moved aggressively into the USA by acquiring a half-interest in 20th Century-Fox from Denver oilman Marvin Davis, the sole owner of the studio, in 1985. Soon after, he set out to create a full-blown fourth TV network, Fox Broadcasting, to challenge the big three networks, ABC, CBS and NBC. The growth of independent stations and the ease of distributing programming by satellite suggested the possibility of a fourth network as a viable enterprise. But not until Rupert Murdoch's effort in 1986 did the fourth network idea have any currency.

To start, Murdoch bought Metromedia Television, the nation's largest group of independent television stations, for $2 billion. (In order to comply with FCC regulations governing the ownership of TV stations, Murdoch became a US citizen.) Murdoch then assembled a network of more than one hundred independent stations, capable of reaching over 80 per cent of all TV homes, and invested heavily in counter-programming aimed at young adults. Fox began broadcasting on a limited basis in spring 1987. The network lost hundreds of millions of dollars over the first three years, but Fox finally turned the corner in 1989. Meanwhile, Murdoch launched his Sky Channel satellite television service in Europe. Murdoch's announced goal was to own every major form of programming – news, sports, films and children's shows – and then to beam them via satellite or TV stations into homes around the globe.

Sony and Matsushita, the two Japanese consumer electronics giants, made their moves next. Sony first acquired CBS Records for $2 billion in 1987 and then Columbia Pictures Entertainment (CPE) from Coca-Cola for $3.4 billion in 1989. The following year, Matsushita, Sony's rival, acquired MCA, the parent company of Universal Pictures, for $6.9 billion. Matsushita's products were sold under the brand names Panasonic, Technics and Quasar, among others. As Andrew Pollack explained, the Japanese companies 'thought the entertainment "software" business could provide higher profit margins than the intensely competitive, and now largely saturated, consumer electronics appliance business. They also thought there would be synergies between the hardware and the software business' (Pollack, 1994). Coca-Cola had acquired Columbia Pictures in

Rupert Murdoch's News Corp. media empire

1982 and attempted to introduce modern scientific marketing techniques to the motion picture business, techniques that made Coca-Cola the leading soft drink brand in the country. But the studio 'bumped along on a downhill path' and experienced frequent management turnovers. Sony executives thought the studio was a better fit with their business. Purchasing CPE, Sony acquired two studios – Columbia Pictures and TriStar Pictures – a home video distributor, a theatre chain and an extensive film and television library. To strengthen CPE as a producer of software, Sony spent lavishly to renovate and refurbish the old MGM studios in Culver City and to hire movie producer Peter Guber to chart a course for the company, which was renamed Sony Pictures Entertainment in 1991. (Signing Peter Guber and his partner Jon Peters cost Sony $700 million and was one of the most expensive management acquisitions ever.)

MCA, once the mightiest talent agency in the business, had acquired Universal Pictures in 1962. Under the leadership of Lew Wasserman, generally regarded as the most powerful man in Hollywood, MCA became a force to contend with. Year in and year out, its films led at the box office and its television programmes dominated prime time. Beginning in the 1980s, MCA expanded into the leisure-time field by acquiring toy companies, music labels, a top independent television station and a stake in a giant theatre chain. Of all its investments, the Universal Studios Theme Park in Orlando, Florida, showed the most potential. After the merger with Matsushita, Wasserman and Sidney Sheinberg, his second in command, hoped to tap into Matsushita's deep pockets and expand even further.

The American press criticised these corporate takeovers, leading people to believe that Japan would 'subvert the content of the movies' and win the 'battle for America's cultural soul'. None of this happened, of course; beginning in 1990, Japan entered into a recession and ultimately lost the trade war with the USA (Sterngold, 1997). Sony Pictures, for its part, had released mostly flops

under Guber, which lead to his resignation as chief executive of the studio in September 1994 after fifteen months on the job. Sony of Japan took a $3.2 billion loss on the studio and announced it could never hope to recover its investment in Hollywood. As reported in the *New York Times*, 'it was a humbling admission for Sony and a stark symbol of the reversal in fortunes for corporate Japan' (Sterngold, 1994).

The Matsushita–MCA marriage foundered as well. Wasserman and Sheinberg, who had successfully run the studio for over twenty years, chafed under the conservative Japanese owners and were convinced they did 'not understand either the corporate nuances of MCA or the dynamic changes of the United States media business' (Fabrikant, 1994). The relationship reached a low when Matsushita vetoed MCA's efforts to acquire Virgin Records, the CBS television network and other initiatives to place it on a par with Time Warner and Viacom. 'To borrow a Japanese saying, the two companies may have been lying "in the same bed, with different dreams",' said the *New York Times*. 'Matsushita had a vague hope of achieving cost-saving synergies by marrying its compact videodisk players and other hardware with MCA's popular culture software. MCA, in contrast, wanted a financial sponsor. But even from the start, Matsushita did not know exactly what kind of new product it wanted to create, putting it at a loss as to how to integrate movies and music into a vast electronics empire' (Dunn, 1995).

Unwilling to cope with the evolving changes in the US entertainment landscape, Matsushita sold off 80 per cent of MCA to Seagram, a Canadian liquor giant controlled by the Bronfman family, for $5.7 billion in 1995. Unlike Sony, Matsushita recovered its investment in Hollywood. Edgar Bronfman Jr, a scion of the Bronfman family fortune, became the new CEO, bringing to a close the twenty-two-year reign of chairman Lew Wasserman and president Sidney Sheinberg, Hollywood's longest-running management team.

A NEW ROUND OF MERGERS

The industry entered a new round of mergers in 1993 and involved cable and network television. Again the mergers were motivated by the belief that in the media business 'there were real financial advantages to owning both the content – television shows and films – and the means of distributing it to people's homes' (Arango, 2008b). Cable television developed from a financially shaky, tightly regulated industry into an economic powerhouse during the 1980s, reaching over half of the country's 90 million TV homes. The existence of reliable communications satellites that transmitted basic and premium programming to local television systems and a relaxed regulatory environment were two of the causes. By 1990, however, cable television had reached a plateau; home video had taken

a toll on pay TV and added channel capacity on most services fragmented an already stagnant pool of cable viewers.

Concerned that the Time Warner merger would overwhelm the competition, Viacom, a leading cable operator, merged with Paramount Communications for $8.4 billion in 1993. Paramount's owner was Gulf+Western, a sprawling conglomerate that acquired Paramount Pictures back in the 1960s. A downsized Gulf+Western had shed more than fifty companies to become a global communications giant in 1989 under a new name, Paramount Communications. Its new focus was on entertainment – Paramount Pictures, Paramount Television, Madison Square Garden, the New York Knicks basketball team and the Famous Players theatre chain in Canada – and on publishing – primarily Simon & Schuster, the nation's largest book publisher. Viacom's owner since 1987 was Sumner Redstone's National Amusements, an important theatre chain situated in the Northeast. Viacom started out as the syndication arm of CBS television. It became a separate public company in 1971, after the FCC issued its Financial Interest and Syndication Rules ('fin-syn') prohibiting the big three networks from owning and syndicating their prime-time programmes. The FCC imposed the rules to prevent the networks from monopolising the television business. Under Redstone, Viacom grew into a leading cable programmer, which comprised the Showtime premium service, the Nickelodeon and USA cable networks and the MTV and VH1 cable music channels. Merging them with Paramount's entertainment and publishing arms put Viacom on a par with Time Warner.

Redstone fought off a hostile takeover bid from Barry Diller to acquire Paramount. To seal the deal, Redstone acquired Blockbuster Entertainment, the nation's largest video retailer, to take advantage of its cash flow from late rental returns. Like Time Warner, Viacom became a completely integrated entertainment conglomerate. Said Redstone, 'The new Viacom not only controls many of the world's most recognizable entertainment and publishing brands, but also has the distribution size and scope to drive these brands into every region of the world' (Flint and Dempsey, 1994).

Network television became another factor in the merger movement when the FCC abolished the controversial Financial Interest and Syndication Rules in 1993. Since the networks could now produce and syndicate prime-time shows on their own, outside suppliers like the major Hollywood studios would likely be hard hit. Although network ratings declined during the 1980s, as viewers defected to cable TV and home video, the big three still reached 60 per cent of the viewing audience and could guarantee 'shelf space' on their schedules for self-produced programmes.

After the suspension of fin-syn, two networks changed hands: Capital Cities/ABC and CBS. Capital Cities/ABC was purchased by the Walt Disney

Company in 1995 for $19 billion. Capital Cities/ABC itself was the result of a merger in 1985 linking Capital Cities Communications – with its television and radio stations, ESPN sports channel, newspapers and trade magazines – and ABC, the no. 1 network in the ratings. Merging these holdings with Disney's formidable movie studio, the Disney Channel pay TV service, and Disney's theme parks, record and book arm and vast merchandising operations cata-pulted Disney to the top spot in the industry in terms of revenues. The deal was brokered by Disney chief Michael Eisner, who had transformed the studio into a motion picture heavyweight. Disney now had the 'global reach that can meet the ongoing demand for American entertainment in the multichannel environ-ment around the world', said Christopher Dixon, a Wall Street analyst. 'It gives them two very strong brand names and the scale to go up against Viacom, Time Warner and News Corp' (quoted in Hofmeister and Hall, 1995).

Time Warner immediately responded to the Disney/CapCities merger in 1995 by acquiring Turner Broadcasting System (TBS), the biggest cable network in the country, for $7.4 billion. Time Warner made the deal even though it steadily lost money after the 1989 merger and suffered from clashing corporate cultures in the executive suite following Steve Ross's death in December 1992. Incurring more company debt, Gerald M. Levin, Time Warner's new CEO, invested heav-ily to upgrade the company's cable infrastructure. Levin saw 'cable as a crucial distribution technology for the so-called information highway', which someday might deliver 'not only television programming, but also telephone service, video-on-demand and home shopping services' (Fabrikant, 1995a). Acquiring TBS, Time Warner hoped to turn Levin's vision into reality.

The creation of maverick broadcaster Ted Turner, Turner Broadcasting had evolved from a small independent television station in Atlanta, Georgia, WTBS, into a superstation reaching a nationwide audience via satellite. To provide a ready supply of inexpensive programming for his station, Turner bought the Atlanta Braves baseball team and the Atlanta Hawks basketball team in 1976. In 1980, he created the Cable News Network, a twenty-four-hour news chan-nel. And in 1986, he acquired MGM/UA Entertainment, comprising two venerable Hollywood studios, from Las Vegas casino mogul, Kirk Kerkorian. The resulting debt load forced Turner to sell back all of MGM/UA to Kerkorian except the MGM film library and two pre-1948 libraries from Warner Bros. and RKO. Although many thought that Turner had been fleeced, Turner immediately went to work to exploit the film libraries, which contained over 3,000 feature films and a vast quantity of cartoons, shorts and television shows. Turner did not stop there. In 1993, Turner moved into the front ranks of Hollywood by acquir-ing two prominent independent producers, Castle Rock Entertainment and New Line Cinema. Castle Rock made its reputation producing top-shelf

pictures; New Line made its fortune producing and distributing genre pictures aimed at adolescents. TBS was therefore more than simply a cable TV network and many synergies were envisioned by the merger with Time Warner. Turner secured a hold on Time Warner's cable system for his channels and Time Warner acquired a lucrative source of programming for its distribution platforms. In the process a new entertainment colossus had been created that might easily dominate the business.

Concluding this round of mergers, Viacom acquired CBS in 1999 for more than $37 billion. CBS was owned by Westinghouse Electric, the industrial and broadcasting behemoth, which purchased the network in 1995, a day after Disney's merger with Capital Cities/ABC. Although CBS had fallen to third place in the ratings, Westinghouse wanted the network to bolster its Group W television stations in the face of new competition from Fox Broadcasting. After the purchase, Westinghouse shed its non-broadcasting businesses and took on the CBS name. Viacom needed CBS to reach a larger, more diverse audience. Viacom's cable networks – Nickelodeon, MTV and VH1 – were popular with children, teenagers and young adults, respectively, while CBS attracted mostly older viewers. As reported by the *New York Times*, Viacom's goal was 'to create a seamless pipeline that delivers advertising, properly diluted with programming, all across the demographic spectrum, where it will at last ooze into the presence of the audience, young (MTV) and old (CBS), through its medium of choice: movies, broadcast television, cable, radio, billboards, the Internet' (Klinkenborg, 1999).

MERGERS AND THE INTERNET

Yet another round of mergers began in 2000. This time they involved the internet. As Kamal Kishore Verma described it,

> In 2000 it was believed that future media growth would be from the 'new' media sector. Traditional and new media channels were rapidly converging into common media platforms. The industry believed that companies operating in one media channel only, either the traditional or the new media, could not play a significant role in the future or, even worse, would vanish. Successful companies will harness the Internet's nearly infinite customer reach and provide high-quality media content, such as entertainment and information to its worldwide customers. (Verma, n.d.)

The Time Warner–AOL merger was the brainchild of Stephen M. Case, the forty-one-year-old billionaire who built AOL from a fledgling dial-up service in the 1980s to an internet powerhouse reaching more than 20 million subscribers. But as a dial-up service, AOL was in danger of falling behind AT&T and

Microsoft, which offered high-speed internet services over high-capacity fibre-optic networks to their customers. Acquiring Time Warner, AOL gained access not only to Time Warner's movies, TV shows and pop music, but also to Time Warner Cable, with its broadband delivery system. Time Warner, for its part, gained easy access to the internet market and tens of millions of potential customers. The announced goal of the new AOL Time Warner was to become a mass-market consumer service that provided 'interactive entertainment, information and e-commerce through everything from desktop computers to handheld devices to television sets' (Lohr, 2000).

The internet bubble of the late 1990s had inflated AOL's share price to more than twice that of Time Warner's even though it had a quarter of the revenues. At the time of the merger, AOL Time Warner had a market value of $342 billion, the fourth most valuable company in the country after Microsoft, General Electric and Cisco Systems. Since AOL's market capitalisation had been higher than Time Warner's at the time of the merger, it acquired a majority interest in the company. Steve Case, as a result, assumed the top position as executive chairman of the board; Gerald Levin, Time Warner's CEO, took the no. 2 CEO spot.

The AOL–Time Warner union was touted as 'the best evidence yet that the old and new media are converging'. Many synergies were envisioned between the two companies, but, within months, the dot.com bubble burst and internet stocks plummeted. At the end of 2002, the company posted a loss of nearly $100 billion, the largest in corporate history. By 2009, the capitalisation of the company had fallen from a lofty $342 billion to $40 billion. AOL had been slow to offer broadband access to its customers and therefore lost subscribers to phone and cable companies and its ability to cross-promote Time Warner content. Moreover, top management had failed to actually integrate the two companies. Steve Case resigned in 2003 and the company dropped 'AOL' from its name. Ted Turner, the largest individual shareholder in the combined company, lost an estimated 80 per cent of his wealth, around $7 billion, and thousands of Time Warner employees lost their jobs as the company retrenched. As Tim Arango in the *New York Times* put it, 'To call the transaction the worst in history, as it is now taught in business schools, does not begin to tell the story of how some of the brightest minds in technology and media collaborated to produce a deal now regarded by many as a colossal mistake' (Arango, 2010).

The AOL–Time Warner merger was not the only one to be crushed on the rocks. Just months after the merger, Vivendi, the French telecommunications company, acquired Seagram's Universal Studios for $34 billion in stock. The deal was spearheaded by Vivendi chairman Jean-Marie Messier, who was aspiring to transform Vivendi from a French water utility into a global media

conglomerate. Vivendi owned or had stakes in wireless internet and media assets in Europe, among them, Havas, a European advertising and communications company; Canal Plus, the largest pay TV channel in Europe; Rupert Murdoch's British Sky Broadcasting satellite service; Cegetel, France's no. 2 mobile phone operator; and Vizzavi, a fledgling wireless internet portal for mobile phones available to Vodafone subscribers in Britain. Messier envisioned a company capable of distributing Universal's movies and music to consumers across a multitude of platforms, including cellular devices, satellite, cable and pay television.

Universal Studios had fallen on hard times under the helm of the young Bronfman. Bronfman saw great opportunity in the music business and transformed the Universal Music Group into the world's largest by buying PolyGram Records from the Dutch firm Royal Phillips Electronics in 1998 for $10 billion. But to finance the purchase, Bronfman sold off nearly all of Universal's television operations – including its production arm and cable networks – to Barry Diller's Home Shopping Networks in 1997. The company was left with no major presence in network or cable television; Universal Pictures had hit a trough; and Universal Music was being undermined by Napster and internet file sharing.

Messier renamed his company Vivendi Universal Entertainment and set out to increase its presence in the US market. In 2001, Vivendi acquired Houghton Mifflin, a major textbook publisher; MP3.com, an online music business; a stake in EchoStar Communications, a satellite operator; and Barry Diller's USA Network, comprising most of Universal's old television operations. Like AOL Time Warner, News Corp. and Disney, Messier created a modern media company that married content and distribution. But his success was short-lived. The expected synergies of convergence did not materialise in time. The dot.com bubble burst, decimating Vivendi's stock, which it had used to finance its buyouts. And because Messier repeatedly overpaid for his acquisitions, Vivendi posted a $14 billion loss at the close of 2001, 'the biggest loss in French Corporate history' ('Jean-Marie Messier Himself', 2003).

In 2002, Messier was ousted as chairman by his board. Jean-Rene Fourtou, his successor, sold off most of the assets Messier had acquired since 2000. In 2003, Vivendi Universal itself was put on the block and sold to General Electric's (GE's) NBC for $3.8 billion in cash and a 20 per cent stake in the new NBC Universal. GE had acquired NBC and its parent RCA in 1986, the same year as the Capital Cities/ABC merger. Under the leadership of John F. Welch Jr, GE was branching out from defence and consumer electronics to technology and service sectors. NBC was a perennial leader in the ratings and conformed to Welch's dictum that GE should only buy the no. 1 entity in any industry. By snapping up Universal's movies, cable channels and TV shows, NBC was betting that content 'will become far more valuable as the media world

Myspace.com, once a heavily visited social networking site, was soon eclipsed by Facebook

moves further into the digital era. "In a digital world", said Bob Wright, NBC's chairman, "we will be able to access content in many more ways … If you have the right content, you can be very successful"' (Furman, 2003).

These initial efforts to harness the internet failed for a host of reasons. The main ones were the bursting of the dot.com bubble and the 9/11 terrorist attacks, which left the internet sector in a shambles. Another was that Steve Case and Gerald Levin at AOL Time Warner and Jean-Marie Messier at Vivendi Universal 'clearly misjudged how fast Internet media would catch on and how much revenue it would generate' (Lieberman, 2003). But the potential of the internet for e-commerce was so great that no studio could afford not to embrace new media in one form or another. Take the case of News Corp. Rupert Murdoch caught the internet fever in 2005, and acquired MySpace, the fast-growing social network, for $580 million. MySpace was founded in 2003 by Tom Anderson and Chris DeWolfe, just as internet commerce was staging a come-back from the dot.com bubble burst in 2001. It stood out from the early social media networks as a 'one-stop Web spot' for young people who 'appreciated having a dedicated space to chat with friends, share photos, connect with their favourite bands and discover new music' (Yiannopoulos, 2009).

MySpace was free to users and derived revenue from banner ads appearing on top of each page. The site had 20 million unique visitors each month when News Corp. acquired it, a figure that eventually peaked at 100 million. Rupert Murdoch beat out Viacom in acquiring MySpace and was 'immediately hailed as an Internet visionary'. Murdoch folded MySpace into a new division called Fox Interactive Media. But the deal 'never quite worked out'. Like other merg-ers before, a high-flying internet company, MySpace, was 'caught in a culture clash precipitated by joining a big media conglomerate, News Corp. Then a competitor arrives on the scene with better technology.' In this case, it was Mark Zuckerberg's Facebook (Arango, 2011). Forced to meet News Corp.'s

ambitious revenue goals, MySpace accepted advertising of increasingly dubious quality. Users fled the site by the millions, and by 2009 MySpace had been overtaken by Facebook. News Corp. put its ailing site on the block. In June 2011, it finally found a taker, the advertising network Specific Media. It paid $35 million for the site, leaving News Corp. with a loss of $545 million.

The majors had yet to discover a formula to successfully exploit the internet. This failure became acute when DVD sales fell and the recession hit in 2008. Linking content and distribution seldom delivered the promised synergies. Taking stock of conditions, at least two companies reversed course by jettisoning distribution. It signalled a major shift in the media industry. Time Warner started the trend in 2004. To reduce its debt load, Time Warner sold off Warner Music to a group of investors led by Edgar Bronfman Jr for $2.6 billion. In 2009, the company spun off two more distribution arms, Time Warner Cable and AOL. The deals were brokered by Jeffrey L. Bewkes, who ascended to chairman and chief executive of Time Warner in 2008. By ridding Time Warner of its distribution business, Bewkes vowed to make it a purely content-driven company. The downsizing led to more layoffs.

Viacom followed suit. In 2005, the company spun off CBS and other properties into a separate public company called CBS Corporation. Viacom's merger with CBS had got off to a shaky start. Following the September 11 attacks and the bursting of the internet bubble in 2001, advertising revenue dried up across the board and Viacom's shares had plummeted. To start the downsizing, Redstone sold Blockbuster Entertainment in 2004. Blockbuster had lost nearly $1 billion in 2003 on revenue of $5.9 billion and its market value had dropped from $8.4 billion, Viacom's purchase price, to less than $3 billion.

The rationale for the CBS breakup, explained the *Economist*, 'is to hive off Viacom's traditional "old" media assets [the CBS network, television and radio stations, outdoor advertising and publishing] and create a smaller, nimbler version of the company [comprising Viacom's cable networks and Paramount film studio] to manoeuvre more easily in a world of "new" digital media, such as the internet, mobile phones and video games' ('Old and New Media Part Ways', 2005). Sumner Redstone, for his part, gave this explanation: 'Ten years ago, as the Internet became a potent force, content vs distribution was the great debate, and the big money was on distribution … I told everyone who would listen that content is king. Content is still king.' By that, he meant there would always be delivery systems of various sorts, all of which would need quality programming to attract customers (Triplett, 2006).

Viacom acquired several small internet entertainment companies after the split, including Atom Entertainment, Harmonix, Y2M and Xfire, but lost out to 20th Century-Fox in an auction to acquire MySpace, a failure that led Redstone

to fire Tom Freston, Viacom's chief executive. 'Sumner Redstone's breakup logic has failed the test of time' (Swann and Goldfarb, 2010). Viacom and CBS shares continued to fall and, in 2008, Redstone became a casualty of the recession when the banks failed to renew his credit. Burdened with over $1.5 billion in debt, Redstone was forced to retrench. To satisfy his lenders, Redstone sold nearly $200 million of his Viacom and CBS stock, unloaded a hefty portion of his National Amusement theatre chain, laid off 850 company employees – 7 per cent of the workforce – and wrote off assets. Not until 2010 did the two companies reverse the trend.

THE CASE OF COMCAST

Given the shift away from synergy and conglomeration, it therefore came as a surprise when Comcast, the nation's largest cable television provider, reached an agreement in December 2009 to acquire a controlling interest in NBC Universal from General Electric for $13.5 billion. While rival networks were being absorbed by Hollywood, GE had held its ground with its network. By 2009, however, GE was ready to deal. NBC had fallen to last place in the ratings, and GE's blue chip stock had plunged during the 2008 financial crisis. Describing the Comcast merger, Andrew Ross Sorkin said,

> It's just like the good old days, when media titans strode the earth in search of the grail of synergy, a magical elixir that emerged from vertically integrating seemingly disparate enterprises. In this case, Comcast – a company with around 24 million customers in 39 states that make up 95 percent of its revenue – wants to diversify when cable systems are under a variety of threats. (Sorkin, 2009)

Comcast wanted NBC Universal as a hedge to becoming a 'dumb pipe', which is to say, merely a conduit that delivers TV and internet services. Comcast CEO Brian L. Roberts stated that 'the deal was a perfect fit for Comcast and will allow us to become a leader in the development and distribution of multi-platform "anytime, anywhere" media that American consumers are demanding'. Although Roberts sounded much like Steve Case when AOL took over Time Warner, the media landscape had changed exponentially since then with the rise of YouTube, Hulu, Netflix, iTunes and their iPads, which allowed consumer 'to watch broadband and Internet-delivered video on their own timetables' ('Comcast's Ripple Threat', 2010).

Comcast had attempted to acquire content twice before. In 2004, it launched a hostile and unsuccessful bid to take over the Walt Disney Company. Later that year, Comcast joined Sony Pictures and a group of investors to outmanoeuvre Time Warner and purchase the legendary Metro-Goldwyn-Mayer studio for

Comcast acquires NBC Universal in 2011, an attempt to create synergies by merging Comcast's pipes with NBC Universal's content

$5 billion. Comcast's stake in the venture gave it access to MGM's library of 4,000 titles. Comcast was intent on expanding its video-on-demand service and by 2005 was offering thousands of older films and television programmes on its service.

Comcast won approval of the merger in January 2011 under certain conditions. (Comcast left the NBCUniversal name unchanged, but removed the space between the two names.) Comcast became the first cable operator to own a major television network, something unimaginable twenty years earlier. The merger linked NBCU's television network, film studio, theme parks and lucrative cable channels – USA, Bravo, SyFy, CNBC and MSNBC – with Comcast's E!, Golf Channel, VERSUS, G4 and Style networks. Under this new configuration, the NBC network and Universal Studios accounted for only a small portion of the total revenues of the joint venture.

CONCLUSION

The twenty-year acquisition spree during which the major media conglomerates vied for competitive advantage underperformed. Obsessed with growth, media moguls imagined synergies where none existed. They overpaid for acquisitions and overestimated the impact of the internet. As Jonathan A. Knee, Bruce C. Greenwald and Ava Seave state in their book *The Curse of the Mogul: What's Wrong With the World's Leading Media Companies*, since 2000, 'the largest media companies have collectively written down $200 billion in assets. "These write-downs represent the real destruction of value from relentlessly overpaying for acquisitions, 'strategic' investments and contracts for content and talent. ... The magnitude of these losses", it added "also reflects the level of desperation among media moguls faced with new competitors, new technologies and new customer demands"' (Hurt, 2009).

Falling DVD revenue and a decline in operating income during the 2008 recession placed increasing demands on the major studios to improve their parent companies' bottom line. As *Variety*'s editor Peter Bart points out, 'the Hollywood entities are run by corporate decree: Mandates on profitability are

set by Wall Street, and the corporate soldiers salute and enforce' (Bart, 2010b). As the following chapters illustrate, the majors cut back on production, shed low-growth businesses, laid off thousands of employees and fled to safety by investing in tentpoles and franchises. Meanwhile, they searched for ways to off-set the decline in DVD sales.

2

Production: Tentpoles and Franchises

The CEOs of the media companies are clear and unequivocal about what they want from their movie studios – more and bigger franchises that are instantly recognisable and exploitable across all platforms and all divisions of the company. As *Variety* noted, 'Since the 2007 writers' strike and the 2008 recession, the studios have felt more pressure to appease parent companies that have become more cost-conscious and profit-hungry. They increasingly need to produce content that moviegoers will instantly recognize and embrace' (Kroll, 2012). The quest of every studio is to find a property that can generate $1 billion at the box office worldwide. Winning franchises in the new millennium have been based on fantasy novels (*Lord of the Rings* and *Harry Potter*), action comics (*Batman* and *Spider-Man*), theme park rides (*Pirates of the Caribbean*), children's fairy tales (*Shrek*), Hasbro toys (*Transformers*), cartoons shows (*Alvin and the Chipmunks*), video games (*Mortal Kombat*) and even original stories (the Pixar pictures). Warner Bros. was the first studio to embrace this strategy, but by the end of the decade all the majors had followed suit.

There is actually nothing new about this strategy; it is the intensity of its implementation that is different. 'At the end of the day, Hollywood is all about making money,' said a major studio boss. 'That sounds cynical, but it's true. My hands are tied having to come up with big franchises. I can't make certain movies anymore, no matter how profitable they might become. I make movies that turn into toys' (Graser, 2012).

Hollywood's love affair with franchises went back at least to the 1960s, with the launch of the first James Bond picture starring Sean Connery, and continued in earnest with the blockbusters of the 70s, like *The Godfather* (1972), *Jaws* (1975), *Rocky* (1976), *Star Wars* (1977) and *Star Trek* (1979), each of which generated a franchise. The success of these pictures conditioned Wall Street and company shareholders to expect substantial returns from the movie business. Today, the majors each release between twenty and thirty pictures a year. In constructing their annual rosters, the goal is to release a few tentpoles for the holiday and summer seasons, and a variety of films at different price levels to feed the multiplexes. Rather than fully funding the entire slate, the majors make fewer

films themselves and put their money mainly on big-budget tentpoles targeted at two audience segments, the 'Teen and Pre-Teen Bubble', consisting of avid filmgoers aged ten to twenty-four, and 'Boomers With Kids', consisting of children, parents and grandparents in the eight-to-eighty demographic. Tentpoles are considered conservative investments for these reasons: (1) they constitute media events; (2) they lend themselves to promotional tie-ins; (3) they are easy sells in world markets and (4) they have the ability to spin off sequels to create a franchise.

The mid-level and low-budget films on their rosters are typically consigned to outside producers, as will be explained later. Here, we need only say that original fare, the mid-level indie-style film, has been a casualty of the tentpole trend, most vividly seen in the closing of more than one speciality unit of the majors. Such films 'are tough sells to an audience', goes the traditional argument. As Fox Film's Bill Mechanic put it, 'They are not the easiest concepts to digest from a trailer or one-sheet. They are often slice of life, character-driven stories and while the cost for stars and marketing costs for these films have accelerated, the audience's appetite for them hasn't' (Brodie and Busch, 1996). Mid-level films have survived, and some win kudos and box-office success, but such films are typically made by the producing partners of the majors or by independents. Hollywood has preferred to place its bets on the safe and familiar. The flight to safety is easily seen in Hollywood's increased reliance on sequels and prequels to prop up sagging franchises. In 2011, for example, for the first time, the seven top-grossing films in the USA were franchise installments, from *Harry Potter and the Deathly Hallows: Part 2* and *Transformers: Dark of the Moon* at the top, through *Fast Five* and *Cars 2*.

THE MAJOR PRODUCTION TRENDS
Comic Book Franchises

To reach the 'Teen and Pre-Teen Bubble', comic books have provided a mother lode of franchises. Comic book franchises have emanated from two sources: DC Comics and Marvel Entertainment. Both trace their roots to the 1930s. DC Comics is now a subsidiary of Time Warner and is famous for a line of superheroes headed by Superman, Batman, Wonder Woman and the Green Lantern. Marvel Comics, the largest comic book publisher in the business, is a recent acquisition of the Walt Disney Co. Marvel's line of superheroes is topped by Spider-Man, the X-Men, Iron Man and the Fantastic Four, to name a few.

The fan base for comic book movies is enormous, witness the four-day Comic-Con event that packs the San Diego Convention Center every year. As *Variety* noted, 'The great thing about Comic-Con is it's a great audience of movie aficionados and fans. They have a ravenous appetite for new product and have

DC Comics' universe of
superheroes

a discriminating eye. They are film lovers and if they like what they see, they'll
talk about it. They're absolutely not shy how they feel about stuff either on the
Web or in person' (Graser, 2008).

Hollywood's interest in superheroes began in the 1970s, when producers Ilya
and Alexandre Salkind acquired the movie rights to Superman from Warner
Bros. and made four movies starring Christopher Reeve. Richard Lester's
tongue-in-cheek installments, *Superman II* (1980) and *Superman III* (1983), were
the high points of the series. Warner produced its first *Batman* live-action fea-
ture in 1989, which was followed by *Batman Returns* in 1992. Both were directed
by Tim Burton and starred Michael Keaton, whose 'dark, mysterious and melan-
choly' portrayal of the superhero departed from the 'campy caped hero
popularized by Adam West in the '60s TV series' (Spillman, 1989). Two lesser
sequels followed: Joel Schumacher's *Batman Forever* (1995), starring Val Kilmer
as Batman, and *Batman & Robin* (1997), starring George Clooney.

Warner reacquired the rights to Superman from the Salkinds and rebooted
the *Superman* and *Batman* franchises, beginning in 2005 with the backing of
Thomas Tull's Legendary Pictures. Tull, a venture capitalist, was interested in
action and adventure films, primarily. 'The 38-year-old Mr Tull is part of a new
generation of film and TV executives who were raised on video games and
comics and are now turning those childhood obsessions into big-budget reali-
ties,' reported the *Wall Street Journal* (Brophy-Warren, 2009). Legendary's first
investments were in Christopher Nolan's *Batman Begins* (2005), starring
Christian Bale, and Bryan Singer's *Superman Returns* (2006), starring Brandon
Routh. They generated respectable grosses, but hardly paid for themselves.

Afterwards, Legendary changed course and began exploiting DC's less famil-
iar properties. In 2006, for example, it backed Zack Snyder's *300*, based on
Frank Miller's graphic novel about the Spartan defeat of the Persians at the bat-
tle of Thermopylae. The film had one of the biggest openings of the year and

grossed $500 million worldwide. In 2008, Legendary returned to the *Batman* franchise and produced Christopher Nolan's *The Dark Knight*, again starring Christian Bale. Nolan's noir-ish *Batman* sequel became the second-highest-grossing film ever in the USA after *Titanic* (1997), bringing in more than $500 million at the box office and more than $1 billion worldwide. Warner's handling of the picture was noted for its viral marketing campaign, which utilised more than thirty websites to leave 'a trail of virtual bread crumbs intended to sate fans' for a year before the summer release (Wallenstein, 2008).

The modern Marvel Comics was launched in 1961 from the pen of Stan Lee, the creator of Spider-Man and numerous other characters. Marvel's core business, publishing, was never very profitable until it started licensing its superhero characters to the movies. The transformation began in 1998, when the company exited bankruptcy protection and was taken over by Toy Biz, a Marvel subsidiary headed by Avi Arad and Ike Perelmutter. The huge success of Fox's *X-Men* and Sony's *Spider-Man* franchises spurred Marvel to go into production in 2005 under the name Marvel Studios. As a licensor, it collected only a small percentage of the box office from its properties. As a producer, it stood to reap all the profits. To get started, Marvel secured a $525 million loan from Merrill Lynch to make up to ten pictures. Marvel then contracted with Paramount to provide the distribution. Marvel agreed to pay Paramount a 10 per cent distribution fee and to cover the marketing costs of its pictures in the USA Marvel's first effort, Jon Favreau's *Iron Man* (2008), starring Robert Downey Jr, Gwyneth Paltrow and Jeff Bridges, was a huge success, bringing in over $100 million on opening weekend from 4,105 theatres. That was the best opening ever for a Paramount live-action picture.

Marvel's library of superheroes made it an attractive takeover target and, in 2009, Disney acquired the company for $4.2 billion. In doing so, Disney picked up a world-class intellectual property and eliminated one of its chief rivals. Marvel's library of superheroes and villains allowed Disney to move into a market where its presence was weak – teenage boys. Certain Marvel characters could be turned into Disney theme parks. And the potential in consumer products was enormous. Time Warner countered Disney's move by restructuring DC Comics into a new division, DC Entertainment, to more aggressively exploit its comic book characters across all platforms.

Family Films

To reach 'Boomers With Kids', the obvious choice was family films. Family films had proven themselves reliable sources of profits since the 1990s. They did especially well in home video. G-rated films often sold five times as many copies as R-rated films, as parents searched for suitable titles for family viewing. The

Disney label was synonymous with family entertainment and, during the 90s, it released a series of hits that included *The Mighty Ducks* (1992) about 'a disgraced boozer in need of redemption (Emilio Estevez as Gordo Bombay) and the hapless bad-mouthed hockey dorks he coaches as a community service'; *101 Dalmatians* (1996), a remake of the popular 1961 animated feature, which starred Glenn Close as the arch villainess Cruella DeVil, 'whose most passionate desire is to make a unique fur coat out of the too-precious puppies'; and *The Santa Clause* (1994) about a hapless toy-company executive played by Tim Allen of TV's *Home Improvement*, who is pressed into service as a substitute St Nick (Wilmington, 1992; McCarthy, 1996).

Other studios contributed to the trend. In 1990, New Line released *Teenage Mutant Ninja Turtles*, a $12 million production made by Hong Kong's Golden Harvest Studios. Popularised in comic books and a syndicated animated series, the live-action version contained human-size, animatronic turtles created by Jim Henson's Creature Shop. *Ninja Turtles* opened to startling business, eventually grossing $136 million domestic to become the top-grossing independent release in film history. Licensing spinoffs from the film generated an estimated $1 billion the first year and two sequels.

20th Century-Fox was the first major to go head to head with Disney by producing the enormously successful *Home Alone* (1990). A mid-budget picture starring a nine-year-old Macaulay Culkin, *Home Alone* was the most successful comedy in film history. The production can be summed up as follows: 'Family loves boy. Family loses boy. Family finds boy. Film grosses $285 million.' Audiences loved the boy and identified with the 'anguish of two parents who accidentally leave their child behind in the mad rush to the airport for their Christmas vacation in Paris' (James, 1990). Fox wasted no time producing *Home Alone 2: Lost in New York* (1992) and other spinoffs.

Universal reached out to the kiddie audience by producing 'Steven Spielberg's favorite TV shows as a kid' (Natale, 1998). Spielberg's company, Amblin Entertainment, made two big family hits for the studio, *The Flintstones* (1994) and *Casper* (1995). Both displayed synergistic potential. As *Variety* put it, watching *The Flintstones* 'is akin to taking a quick spin on the Universal Studios tour with a detour through the City Walk attraction, so loaded is it with technical gizmos, showbiz in-jokes and product plugs. In a day when popular movies have more in common with theme parks than old-school artistic traditions, this one fits right in' (McCarthy, 1994). Going into the new millennium, Hollywood planned on filling the screens with even more 'princesses, monsters, talking animals, bright school kids and scrappy ballplayers' (Smith, 2002).

Disney retained its lead in animated features with *The Little Mermaid* (1989) – the studio's first open attempt to court baby-boomers and their children.

Janet Maslin noted that 'in combining live-action directorial techniques with animation, devising a story that reflects adult attitudes and recalling baby boomers' fond memories of the traditional Broadway score, Disney has made its target audience clear' (Maslin, 1991). *The Little Mermaid* initiated a string of record-breaking hits from Disney that included *Beauty and the Beast* (1991), *Aladdin* (1992) and *The Lion King* (1994). *The Lion King*, a musical about Simba, a lion cub who endures certain rites of passage before becoming the ruler of his kingdom, was the no.1 box-office hit of 1994 and sold more than $1 billion worth of licensed merchandise, including Disney's first no.1-ranked soundtrack since *Mary Poppins* in 1964. But the cost of producing state-of-the-art animation was escalating and, after *Lion King*, Disney cut its 2,000 plus animation staff in half.

Disney, meanwhile, had hedged its bets by forming a joint venture with Pixar in 1991 to finance and distribute three Pixar computer-animated feature films. Founded by Apple Computer's Steve Jobs in 1986, Pixar became a public company in 1995 with headquarters in Emeryville, California, across the bay from San Francisco. *Toy Story* (1995), its first feature, made computer animation a commercial and artistic force. The characters were admired for having the same facial mobility as the hand-drawn characters of cel animation. The picture was also admired for its provocative and appealing story about a cowboy marionette named Woody and Buzz Lightyear, a galactic superhero with an arsenal of flashy gadgets. (They were voiced by Tom Hanks and Tim Allen, respectively.) The 'clever mix of simplicity and sophistication ... cuts across all age barriers with essential themes', said *Variety* (Klady, 1995). Pixar's two other films were *A Bug's Life* (1998) and *Toy Story 2* (1999).

Pixar renegotiated its deal with Disney in 1997 and, after delivering *Monsters, Inc.* (2001) and *Finding Nemo* (2003), the studio was acquired by Disney in 2006 for $7.4 billion. By then, Pixar's pictures had generated $3.2 billion worldwide, won nineteen Academy Awards and sold more than 150 million DVDs. After the merger, Pixar released *Cars* (2006), *Ratatouille* (2007), *WALL-E* (2008), *Up* (2009), *Toy Story 3* (2010) and *Cars 2* (2011). *Toy Story 3*, Pixar's eleventh hit in a row, became the highest-grossing animated film of all time, taking in 'more than $1 billion at the box office, plus $650 million on home video, $250 million from books, $220 million from videogames and $7.3 billion in other merchandise sales, while launching park rides and cruise ship shows, turning it into a $10 billion property', reported *Variety* (Graser, 2011a).

Pixar had set the standard in computer-generated feature animation, but it did not have the field to itself. In 1998, DreamWorksSKG released *Antz* (1998), the second computer-animated feature to be released after *Toy Story*. DreamWorksSKG was founded in 1994 by Steven Spielberg, Jeffrey Katzenberg

Pixar's *Toy Story* (1995)

and David Geffen. In 2000, the company formed DreamWorks Animation, headed by Katzenberg, the former head of Disney's film division and the man behind Disney's string of animated hits leading up to *The Lion King*. Katzenberg led off with *Shrek* (2001), which was based on William Steig's popular fairy-tale book. It won the first Academy Award for best animated feature and spawned a franchise.

After a false start in traditional cel animation, 20th Century-Fox placed it bets on CGI animation and acquired Blue Sky Studios located in White Plains, New York, in 1998. Blue Sky was headed by Chris Wedge, who won an Oscar in 1998 for his short animated film, *Bunny*. Blue Sky's first CGI feature, *Ice Age* (2002), became a surprise family hit, taking in $380 million worldwide and selling more than 27 million DVDs. *Variety* said that Wedge and collaborators had set 'new standards for computer-generated anthropomorphism. There's something mat-ter-of-factly astonishing about the vivid precision of key details, ranging from the seemingly 3-D qualities of animals roaming through detailed landscapes to the movement of wind-ruffled hairs on woolly mammoths and saber-toothed tigers' (Leydon, 2002). Blue Sky's second feature, *Robots* (2005), was something of a disappointment, but the *Ice Age* sequel, *Ice Age: The Meltdown* (2006), and *Horton Hears a Who!* (2008), based on the Dr Seuss children's classic, were huge hits. 'The bet paid off big time,' said *Variety*, 'and established Fox as only the third studio, along with DreamWorks and the independent Pixar, to launch a successful CGI franchise' (Fritz, 2008).

3-D

In 2005, with the release of Disney's *Chicken Little*, the novelty of 3-D made computer-animated family features even more appealing. 3-D became a factor in the production trend, the studio's first fully computer-animated film. Until then, 3-D films could be seen only in specially equipped IMAX theatres and required viewers to wear high-tech glasses. Disney released *Chicken Little* in two versions: in 3-D to eighty-five specially equipped theatres and in 2-D to conventional theatres. Disney worked with Lucasfilm's Industrial Light & Magic to handle the digital rendering of the picture and with Dolby and Real D to perfect a 3-D digital projection system which could be installed in the selected theatres. *Chicken Little*'s 3-D release outperformed the standard rollout by three to one.

The widespread diffusion of 3-D had to wait until industry-wide technical standards were set for digital projection and a method of financing the conversion had been found. The tipping point occurred in 2009, when the number of screens with digital projection reached 16,000 worldwide. Of that number, around 3,500 screens were equipped to show 3-D. The 3-D hits of 2009 included *Cloudy with a Chance of Meatballs* from Sony Pictures, *Monsters vs Aliens* from DreamWorks Animation and *Ice Age: Dawn of the Dinosaurs* and James Cameron's *Avatar* from Fox. *Avatar*, the record setter, combined immersive 3-D images and sophisticated performance-capture technology. The picture cost $460 million to produce and market and opened in December 2009 across 3,450 theatres, of which some 2,000 were 3-D venues. On opening weekend, the 3-D venues earned nearly $27,000 each on average, while the 2-D theatres took in around $16,000 each. *Avatar* went on to gross nearly $3.7 billion worldwide to rank no. 1 in box-office history.

3-D hit its stride in 2010 and garnered plenty of headlines, both for and against the technology. That year, twenty-five films were released in 3-D versions, up from twenty in 2009. Some, like Fox's *Clash of the Titans* and Disney's *Alice in Wonderland*, were retrofitted 2-D versions known as '3-D Lite'. Top 3-D titles included *Toy Story 3* and *Alice in Wonderland* from Disney, *Shrek Forever After* and *How to Train Your Dragon* from DreamWorks Animation and *Despicable Me* from Universal. *Despicable Me* was Universal's entree into the digital-animation market. It was produced by Chris Meledandri, whom Universal Pictures hired away from Fox in 2007 to set up a new low-cost animation unit called Illumination Entertainment. *Despicable Me* cost only around $69 million and took in over $544 million worldwide.

The success of such films 'has laid groundwork for a new conventional wisdom that will hold at least until the first major 3-D flop', said A. O. Scott (2010). That occurred in March 2011 with the release of Disney's *Mars Needs Moms* 'about a 9-year-old boy whose mother is abducted by Martians'. It was produced

by Disney's new ImageMovers Digital unit headed by producer-director-writer Robert Zemeckis and utilised Zemeckis's motion-capture animation technique. Disney spent more than $175 million on the picture, but it grossed less than $40 million worldwide, making it 'one of the biggest box-office bombs in movie history', said Brooks Barnes (2011b). Critics and audiences alike rejected the film. Part of the problem was Zemeckis's motion-capture style, which could make facial expressions look unnatural. Another was the high 3-D ticket surcharge, which might have turned consumers away.

The disaster did not spell an end to family films or to 3-D. Universal's Illumination Entertainment released *Hop* (2011) on the heels of *Mars Needs Moms*. A live-action and cartoon hybrid that cost $63 million to make, *Hop* was released in time for Easter and far exceeded expectations. Audiences were willing to embrace quality and pay a premium for it. Rob Moore, a Paramount marketing executive, affirmed that 'the whole 3-D adventure comes down to the old issue of quality. Audiences will pay to see movies that use 3-D well' (Bart, 2011a). The opinion was validated by the release of three summer hits in 2011 – Paramount's *Transformers: Dark of the Moon*, Disney's *Pirates of the Caribbean: On Stranger Tides* and Warner's *Harry Potter and the Deathly Hallows: Part 2* – each of which grossed over $1 billion worldwide. All three pictures were released in 3-D.

RATIONALISING PRODUCTION

The dot.com bubble burst, declining DVD sales and the recession, coupled with Hollywood's tentpole strategy, created a buyer's market for the majors. The cutback in production and the high-risk investments in blockbusters reflected a cautious approach to film-making, which presented fewer employment opportunities for all levels of talent. Having the upper hand in dealmaking, studios reduced risks by sloughing off riskier, mid-level pictures to outside investors and offering tougher terms in negotiatons with participants on their projects.

Inhouse Productions

Studios construct their annual rosters by producing films inhouse and by partnering with outside producers. Inhouse productions are fully financed by the studio and are developed by staff producers or by independent producers with housekeeping deals. Studios finance their pictures with internally generated funds and/or by taking out lines of credit from a bank, insurance company or pension fund – a practice known as 'balance sheet' borrowing. A line of credit allows a studio to draw down funds as needed. For repayment, the lending institution looks to the studio itself – its assets and its revenue flow – and not to the individual performance of a picture or slate of pictures.

Housekeeping Deals

Housekeeping deals became standard practice beginning in the 1950s, when Hollywood shifted from the studio system method of production to unit production. To secure a steady supply of quality product, studios entered into financing/distribution deals with top producers, directors and actors and set them up in individual production units. In so doing, the studio covered the overhead expense of maintaining an office and staff; it provided a discretionary fund to purchase properties; and it paid the producer a fee as an advance in return for first dibs on any project in development. If the studio greenlit a project, it would finance the picture and share the profits in return for worldwide distribution rights. A typical housekeeping pact cost a studio $1 million and more annually just for the overhead. Some of the more enduring relationships have been with Steven Spielberg, Jerry Bruckheimer, Scott Rudin and Brian Grazer. Spielberg's on-and-off relationship with Universal began in the 1980s when his production company, Amblin Entertainment, delivered a string of hits that included Spielberg's *ET: Close Encounters of a Third Kind* (1982) and *Jurassic Park* (1993) and Robert Zemeckis's *Back to the Future* (1985). Bruckheimer's relationship with Disney began in the 90s and resulted in the *Pirates of the Caribbean* franchise. Rudin's relationship with Paramount lasted ten years and resulted in a series of smaller, personal films such as Albert Brooks's *Mother* (1996), Jerry Zaks' *Marvin's Room* (1996), Peter Weir's *The Truman Show* (1998), Alan Parker's *Angela's Ashes* (1999) and Stephan Daldry's *The Hours* (2002). Brian Grazer and partner Ron Howard founded Imagine Entertainment in 1987 and have been delivering hits to Universal ever since, among them Ron Howard's *Apollo 13* (1995) and *The Da Vinci Code* (2006).

Pacts with veteran film-makers are still being made, but not with middle-range talent. Such deals have shrunk dramatically in number and in size in recent years as studios have been forced to trim financial excesses. *Variety* reported one studio president saying, 'We are all under enormous pressure from our corporate parents to make our numbers, and if you can trim $5 million from your budget by dropping overall deals, it is the easiest place to take out money' (Fleming and Garett, 2008). Such cutbacks were just the first of many that affected production routines in the new millennium.

Talent Agents

Agents function as the middlemen of show business. They represent talent, which is to say actors, writers, directors, producers and other artists, and their job is to sell the services of their clients to buyers of talent – film and television producers, publishers and entertainment promoters of all stripes. Originally concerned with getting the highest possible terms for their clients, agents gradually

took an active role in shaping their clients' careers. The business changed in 1975, when Michael Ovitz, Ron Meyer, Bill Haber, Mike Rosenfeld and Rowland Perkins left the venerable William Morris Agency to found Creative Artists Agency. CAA attracted the top directors and stars with the promise of securing top dollar for their services and delivering on their word. CAA also aggressively took on many of the traditional functions of the studios, searching out properties and putting together packages consisting of star, director and writer, which they offered to the studios on an all-or-nothing basis. With names such as Tom Hanks, Tom Cruise, Robert De Niro, Demi Moore, Martin Scorsese, Robert Zemeckis and Sydney Pollack on its roster, CAA could just about dictate the terms when it came to salaries.

Today, Creative Artists Agency and William Morris Endeavor Entertainment are the biggest names in the business, with offices in Beverly Hills, New York and in European capitals. They represent a broad range of established talent, including Olympic stars and former US presidents. Other important agencies include International Creative Management and the United Talent Agency. Smaller independent agencies abound and typically specialise in representing a single type of client, such as writers or actors. Also they are more prone to solicit new and untried talent. William Morris Endeavor was formed in 2009, when two of the entertainment industry's largest talent agencies, William Morris and Endeavor, agreed to merge. William Morris was founded in 1898; Endeavor in 1995 by four agents from International Creative Management. The combined agency is headed by Ariel Z. Emanuel, brother of Rahm Emanuel, who served as the White House chief of staff in the Obama administration from 2009 to 2010.

During the new millennium, the balance of power between talent agents and the studios shifted. Companies like Time Warner, Walt Disney and Sony were shedding jobs, cutting back on production and closing units to save on expenses and were less inclined to quibble over terms with talent agents. As Peter Bart of *Variety* observed, 'The entertainment industry is facing more of a buyer's market than at any time in several generations' (Bart, 2010a). Although agencies such as CAA are still very influential, their power has diminished since the 1990s.

Development Hell

The renewed focus on the bottom line has also impacted the studio-development process. Established screenwriters who sold their script or landed an assignment were once able to negotiate deals that included a first draft, two sets of revisions and a polish, for which they were paid pre-negotiated fees each step of the way. To cover all the bases, studios also spent lavishly to develop numerous projects simultaneously. Writers were being paid $1 million for a screenplay

draft and projects were racking up $5 million in costs before they were abandoned. Projects languished interminably in what became known as 'development hell' as executives demanded successive rewrites. It was a wasteful process since only one project in ten in development was ever greenlit. Today, studios are being more selective in their spending. 'The biggest shift is the way resources are now being largely earmarked for existing franchises,' reported *Variety*. 'Gone are the days when a studio might pre-emptively buy a script that it had no intention of making just to take it off the market. Pitches are also out. Scripts without talent attached are ice cold. One-step writer deals are "in" to save money' (Graser, 2010c). One-step deals paid a writer for a first draft and left undetermined fees for additional work. 'In a landscape of waning producing deals and fewer pictures in the pipeline,' said *Variety*, 'writers say it's become especially difficult to insist on getting paid for rewrites – even if they end up doing more than a dozen drafts. Their fear: not getting a next assignment' (McNary, 2010).

Star Salaries

During the 1990s, agents succeeded in negotiating 'first-dollar gross' deals that gave top producers, stars, directors and screenwriters a fee upfront and points – a percentage of the box-office gross on their pictures from the first ticket sold. Top stars routinely earned $30 million and more from such deals. Lesser lights typically received the much-derided 'net profit' deals that gave them a fee upfront and a share of the profits after their pictures broke even. But few films ever reached that point under studio accounting, which apportions huge overhead charges and other fees to production budgets (Cieply, 2010a). Since studio accounting makes most films appear unprofitable, talent understandably prefer first-dollar grosses.

Hollywood chieftains acquiesced to wage inflation because of the enduring belief that stars provided insurance for big-budget pictures. As noted by the *New York Times*, 'the industry still places an enormous importance on superstar power based on a straightforward fact: On average, movies that have big names starring in them make more money at the box office than movies that do not.' A big reason is that star-studded vehicles are easier to market. As Arthur S. DeVany stated, 'By helping a movie open – attracting lots of people in to see a movie in the first few days before the buzz about whether it's good or bad is widely known – stars can set a floor for revenues ... But they can't make a film have legs' (Porter and Fabrikant, 2008). However, stars helped drive DVD sales, the largest revenue source for the majors going into the new millennium.

The downside to wage inflation is this: 'The movies that had to carry these fees became safer, more formulaic and less interesting, and to make their money

back they needed to perform on a global scale. "The bigger the movie stars become", says producer Mark Johnson, "the more constricting their roles and the scope of their roles". Sequelitis contributed to boosting star fees. Once stars got paid a higher figure, agents would demand it again,' Anne Thompson reported (2008a).

But declining DVD sales and the recession forced studios to become increasingly tightfisted. Nothing signalled the change in attitude more than Sumner Redstone's firing of Tom Cruise in August 2006. The decision by Viacom's chairman to end Paramount's fourteen-year relationship with Cruise's production company was ostensibly triggered by Cruise's bizarre behaviour on Oprah Winfrey's television talk show. But some observed that Paramount was tired of paying out $10 million a year to carry Cruise's company. In either case, Redstone's 'public slap at one of America's most visible stars' seemed to indicate 'a huge paradigm shift in the industry in terms of what constitutes a star and how much power a star has' ('Paramount Cuts Ties with Tom Cruise's Studio', 2006).

In the new order, 'the actors who used to make $15 million are making $10 million. The film-makers who used to make $10 million are making $6 million. The writers who used to get a three-step deal, guaranteeing payments on a series of rewrites, now get one,' reported the *Los Angeles Times* (Goldstein and Rainey, 2009). The balance of power had clearly shifted to the majors. Instead of 'first-dollar gross' deals, studios now offer 'cash-break zero' deals – CB zero deals, for short – which pay a star or film-maker a reduced salary upfront in return for a share of the profits after the studio has recouped its cash investment, which is to say its production and marketing costs. If a picture flopped, the participants walked away with a reduced salary; if the picture succeeded, they could score big. For example, Sandra Bullock acquiesced to a CB zero deal for starring in *The Blind Side* (2009) and earned more than $20 million when it became a hit.

New Methods of Financing

To reduce the risks of production financing, the majors have had an array of options to choose from. The first was 'soft money' in the form of subsidies, rebates, tax breaks and the like that governments made available to film producers under certain rules with the goal of creating jobs and/or boosting local film industries. Such incentives stimulated a second round of runaway production reminiscent of the postwar phenomenon when the majors moved much of their production to Rome and London. Beginning in the 1990s, American film production migrated to Canada, Ireland, the UK, the Netherlands, Belgium, Luxembourg, Iceland, Austria, New Zealand and Australia. In Canada, for

example, a favourable exchange rate, lower wage costs and government tax breaks allowed American film and television producers to reduce production costs by 25 per cent or more by shooting in that country. By 2001, Vancouver, Toronto and Montreal had become major production centres and thousands of jobs were being lost in Hollywood in the process. New Zealand too became a major production centre when the government instituted a subsidy scheme and landed Peter Jackson's *Lord of the Rings* franchise.

In an effort to win back film production from across the border and generate jobs, economic activity and tax revenues, Louisiana, New Mexico, Illinois, New York, Florida, Texas, Michigan and other states instituted tax incentive packages of their own. Film subsidies proliferated when times were good, but when the economy went sour in 2008 states began to question the value and efficacy of such incentives. Nonetheless, film shoots in Los Angeles by the major studios plummeted from seventy-one in 1996 to twenty-one in 2008, leaving local-based film crews and technicians unemployed.

With the growth of home video and pay TV, which were thought to make the movies safer bets, a second option presented itself – outside investment. Disney, for example, entered into a partnership with Japanese banks and investors in 1990 and raised $600 million in financing, enough for a year's supply of pictures. During the 90s, German tax shelters provided Hollywood producers a constant flow of financing until Angela Merkel's coalition government closed the loophole in 2005. In 2007, Warner Bros. and Abu Dhabi Media Company, an arm of the United Arab Emirates government, struck a deal worth $1 billion to build a theme park and make movies and video games together.

More often, the majors went into partnership with well-connected independent producers to share the burden. Companies like Lakeshore Entertainment, Village Roadshow and New Regency Productions raised their own financing and fronted 50 per cent or more of their production budgets. In partnering with such companies, the majors retained worldwide distribution rights, but charged lower fees for the service. Take the case of New Regency, founded in 1991 by Arnon Milchan, a prolific independent producer and former German industrialist. In 1997, Milchan entered into an exclusive production/financing deal with Fox. Milchan put up $300 million in financing from private investors; Fox put up $200 million in return for a 20 per cent stake in Milchan's company and worldwide distribution rights. Between 1998 and 2011, New Regency either co-financed or fully financed fifty-five movies for the studio which generated more than $5.3 billion at the box office. The list includes a few breakout hits, such as *Mr and Mrs Smith* (2005), *Marley & Me* (2008) and *Alvin and the Chipmunks* (2007), but most were what *Variety*

called 'meat-and-potatoes fare that looks far more impressive on the bottom line than on the top' (Swanson, 2001). In 2011, Fox announced a nine-year extension on the pact.

In the new millennium, a flood of money poured into Hollywood from private investors and hedge fund managers who thought they could beat Hollywood at its own game. The majors were happy to welcome them. A few earned their fortunes during the technology boom of the late 1990s and had got out before the market went bust. The list includes Philip F. Anschutz, the founder of Quest Communications; Fred Smith, the founder of FedEx; Jeff Skoll, the co-founder of eBay; Thomas Tull, a venture capitalist and former president of Convex Group, a media investment company; and Mark Cuban and Todd Wagner, the founders of Broadcast.com.

Thomas Tull's association with Warner Bros. has already been mentioned. Fred Smith is another case in point. In 1997, Smith decided to back a production venture pitched to him by Broderick Johnson and Andrew A. Kosove, two Princeton economics graduates. They formed a production company called Alcon Entertainment, after the Greek mythological archer. Alcon planned to develop and fully finance its pictures and arrange distribution through a major company. The full financing would allow the company to secure a low distribution fee and recoup its investment in the domestic market. Alcon would make its profits in the international market, which it intended to handle on its own. Alcon's first film flopped, but the second, *My Dog Skip* (2000), a low-budget family film, was a surprise hit and enabled the company to secure a five-year output deal with Warner Bros. To reduce its overheads, Johnson and Kosove worked out of unpretentious offices in Los Angeles. They controlled development costs by taking on projects that came with completed scripts and sometimes with film-makers attached. And they protected their exposure by pursuing mid-size pictures in the $15–$50 million price range. Alcon succeeded by producing singles and doubles, as Kosove put it, among them, *Insomnia* (2002), *Racing Stripes* (2005), *The Sisterhood of the Traveling Pants* (2005), *The Wicker Man* (2006), *16 Blocks* (2006) and *PS I Love You* (2007). In 2009, it had its first major hit, John Lee Hancock's *The Blind Side*, starring Sandra Bullock. Produced at around $29 million, the picture took in $256 million at the domestic box office and earned Miss Bullock an Oscar as best actress.

Hedge funds became a factor in film financing beginning 2002 and popularised a new type of instrument – slates. Knowing that most pictures lost money, and that maybe two out of ten struck it big, the plan was to invest in a slate of a dozen or more pictures at once on the assumption that, in aggregate, the pictures would earn a profit after all had been released. Hedge fund money poured

in even as DVD sales declined. The outlook for movies still looked good given the availability of state subsidies and the growth of the overseas market. Such was the thinking behind the investments.

Entering a slate deal, the hedge fund put up half the budget for the upcoming productions enumerated by the studio for financing. As the pictures were released, the studio deducted a modest distribution fee, the prints and advertising (P&A) expenses and the money to pay gross points participants. The remainder went to pay off the production costs, after which the profits, if any, were split 50–50 with the outside investor. Wall Street had two gripes about the deals: (1) investors ranked third or fourth in the revenue stream after the distribution fee and other expenses were skimmed off the top and (2) studios often excluded tentpoles and sequels from their slates. Investors, nonetheless, had no choice but to accept a studio's terms, knowing that if they passed on a deal, another group of investors would emerge from the wings.

Ryan Kavanaugh's Relativity Media pioneered the investment strategy. With the backing of the Elliott Management hedge fund, Relativity put up more than $1 billion in slate financing for Sony Pictures and Universal, beginning in 2004. By 2010, Relativity had financed, co-produced or produced more than 200 features. However, the financial crisis of 2008, brought about by the subprime mortgage crisis, pretty much killed the market for slate deals. Several large banks and hedge funds that had led Wall Street into the movie business posted tens of billions in losses and laid off hundreds of employees. Afterwards they sought safer harbours for their capital and searched elsewhere for possibilities. Despite the reversal, Relativity has stayed afloat.

STUDIO PROFILES

The following studio profiles describe the top managements that ran the companies and the production policies that propelled them.

Warner Bros.

Warner Bros., the largest Hollywood studio, was known for its stable management. Barry M. Meyer and Alan F. Horn ran the studio from 1999 to 2011, as chairman and president, respectively. Meyer came up through the ranks and had headed Warner's legal affairs department and television production and distribution operations. Horn was an outsider who joined the studio in 1996, when Castle Rock Entertainment, the independent production company he co-founded became a Warner Bros. subsidiary. Castle Rock had turned out such hits as *When Harry Met Sally …* (1989), *Misery* (1990), *City Slickers* (1991), *A Few Good Men* (1992) and *In the Line of Fire* (1993), as well as the hit *Seinfeld* (1990–98) television show for NBC.

Warner released the first *Harry Potter* film, *Harry Potter and the Philosopher's Stone*, on 16 November 2001; a month later, it released the first installment of the *Lord of the Rings* franchise, *The Lord of the Rings: The Fellowship of the Ring*. After the reviews and box-office returns came in, it became clear that Meyer and Horn 'intend to run a movie-franchise factory', reported the *New York Times*. 'Not only do they hope to deliver the same kind of franchise films that were notable in the era of Bob Daly and Terry Semel,' they,

> plan to produce even bigger and more frequent franchise films, wringing more profits and extending a concept's shelf life through television spinoffs, product tie-ins, movie soundtracks, promotion Web sites and other multimedia means ... No other studio now has so aggressively embraced the franchise strategy, in which films are no longer mere movies but brands. (Holson and Lyman, 2002)

The *Harry Potter* franchise was based on the seven novels by J. K. Rowling, a single mother in Edinburgh who started her writing career while on welfare. Warner's franchise spanned a decade and comprised eight pictures, after the studio decided to split the final installment, *Harry Potter and the Deathly Hallows*, into two movies. The manuscript of Rowling's first book, *Harry Potter and the Philosopher's Stone*, was rejected by numerous publishers because it was considered too dark for a children's book. It was eventually acquired by Bloomsbury Publishing in London, which gave Rowling an advance of £2,500. The first *Harry Potter* book came out in the UK in 1997 and was an immediate sensation. Warner Bros. acquired the motion picture rights to the first four novels in the series in 1999 for £1 million.

As noted by the *Economist*, 'Harry Potter was in the vanguard of a new approach to big-budget film-making.' Unlike the *Batman* pictures, which were carried by stars the likes of Jack Nicholson and Michael Keaton, the *Harry Potter* franchise was 'a wholly different product'. At the start, the leads were performed by obscure child actors – Daniel Radcliffe, Rupert Grint and Emma Watson – who remained with the franchise to the very end, performing alongside veterans like Maggie Smith and Michael Gambon, and grew into adults with no scandals. The franchise was produced in partnership with David Heyman, an aspiring British film producer who convinced Rowling to sell the motion rights to the franchise to Warner. The films were made by Heyman's Heyday Films at Leavesden Studios, a former Rolls-Royce factory north of London. Once going, the series kept 800 workers employed for a decade. Heyday Films oversaw all the films and was unusually stable. The first two installments were directed by Chris Columbus of *Home Alone* fame; afterwards, the franchise 'was handed to non-American directors more associated with independent film and television' –

Alfonso Cuarón, Mike Newell and David Yates. All but one of the screenplays were written by Steve Kloves, and the lead designers stayed with the franchise throughout. 'It's as though the auteur tradition has been fused with the industrial approach to film making that was common practice in Hollywood before the war,' said the *Economist* ('The Harry Potter Economy', 2009). In 2010, Warner purchased the studio and invested £100 million in the 170-acre site to create a permanent Harry Potter exhibition and to take advantage of British tax credits for Hollywood films shot in the UK.

Harry Potter and the Philosopher's Stone, the first picture in the series, was released just after the highly publicised AOL–Time Warner merger and utilised the cross-promotion opportunities of the new media conglomerate. The Warner Bros. movie had its soundtrack recorded by Atlantic Records, a Warner Music Group label; the film was featured on the cover of *Entertainment Weekly* and an advance review appeared in *Time*, two Time Inc. brands; and from the start, AOL promoted the picture on the internet 'through games, competitions, sneak previews and advance bookings'. As Richard Parsons, the company's new CEO said, *Harry Potter* 'is a prime example of an asset driving synergy both ways. [W]e use the different platforms to drive the movie, and the movie to drive business across the platforms' ('Harry Potter and the Synergy Test', 2001). The *Philosopher's Stone* took in $31 million the first day – a record – and opened on 8,200 screens in 3,672 theatres in the USA – another record. It went on to become the highest-grossing film of 2001.

The franchise had remarkable staying power and topped Warner Bros.' rosters each year they were released. *Harry Potter and the Deathly Hallows: Part 2* concluded the franchise. It was released in the summer of 2011 in both 2-D and 3-D, and broke box-office records around the world. By the end, the franchise had grossed over $7.5 billion, with the largest portion coming from overseas. Adjusted for inflation, the *Harry Potter* pictures came in second to the *Stars Wars* series, and like the *Star Wars* franchise, *Harry Potter* generated billions from the sale of consumer products, video games and DVDs. The movie franchise also helped make J. K. Rowling a billionaire.

The *Lord of the Rings* franchise was based on the J. R. R. Tolkien literary classic and was produced by New Line Films, the Time Warner subsidiary headed by Robert Shaye and Michael Lynne. In 1998, the project was brought to New Line by New Zealand director Peter Jackson after it was rejected by other studios. New Line decided to produce it as a trilogy, but the projected $270 million budget far exceeded New Line's resources. New Line therefore proposed shooting the pictures concurrently over eighteen months to effect economies of scale. Still, it was a risky venture; Peter Jackson had no prior experience directing big-budget projects, and if his first effort flopped, New Line would be sitting on two worthless sequels.

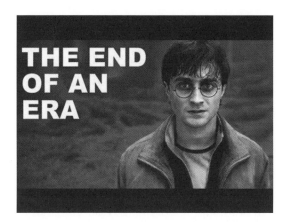

Harry Potter and the Deathly Hallows: Part 2 (2011), the end of an era

To protect its downside, New Line sold off the foreign rights to the trilogy piecemeal, which brought in about $55 million per film. It brought in another $11 million per film from merchandising and licensing deals. A final $10 million per film came in the form of tax incentives from the government of New Zealand, where the films were to be shot. The exercise left New Line vulnerable for less than 20 per cent of each film's production costs.

The *Lord of the Rings* pictures – *The Fellowship of the Ring* (2001), *The Two Towers* (2002) and *Return of the King* (2003) – opened in successive years on the Wednesday of the week before Christmas and instantly became must-see events everywhere. Gordon Paddison, New Line's VP of New Media and Integrated Marketing, tapped all the AOL Time Warner platforms to promote the pictures, but his most effective weapon was undoubtedly his fan-based internet campaign, which is discussed in the following chapter.

To fill out its annual roster and to reduce its exposure to risk, Warner Bros. relied on Village Roadshow, Legendary Pictures and Alcon Entertainment as co-production partners. Village Roadshow and Legendary set up at Warner's Burbank Studio and were considered full producing partners, 'involved in all stages of the process, including budgeting, casting, greenlighting, marketing and merchandising' (McClintock, 2009b). They each put up half the budget of a picture in exchange for half the profits from all revenue streams. Warner handled worldwide distribution.

Village Roadshow, the most prolific of the group, is a subsidiary of Village Roadshow Ltd, Australia's largest media company with interests in movie theatres, TV and radio stations and theme parks. Its relationship with Warner began in 1996 when it secured a $250 million credit facility to co-produce twenty pictures over five years with the studio. Village Roadshow later secured additional financing and the arrangement was eventually extended to 2015. To date, Village Roadshow has co-produced over sixty pictures with Warner, among them: *The*

Matrix and the *Ocean's …* franchises; *Analyze This* (1999), *Training Day* (2001), *Charlie and the Chocolate Factory* (2005), *Sex and the City 2* (2010); and three pictures partnered with Clint Eastwood's Malpaso Productions – *Space Cowboys* (2000), *Mystic River* (2003) and *Grand Torino* (2008). Village Roadshow is also a production partner in Australia, where Warner built a studio complex to take advantage of lower production costs and diverse locations.

Time Warner underwent a major restructuring in January 2008, when Jeffrey L. Bewkes took over as CEO of the company. Bewkes, the former head of Home Box Office, had 'a reputation for being less attached to history and more deeply immersed in the challenges facing his company's businesses', reported Tim Arango. 'In an effort to focus more sharply on "content creation" (or what nonsuits still like to call movies and television shows) … [Bewkes] is whittling down the company's many branches. It's a makeover that will unravel about two decades worth of mergers that created … the world's biggest media company' (McNary, 2009).

In February 2008, Time Warner announced that New Line would be folded into Warner Bros. as a small genre arm and cease operating as a full-service, stand-alone unit. The decision eliminated 500 New Line jobs, including those of Bob Shaye and Michael Lynne, the founders of the studio. In May 2008, Time Warner closed the Warner Independent Pictures and Picturehouse speciality units, a decision that eliminated seventy jobs. In January 2009, Time Warner cut nearly a thousand more jobs, close to 10 per cent of its workforce, in an effort to put more money into content. As the company explained, 'Based on the global economic situation and current business forecasts, the studio will have to make staff reductions in the coming weeks in order to control costs' (Arango, 2008a). The spinoffs of Time Warner Cable and AOL in 2009 led to even more job cuts.

To maintain Warner Bros.' no. 1 status as a content provider, Bewkes, in 2011, replaced Alan Horn with Jeff Robinov as president of the studio. Alan Horn had overseen the *Harry Potter* franchise as well as numerous mainstream hits, such as Wolfgang Petersen's *The Perfect Storm* (2000), Steven Soderbergh's *Ocean's Eleven* (2001), Clint Eastwood's *Million Dollar Baby* (2004), Zack Snyder's *300*, Martin Scorsese's *The Departed* (2006) and Christopher Nolan's *The Dark Knight*. Robinov, a former talent agent who joined Warner in 1997, was 'known for having an edgier taste than Horn' and was more in tune with the younger generation of moviegoers (Eller, 2010). Robinov's first move was to greenlight a two-part version of J. R. R. Tolkien's novel, *The Hobbit*, to fill the gap left by the winding down of the *Harry Potter* franchise. He then proceeded to mine DC Comics and gave the go ahead to Martin Campbell's *The Green Lantern* for release in 2011 and *The Dark Knight Rises*, the culmination of Christopher

Nolan's *Batman* trilogy, in 2012. It was clear that Robinov intended to stick to 'the Warner way' producing star-driven pictures backed by effective marketing campaigns (Barnes, 2010e).

Walt Disney Pictures

Walt Disney Pictures is a subsidiary of the Walt Disney Company, the world's largest media conglomerate. The Disney empire is largely the legacy of Michael Eisner who was brought in as chairman in 1984 to revive a moribund company. Eisner was the former CEO of Paramount Pictures. To run Disney's studio, Eisner hired Jeffrey Katzenberg, who had worked under Eisner at Paramount as president of production. Disney was on the verge of branching from family entertainment to the young adult market under a new label, Touchstone Pictures. Its first release was *Splash* (1984), starring Daryl Hannah. Under Katzenberg, Disney increased its output, but, to control costs, hired gifted but out-of-favour actors whose services could be secured inexpensively. The strategy resulted a string of hits that included *Down and Out in Beverly Hills* (1986), *Ruthless People* (1986), *Three Men and a Baby* (1987), *Stakeout* (1987) and *Who Framed Roger Rabbit?* (1988).

In 1990, Disney formed a third production unit call Hollywood Pictures. Disney anticipated a product shortage following the recent surge of new theatre construction. More importantly, Disney wanted to build its film library – which comprised a mere 150 features when Eisner took charge – to feed the growing home video market. Hollywood Pictures also targeted young adults. Its first release was Frank Marshall's *Arachnophobia* (1990), which was co-produced with Steven Spielberg's Amblin Entertainment. Touchstone's and Hollywood's pictures were financed by Silver Screen Partners, a limited partnership that raised its money through public offerings.

In 1993, Disney became the first major to branch out into the speciality market in a significant way by acquiring Miramax Films. Miramax came with an extensive library of foreign titles and a reputation as a perennial Oscar contender. Adding the Miramax label to its roster, Disney's strategy was 'to foster an eclectic slate of projects', according to Peter Bart of *Variety*. 'While rival entertainment companies pursue the Time Warner model to become diversified, albeit debt-ridden, hardware-software conglomerates, Disney is determined to become the largest producer of intellectual property in the world' (Bart, 1993).

Disney's success in animation was largely Katzenberg's doing, as previously discussed. Despite his track record, Eisner refused to promote Katzenberg to president in 1994 to replace Frank Wells, Eisner's second in command, who had been killed in a helicopter accident. Instead, he chose Michael Ovitz to fill the

slot, a founder of the Creative Artists Agency, which became the most powerful talent agency in the business. Among other things, Ovitz was a specialist in corporate acquisitions, consulting and marketing. In 1989, for example, he helped Sony buy Columbia Pictures from Coca-Cola for $3.4 billion and, in 1990, he negotiated Matsushita's $6.9 billion acquisition of MCA in 1990. Leaving the agency business to replace Frank Wells at Disney, Ovitz followed in the footsteps of his partner Ron Meyer, who earlier in 1995 replaced Sidney Sheinberg as president and CEO of Universal Studios.

After just fourteen months in office at Disney, Eisner fired him, with the public explanation that Ovitz had been unable to carve a role for himself in the company. Speculation had it that Eisner planned on turning over the day-to-day operations of company to Ovitz, but had a change of heart after the hire. Ovitz left the studio with a severance package estimated at over $125 million, the size of which was contested by Disney shareholders.

Katzenberg resigned from Disney after being passed over for the no. 2 job and immediately teamed up with Steven Spielberg and David Geffen to form a new production venture, DreamWorksSKG. He then brought a $250 million lawsuit against Disney claiming that the studio had reneged on its profit participation deal covering the pictures and TV shows Katzenberg nurtured during his ten years as head of the studio. The suit was settled out of court in 1997 for an undisclosed sum.

To replace Katzenberg, Eisner hired Joe Roth, the former production chief at 20th Century-Fox. Under Roth's watch, Disney released a series of big-budget action pictures produced by Jerry Bruckheimer, among them *Dangerous Minds* (1995), *The Rock* (1996), *Con Air* (1997) and *Armageddon* (1998). *Armageddon,* a disaster film starring Bruce Willis, became the highest-grossing live-action picture to come out of Disney up to that time, grossing $555 million worldwide. In 1999, *The Sixth Sense*, also starring Willis, did even better, grossing $675 million worldwide.

Roth also backed a series of smart films like *Cradle Will Rock* (1998), *A Civil Action* (1998), *Beloved* (1998), *The Insider* (1999) and *O Brother, Where Art Thou?* (2000). They were described as 'expensive films that critics liked but audiences shunned'. Michael Mann's *The Insider*, for example, cost $76 million to make and landed seven Oscar nominations, but took in only $29 million domestic. In 2000, Roth handed in his resignation, ostensibly to strike out on his own as an independent producer. He was ultimately replaced by Dick Cook, a long-time Disney executive, in 2002.

Disney experienced a number of setbacks following the September 11 attacks: attendance at its theme parks was down; its ABC TV network had fallen in the ratings; and its hand-drawn animated films were losing out to computer-

generated versions. Pressure from investors forced Eisner to cut costs in all divisions. Disney's animation unit took one of the biggest hits.

Eisner's twenty-one-year career at the Walt Disney Company ended in 2005 following a shareholder's revolt and contentious battles with the Disney board. Eisner had his critics, but Disney had thrived under his leadership. As Edward Jay Epstein noted,

> In 2005, Disney was one of the richest companies in America … Its tax-free cash flow had increased 29 times, to $2.9 billion. Its film library had grown to 900 features, which were licensed on TV and sold on video and DVD, and its home-entertainment division accounted for nearly one-third of the revenues of the entire industry. Its share price, reflecting this robust health, had risen to $28.25. (Epstein, 2005b)

Robert A. Iger, Disney's second in command since 2000, took over as CEO in 2005. Iger's announced goal was to focus on cross-platform properties that could connect all Disney's divisions – theme parks, TV, video games, websites, consumer products. He said this in response to sputtering DVD sales, when social media was changing film marketing and when consumers were 'demanding to watch films when and where they want' (Barnes, 2010c). Iger no doubt had in mind Jerry Bruckheimer's *Pirates of the Caribbean: The Curse of the Black Pearl*, a surprise hit which launched a franchise in 2003. It starred Johnny Depp, Orlando Bloom and Keira Knightley, and was inspired by Disney's popular theme park attraction, which had drawn millions of customers over the years at the California and Florida parks and spawned a subculture of adult fans. Bruckheimer received a new five-year contract in 2005 and went on to produce *Pirates of the Caribbean: Dead Man's Chest* (2006), *Pirates of the Caribbean: At World's End* (2007) and *Pirates of the Caribbean: On Stranger Tides*. The pictures set all kinds of box-office records, and became the fourth most lucrative franchise of all time.

Iger wasted no time on a complete studio overhaul. In January 2006, Disney propped up its faltering animation unit by acquiring Pixar for $7.4 billion. Pixar contemplated finding another distributor after delivering its fifth and final picture on its first Disney contract, *Cars*. Pixar made the decision in 2004, when Pixar and Eisner could not come to terms over sequel rights. Eisner had held firm in the hope that Disney's upcoming animated feature, *Chicken Little*, would 'return Disney to the glory of its past in animation' and make Disney less dependent on Pixar for 'new animated movie characters that could be adapted for theme park rides, consumer products and television' (Holson, 2005a). Eisner departed and *Chicken Little* did well at the box office. Still, losing Pixar to a

competitor would cripple Disney's animation business, so Iger made his move. Pixar remained headquartered in Emeryville, California. After the merger, Steve Jobs became Disney's largest shareholder and was elected to serve on the board; Pixar's Edwin C. Catmill and John A. Lasseter took over as president and chief creative officer, respectively, of the combined animation units, Walt Disney Animation Studios and Pixar Animation Studios. Lasseter is credited with providing the creative vision that has restored Disney as the undisputed leader of animated commercial cinema. However, the redundancies created by the merger resulted in the elimination of an additional 160 jobs from Disney's payroll.

Later that year, Iger fired Touchstone president Nina Jacobson, cut 650 jobs from its payroll and reduced its output by a third. Touchstone had been going nowhere in recent years, and the exercise was supposed to save Disney between $90 and $100 million a year. Iger replaced Jacobson with Oren Aviv, Disney's president of marketing since 2000.

To buoy up Disney's live-action division, Iger formed an alliance with DreamWorksSKG in February 2009, effectively poaching the company from Paramount. Steven Spielberg and his partners sold their company to Paramount in 2005 for $1.6 billion. As part of the deal, Spielberg and Geffen agreed to stay on and produce four to six pictures a year for three years. To run the unit, Paramount brought in Stacey Snider, the former chair of Universal Pictures. But Spielberg and Snider bristled under Paramount's treatment and decided to strike out on their own by forming a new DreamWorks in 2008. (Geffen had already retired.) Searching for a distributor, they approached Universal first, but Disney's counter-offer of $100 million in financing sealed the deal. For its part, DreamWorks agreed to deliver a blockbuster or two each year and four smaller films in popular genres.

To ensure a steady supply of tentpoles aimed at teenage boys, Disney purchased Marvel Entertainment for $4 billion in 2009, as previously noted. Iger next forced the resignation of Dick Cook as chairman of Walt Disney Studios in September 2009, just weeks after closing the Marvel deal. He replaced Cook with Rich Ross, president of Disney Channels Worldwide. As the *New York Times* understood it, Cook had shown 'a reluctance to adopt a new focus on companywide franchises' (Barnes and Cieply, 2009). The Ross appointment surprised the industry. As *Variety* observed, the choice signified 'just how much the studio has become less of a star at the company in recent years' and how much 'it's been overshadowed by the company's TV networks'. Explaining his appointment, Iger said that Ross had turned Disney Channels 'into a real creative engine for the company, and an effective means of delivering content and supporting the brand on a global basis. The leader of the studio needs very much

to be able to do that' (Graser, 2009). Ross focused on projects that conformed squarely to the company's three main brands – Disney (family), Pixar (animation) and Marvel (superheroes) – 'the better to cut through the marketplace clutter', he said. To that end, Disney closed down both the Touchstone and Miramax units.

Iger completed his overhaul in March 2011, when he shuttered Robert Zemeckis's ImageMovers Digital studio. Disney acquired the company at Dick Cook's urging in 2007. The studio was based in San Francisco and specialised in motion-capture animation. Zemeckis's technology required actors 'to perform on bare sets while wearing uniforms outfitted with sensors' while computers recorded their movements. The studio's first release, *A Christmas Carol* (2009), was overshadowed by James Cameron's *Avatar*, and its second, *Mars Needs Moms*, failed completely and Disney was forced to write off nearly all of its $175 million investment in the picture.

Iger's reorganisation hit a glitch in 2012, when he pressed Rich Ross to resign as chairman of the studio. As reported by Brooks Barnes, 'it was Mr Ross's spotty track record with films that assured his fate'. On Ross's watch, Disney released several hits, among them *The Muppets* (2011), *Pirates of the Caribbean: On Stranger Tides* and a 3-D rerelease of *The Lion King* (2011). But its failures were even bigger, most notably *John Carter* (2012), a science-fiction megaflop that forced Disney to take a write-down of around $200 million and record an operating loss of between $80 million to $120 million in the second quarter of 2012. Brooks Barnes noted that Ross's departure would not change the studio's approach to movie-making, but Barnes predicted Iger would find the going tough to find a new chief, someone stronger than the powerful subdivision chiefs of Pixar, Marvel and DreamWorks 'who can navigate Hollywood's murderous upper ranks' (Barnes, 2012). Iger found that person in Alan Horn, the former president of Warner Bros. Pictures, in June 2012. Horn's nurturing of family-friendly films such as *Harry Potter* made him a 'safe-bet selection' to restore Disney's 'lost lustre' by putting 'the studio back in the hands of a traditional movie executive', said the *Los Angeles Times* (Chmielewski, 2012).

Sony Pictures Entertainment

When Sony, the Japanese electronics giant, purchased Columbia Pictures Entertainment from Coca-Cola for $4.9 billion in 1989, it acquired one of the least successful of the Hollywood majors. To revive the studio, Sony gave producers Peter Guber and Jon Peters a five-year contract to serve as co-chairmen of the company. This cost Sony three-quarters of a billion dollars broken down as follows: $200 million to buy out the Guber–Peters Entertainment Co.; $500 million to free the pair from their producing contract with Warner Bros.; and

$50 million to give them a one-time bonus. In addition, Sony spent an estimated $100 million to refurbish and rebuild the old MGM lot in Culver City to house the studio. (As part of the settlement with Warner Bros., Columbia was forced to move from the Burbank Studio lot it shared with Warner.) The deal shocked Hollywood. Guber and Peters had held executive producer or producer responsibilities on such hits as *Rain Man* (1988), *Batman* (1989), *Flashdance* (1983) and *A Star Is Born* (1976), but they had never before run a major studio. And never had such executives been so extravagantly compensated. Michael P. Schulhof, chairman of Sony Corp. of America, orchestrated Sony's entrance into the entertainment business and was the man behind the hire. After the merger, in 1991, Sony changed the name of the company to Sony Pictures Entertainment.

Columbia Pictures Entertainment comprised two studios – Columbia Pictures, the venerable Hollywood studio founded by Harry Cohn in the 1920s, and TriStar Pictures, founded by Coca-Cola in 1982 as a joint venture of Columbia Pictures, Home Box Office and CBS. (HBO and CBS had since withdrawn their stakes in the studio.) Mark Canton ran Columbia Pictures and Mike Medavoy, TriStar. Sony Pictures initially performed reasonably well under the Guber–Peters regime. With hits such as *Terminator 2*, *Hook*, *Prince of Tides* and *Bugsy*, Sony dominated the American box office in 1991 with a 20 per cent market share. In 1991, Jon Peters resigned as co-chairman of CPE after only two years and Guber was left to run the company on his own. Under Guber, Sony became an unmitigated disaster. 'Sony's track record in Hollywood has been stamped by high-level management turmoil, huge buyouts of executives, lavish overspending and a persistently shaky movie division,' reported Bernard Weinraub (1996). In 1994, Sony took a $3.2 billion writeoff against losses at the studio and announced that 'it could never hope to recover its investment' in Hollywood (Sterngold, 1994). Peter Guber was forced to resign following the announcement. Later, Michael Schulhof was ousted as well.

Taking charge of Sony's US operations, Nobuyuki Idei, Sony's Tokyo-based president, hired John Calley, a veteran Warner Bros. executive, to run the studio as chairman, and Howard Stringer, the former head of CBS News, to fill Schulhof's spot at Sony Corp. of America. Calley installed Amy Pascal, former president of Turner Pictures, as president of Columbia Pictures and Chris Lee as president of TriStar. Sony Pictures scored big at the box office in 1997 on projects that were approved before Calley came aboard – Cameron Crowe's *Jerry Maguire*, Wolfgang Petersen's *Air Force One*, P. J. Hogan's *My Best Friend's Wedding* and Barry Sonnenfeld's *Men in Black*. In 1998, Calley merged the two studios into one production unit – Columbia TriStar Motion Pictures Group – as a cost-saving measure, with Amy Pascal as president. Columbia and TriStar continued to produce films under their own labels.

To find a possible replacement for John Calley, who was planning his retirement, Stringer brought Joe Roth, recently of Walt Disney Studios, into Sony's fold in 2000 by investing $75 million in Roth's new production venture, Revolution Studios. Roth planned on making thirty-six pictures over the next six years. They were to be quality pictures with modest budgets. Roth lived up to his promise initially, producing such hits as *Black Hawk Down*, *America's Sweethearts* and *The Animal* in 2001. But in 2002, Roth abandoned his original strategy and produced a series of costly failures. Sony lost big in the venture and, needless to say, Stringer no longer considered Roth an heir apparent. Revolution cut back in 2005 and closed its doors in October 2007.

Sony Pictures acquired the movie rights to Marvel's Spider-Man character in 1999. To produce the picture, Sony hired Laura Ziskin, a pioneering female producer who previously ran the Fox 2000 production unit at 20th Century-Fox from 1994 to 1999. Ziskin and director Sam Raimi became the creative force behind the *Spider-Man* franchise. Ziskin, for example, was behind the risky casting choice of Tobey Maguire, who was best known for quirky roles in more sophisticated movies, and she was the one who suggested adding the love interest between Maguire and Kirsten Dunst, which helped attract teenage girls. *Spider-Man* was released on 3 May 2002 and took in an estimated $114 million from 7,500 screens on its opening weekend, far exceeding the previous record set by *Harry Potter and the Philosopher's Stone* in autumn 2001. *Spider-Man* opened well before school was out and faced little competition from other summer tentpole releases. It went on to earn well over $1 billion worldwide. Thanks to *Spider-Man*, Sony ranked no. 1 in market share for 2002 and posted a profit for the second time since Sony bought Columbia Pictures in 1989.

Spider-Man 2 opened on 30 June 2004, to take advantage of the long holiday weekend, and took in a record-breaking $40 million on opening day. As *Variety*'s Todd McCarthy reported, the sequel,

> improves in every way on its predecessor and is arguably about as good a live-action picture as anyone's ever made using comic book characters … [T]he action sequences are more exciting, the visual effects – particularly Spider-Man's swings through the canyons of Manhattan – are more natural and compelling and even Danny Elfman's score is improved. Most importantly, however, the script [by Alvin Sargent] provides a depth and dramatic balance quite rare in this sort of fare. (McCarthy, 2004)

Produced at a cost of $200 million, the picture went on to gross $373 million domestic and $784 million worldwide. More than anything else, the picture

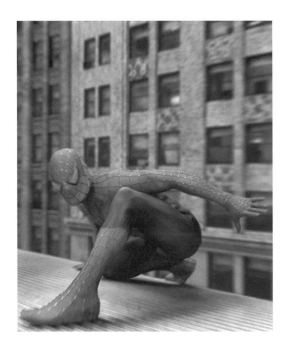

Sony holds the film rights to Marvel's Spider-Man, which became a mother lode of profits for the studio

helped offset parent Sony Corp.'s sagging earnings in electronics and video games.

Spider-Man 3 did not measure up to the first sequel in quality, but broke records nonetheless. Produced at a cost of $258 million, the most Sony had ever laid out for a picture, *Spider-Man 3* was launched in 2007 with nine premieres around the globe. The world premiere took place in Tokyo, a first for a Hollywood movie. Howard Stringer, the Sony Corp. chief, used the occasion to tout the 'Sony United' marketing campaign, which was supposed to drive hardware sales with films, games and online content. In the USA, *Spider-Man 3* opened on over 10,000 screens in 4,252 theatres, the widest opening of all time, and 'leapt easily over several other major box office records', said *Variety* (Mohr, 2007b). The final worldwide take came to $900 million. The *Spider-Man* pictures ranked no. 1 in ticket sales on Sony's roster each year they were released. A fourth installment was cancelled when Maguire and Raimi withdrew from the project over disagreements with the script. Their departure gave Sony the chance to reboot the franchise by making 'a younger, cheaper installment of the superhero franchise' released in 2012 (Siegel, 2010).

Sony had its *Spider-Man* franchise, but it did not focus all its energy on tentpoles. In 1992, Sony formed Sony Pictures Classics to handle foreign and upscale art films (see Chapter 6). And in 1998, it rebooted Columbia's old Screen Gems television subsidiary and turned it into a producer/distributor of low-budget genre films, which were sold on discs and cassettes around the world

without theatrical release. Clint Culpepper, a veteran Sony executive who ran the operation from the start, introduced the strategy of opening a handful of horror, science fiction and action thrillers in theatres first to greatly enhance their appeal on video. Screen Gems rode the crest of the horror wave, beginning with such robust franchises as *Resident Evil* (starring Milla Jovovich) in 2002 and *Underworld* (starring Kate Beckinsale) in 2003. Screen Gems also succeeded with movies tailored to black audiences, among them Sylvain White's *Stomp the Yard* (2007), Preston A. Whitmore III's *This Christmas* (2007) and *First Sunday* (2008), a comedy caper starring Ice Cube. In 2008, Sony extended Culpepper's contract as president through 2012.

John Calley stepped down as chairman and chief executive of Sony Pictures in October 2003 following the success of the first *Spider-Man* picture. To replace him, Stringer chose an outsider – Michael Lynton, the former CEO of AOL Europe, and made him co-chair of the motion picture group with Amy Pascal.

In 2005, Stringer himself was elevated to the top spot of Sony Corp. following the resignation of Nobuyuki Idei. Sony had been in turmoil ever since the 'Sony shock' of 2003, when the company posted massive losses and eliminated much of its worldwide workforce, including 9,000 jobs in the USA. Once known for creating elegant products like Walkman, Trinitron TV and PlayStation, Sony was being outpaced by Apple's iPod and upstart manufacturers of flatscreen TVs in South Korea, Taiwan and China. Stringer had grown in stature within Sony when he led an effort to acquire MGM from Kirk Kerkorian in 2004. Sony wanted MGM's library of 4,000 films to help its Blu-ray technology win the DVD format war. Rather than purchasing MGM outright, Sony took on equity partners and successfully bid $5 billion for the studio. Sony ended up owning a 20 per cent stake. Idei voluntarily stepped down to make way for Stringer in the hope that Stringer could repeat his success at rejuvenating Sony Pictures. Stringer became the first westerner to lead a Japanese company.

During Pascal's and Lynton's tenure, Sony Pictures had its best year in 2006, when it released Rob Howard's *The Da Vinci Code* starring Tom Hanks and ranked no. 1 at the domestic box office. Sony acquired the rights to the picture three months before the Dan Brown novel became a worldwide bestseller. In 2009, Sony released the sequel, Rob Howard's *Angels & Demons*. By then conditions had deteriorated. In 2009, Sony Pictures cut its workforce by over 250 employees; a year later, it fired 450 more. The cuts were attributed mainly to a steep decline in DVD revenue.

Sony produced a number of hits in 2010, most notably David Fincher's biopic, *The Social Network*. *The Social Network* won bellwether awards from the New York Film Critics Circle and the Los Angeles Film Critics Association, but lost out to Darren Aronofsky's *Black Swan*, which took the top honour at the

Academy Awards. The last time Columbia won a best picture Oscar was in 1987, for Bernardo Bertolucci's *The Last Emperor*. The profits from Sony's hits could not offset the losses of its failures, which contributed to Sony Corp.'s net loss of $3.2 billion for the fiscal year 2010. There were other factors, of course, not the least of which was the 11 March earthquake and tsunami that disrupted production at several Sony's plants in northern Japan. The main one, perhaps, was Stringer's inability to revitalise the Sony brand by creating synergies between Sony's two pillars – hardware and content. A case in point was Sony's experiment with its first computer-generated animated hit, *Cloudy with a Chance of Meatballs*, a 3-D cartoon based on a popular children's book. After the theatrical run, Sony made the picture available to owners of Sony Bravia TVs and Blue-ray disc players with internet capability on demand for a $25 fee before the DVD window. The experiment was designed to offset the decline in DVD sales, but theatre owners were furious and some yanked the picture from their screens. 'Ruminating about whether Sony will continue to pursue entertainment as a synergy to selling electronics after Mr Stringer departs [in 2012] is one of Hollywood's favorite parlor games,' said the *New York Times* (Tabuchi and Barnes, 2011).

Paramount Pictures

After Viacom acquired Paramount Communications in 1993, Sumner Redstone left the movie division in the hands of Sherry Lansing, chairman of Paramount's Motion Picture Group. Lansing became the first woman to run a major Hollywood studio when she was appointed president of production at 20th Century-Fox in 1980. She joined Paramount in 1982 as an independent producer and assumed the top spot in 1991. At Paramount, she reported to Stanley Jaffe, the Paramount Communications CEO, and Lansing's former producing partner.

In 1994, Redstone replaced Jaffe with Jonathan Dolgen, a lawyer and business affairs specialist. Dolgen adopted a risk-averse strategy, and for ten years Paramount was regarded as a paragon of a well-run studio, earning profits every year. Sherry Lansing had creative control over Paramount's slate, but Dolgen oversaw its financing. He promoted fiscal austerity and, to reduce the downside of expensive movies, he brought in outside investors to share the burden. As noted by the *Los Angeles Times*, Dolgen's approach was initially derided, but 'it was eventually copied throughout Hollywood' (Hofmeister and Eller, 2004).

Dolgen's savviest move was to link up with 20th Century-Fox to co-produce James Cameron's *Titanic*. Paramount agreed to put up $65 million in return for the domestic distribution rights. Dolgen capped Paramount's contribution to the picture, so that when the budget soared to $200 million, Fox had to cover

the overage in return for the foreign distribution rights. Although both studios profited handsomely when *Titanic* set an all-time box-office record, Paramount's take was far bigger.

Dolgen's risk-averse approach had downsides. It inhibited Paramount's ability to spend competitively and develop the kinds of franchises that had been enriching Warner, New Line and Disney. It also gave Paramount the reputation as a penny pincher. Paramount went into slump beginning in 2002. Dolgen resigned in 2004 and Lansing stepped down as chair in 2005 at the expiration of her contract.

To replace the pair, Viacom brought in Brad Grey as the new chairman and CEO of the studio in 2005. Grey was the co-owner of Brillstein–Grey, a talent management company, and a producer of *The Sopranos* (1999–2007) for HBO. 'No studio in memory has ever brought it a head of production so lacking in formal film-making credentials or corporate experience,' said Peter Bart of *Variety* (2005). But in short order Grey reinvented Paramount from the bottom up.

Grey's first move as CEO was to strike an exclusive distribution deal with Marvel Studios in 2005. *Iron Man*, Marvel's first release, was a huge success, as previously discussed. Afterwards, Paramount and Marvel struck a new deal which gave Paramount worldwide distribution rights to Marvel's next five pictures. Marvel had been using local distributors overseas until then. Subsequent releases included *Iron Man 2* (2010), *Thor* (2011), *Captain America: The First Avenger* (2011) and *The Avengers* (2012). Paramount eventually netted $300 million in profits from the deals.

Grey's next move was to acquire DreamWorksSKG for $1.6 billion in 2006. Viacom paid $774 million in cash for the studio and assumed $849 million of DreamWorks' debt. DreamWorksSKG was founded in 1994 by Steven Spielberg, Jeffrey Katzenberg and David Geffen, three of the biggest names in entertainment. After raising $2 billion in financing for their venture, the partners set out to build a fully fledged movie studio to challenge the majors. To produce their movies, TV shows, music albums and interactive media, they originally planned on building a state-of-the-art studio complex near Los Angeles International Airport, but construction and other problems forced them to abandon the project in 1999. DreamWorks had to rethink its goals, and its core business now became producing movies. DreamWorks released several hits, among them Spielberg's *Saving Private Ryan* (1998), which won five Academy Awards including best director for Spielberg, and Sam Mendes's *American Beauty* (1999) and Ridley Scott's *Gladiator* (2000), both of which won Best Picture Oscars. But too many costly flops brought the studio close to bankruptcy twice.

DreamWorks established a separate division called DreamWorks Animation in 2000. It led off with *Shrek*, which won the first Academy Award for best

Shrek (2001), from DreamWorks Animation, initiated the highest-grossing animated franchise

animated feature and spawned a franchise. But afterwards the division had a tough time finding its animation groove. Pixar, meanwhile, was pumping out hit after hit, beginning with *Toy Story* and continuing with *A Bug's Life* and *Monsters, Inc.* By 2003, DreamWorks Animation had lost over $300 million; to keep it afloat, the partners spun it off as a separate publicly traded company in 2004 with Katzenberg as its head. As a result of the DreamWorks buyout, DreamWorks Animation would now be releasing its pictures through Paramount.

Industry observers claimed that Paramount paid too steep a price for DreamWorks, but Paramount recouped much of its investment by selling off DreamWorks' library of fifty-nine live-action films to an investment firm headed by George Soros for $900 million. Spielberg and Geffen signed employment contracts with Paramount and agreed to produce four to six films a year for three years. Spielberg did not have to direct any of them, however, just produce them. To further reduce its exposure in the buyout, Paramount could look forward to collecting distribution and marketing fees on the pictures and to reducing studio overheads by merging DreamWorks' distribution arm with Paramount's, laying off more than a hundred employees in the process. To run its new DreamWorks division, Paramount snatched Stacey Snider away from Universal Studios, where she held the top job as head of production.

And as a final move, Grey created a new speciality division in 2006, Paramount Vantage, to replace Paramount Classics. By Grey's reckoning, the old division, which Sherry Lansing launched in 1998, had underperformed

compared to Fox Searchlight and Focus Features, and in 2005, he fired the founders and co-chairs, David Dinnerstein and Ruth Vitale, and shuttered the operation. Their firing was 'the latest step in what has amounted to a virtual clean sweep of the studio's hierarchy by Mr Grey', said the *New York Times* (Waxman, 2005).

In 2007, Paramount had its best year ever at the box office and ranked no. 1 in market share, thanks mainly to *Shrek the Third* and *Bee Movie* from DreamWorks Animation and Michael Bay's *Transformers* and Will Speck and Josh Gordon's *Blades of Glory* from DreamWorks. In 2008, Paramount lost the services of Steven Spielberg and Stacey Snider to Disney. According to *Daily Variety*, Spielberg and Snider 'thought they were a satellite company working alongside Paramount … But Grey made it clear that he considered DreamWorks to be not a sibling company but one of several labels answering to him, like MTV Films or Paramount Vantage' (Siegel and Thompson, 2008).

As a vote of confidence, Viacom, in 2009, extended Grey's contract for another five years. Adopting a lean and mean strategy, Paramount released thirteen films in 2009 and turned its attention to franchise development by rebooting the *Star Trek* series and by co-producing two blockbusters based on Hasbro toys, Michael Bay's *Transformers: Revenge of the Fallen*, with DreamWorks, and Stephen Sommers's *GI Joe: The Rise of the Cobra*, with Spyglass Entertainment. *Transformers* was trashed by the critics but outperformed the original and validated Paramount's strategy of building tentpoles around toys. In 2009, Paramount also released two Oscar contenders, Jason Reitman's *Up in the Air* and David Fincher's *The Curious Case of Benjamin Button*, as well as Oren Peli's *Paranormal Activity*, a micro-budget horror picture that originally played at the Screamdance and Slamdance film festivals in 2007. The guerilla-style marketing campaign behind the film generated over $100 million at the box office, making it one of the most profitable pictures ever made in relationship to its budget. Paramount came in second at the box office in 2009, with a market share of 13.9 per cent and a total take of nearly $1.5 billion. It achieved this by releasing thirteen films, compared to twenty-eight films by Warner Bros., which had the top share of 19.8 per cent and $2.1 billion gross. A similar story can be told about Paramount in 2010. Peter Bart of *Variety* revised his original opinion of Grey and summed up his achievement by saying, 'All in all the Paramount record stands as a success story at a time when the industry needs success' (Bart, 2011b).

20th Century-Fox

Tom Rothman and Jim Gianopulos took over the running of 20th Century-Fox Filmed Entertainment as co-chairs in 2000. Rothman came to Fox from the

Samuel Goldwyn Co. in 1994, and was originally hired to serve as the founding president of Fox Searchlight. In 1995, Rothman, at age forty, was bumped up to president of 20th Century-Fox Film to succeed Tom Jacobson, who resigned to go into independent production. Gianopulos had previously presided over Fox's international distribution division since 1994.

Until 1994, 20th Century-Fox was the company's sole production unit. In a major overhaul designed to increase output, News Corp. president Peter Chernin and Fox Film chief Bill Mechanic created three additional production units: Fox 2000, Fox Family Films and Fox Searchlight Pictures. Each worked within different budget ranges and each targeted different audience segments. Fox 2000 was run by Laura Ziskin and had the goal of producing eight to twelve pictures a year aimed at young women. Fox Family Films was run by Chris Meledandri and went head to head with Disney by producing both live-action and animated family fare. Fox Searchlight, the speciality unit, was run by Tom Rothman and reached out to sophisticated adults.

In the tentpole and franchise category, 20th Century-Fox's reputation rests mainly on James Cameron's *Titanic* and *Avatar*, George Lucas's rebooted *Star Wars* series and Marvel's *X-Men*. Fox and Paramount produced *Titanic* as a joint venture, with Fox receiving the foreign distribution rights, as previously noted. Cameron's 'story of young lovers who meet aboard the ill-fated ship' starred two young actors, Leonard DiCaprio and Kate Winslet, and took on an 'event status'. *Titanic* opened in the USA on 19 December 1997 and had remarkable staying power, ranking no. 1 at the box office for fifteen weeks. It went on to gross $1.8 billion worldwide – a record – and to win eleven Oscars, including best picture and best director. Unlike other high-concept disaster films of the period, *Titanic* attracted a predominantly female audience.

Avatar received its US opening on 18 December 2009, and passed *Titanic*'s record as the highest-grossing picture in just thirty-nine days. *Avatar* was released in both 3-D and 2-D versions, in 3,452 theatres in the USA and 106 countries abroad. Fox reported that 72 per cent of worldwide sales came from 3-D screens. Cameron had hoped to open his picture on a larger number of 3-D screens, but the downturn in the credit markets had slowed the installation of digital projectors. Cameron spent four and a half years in production and used his performance-capture technology to create over 2,500 digital effects. The picture was largely shot at Cameron's Lightstorm Entertainment facility in the Playa del Rey section of Los Angeles, where DreamWorks had once planned to set up shop. The result was the most expensive movie ever made – an estimated $250 million. Like it did for *Titanic*, Fox reduced its financial exposure by taking in outside investors, among them Paramount Pictures, which again received the domestic distribution rights. *Avatar* was nominated for nine

James Cameron's *Avatar* (2009), the worldwide box-office champ (not adjusted for inflation)

Academy Awards, and won for art direction, cinematography and visual effects. The eye-popping results led Cameron and Fox to retrofit *Titanic* in 3-D for spring 2012 release and lay plans for two *Avatar* sequels, with the first scheduled for 2014 release.

To prepare a new generation of filmgoers for George Lucas's next installment of the *Star Wars* franchise, Fox rereleased the original *Star Wars* trilogy in 1997. Lucas had planned three prequels. *Episode I: The Phantom Menace* (1999) was 'wildly anticipated and heavily hyped'. 'Its arrival', said the *Los Angeles Times*, was trumpeted 'on the cover of just about every magazine except the *New England Journal of Medicine*' (Turan, 1999). Taking special effects cinematography to a new level, *The Phantom Menace* contained almost 2,000 effects shots that took up sixty minutes of screen time. Lucas reportedly aimed his picture at a new crop of children who were familiar with the series via video rather than the original audience, which was now in its thirties.

Unlike the first films, which were relatively inexpensive to produce, the prequels had budgets exceeding $100 million. George Lucas's company, Lucasfilm, footed the bills and collected all of the profits, including the proceeds from the *Star Wars* merchandise, DVDs, books, soundtracks and video games. Fox had worldwide distribution rights to the pictures and collected an undisclosed distribution fee. *Episode I* took in the most revenue – $924 million worldwide; *Episode II: Attack of the Clones* (2002) took in considerably less, $656 million; but *Episode III: The Revenge of the Sith* (2005) rebounded to $848 million. Most critics believed the final episode was the best of the series. A. O. Scott in the

New York Times said, *Revenge of the Sith* 'comes closer than any of the other episodes to realizing Mr Lucas's frequently reiterated dream of bringing the combination of vigorous spectacle and mythic resonance he found in the films of Akira Kurosawa into American commercial cinema. [T]he sheer beauty, energy and visual coherence of *Revenge of the Sith* is nothing short of breathtaking' (Scott, 2005a). *Variety*'s Dale Pollock stated,

> The age range of moviegoers that turned out for *Episode III*'s opening week across the globe is a good indication of the firm hold *Star Wars* has on media-shaped world culture. True intergenerational events are rare in our segmented world, and *Star Wars* has become a legacy passed from boomer parents to today's college students and kids. (Pollock, 2005)

The year 2005 marked the studio's fourth consecutive year of record earnings, thanks in great part to the *Star Wars* pictures.

Fox acquired the movie rights to Marvel's X-Men characters Wolverine, Storm and Cyclops in 1994. The X-Men superheroes 'are the world's best-selling group of comic books and America's most popular Saturday morning network cartoon show', said the *New York Times*. '[T]he X-family accounted for over 14 percent of the comic market, more than the combined total of the next four families: Spider-Man, Batman and Dark Horse' (Martin, 1994). Bryan Singer's *X-Men* (2000) went into production while Marvel's *Spider-Man* was in development at Sony and *Incredible Hulk* (2008) was in preproduction at Universal. Hollywood was still apprehensive about investing in superhero vehicles. Warner's *Superman* movies barely returned their investment, and its latest entry, *Batman & Robin*, had underperformed. *X-Men* starred Hugh Jackman as Wolverine, Patrick Stewart as Professor Charles Xavier and Ian McKellen as Magneto and opened in the summer of 2000 to mixed reviews, but it took in enough at the box office to greenlight a sequel and reinvigorate Hollywood's interest in comic book adaptations. Bryan Singer's *X2: X-Men United* followed in 2003 and Brett Ratner's *X-Men: The Last Stand* in 2006. The three pictures in the series generated $1.2 billion in ticket sales. The worldwide take had gone up with each installment. To wring added life out of the franchise, Fox produced two prequels, Gavin Hood's *X-Men Origins: Wolverine* in 2009 and Matthew Vaughn's *X-Men: First Class* in 2011. The first starred Hugh Jackman, as Wolverine, the anchor of the first three pictures, and explains how Wolverine discovers his superhuman powers. The second presented an origins story of the mutants and contained a cast of untested young actors. *First Class* took in $55 million in 3,641 theatres the first weekend, far exceeding Fox's expectations, and succeeded in rebooting the sagging franchise.

Hugh Jackman in *X-Men Origins: Wolverine* (2009)

Meanwhile, Fox 2000 never realised its original vision of targeting the female audience. The unit had struggled under Ziskin, and she was replaced by Elizabeth Gabler as president in 1999. Ziskin moved to Sony Pictures, where she developed and produced the *Spider-Man* franchise. Under Gabler, a production executive at Fox since 1988, Fox 2000 functioned as a secondary live-action division of the studio, contributing three to five titles a year to Fox's roster. As reported by Anne Thompson, Gabler was,

> regarded by Fox bosses Jim Gianopulos and Tom Rothman as a stable, savvy shepherd of the mid-size label. Gabler enjoys a level of freedom that's increasingly rare amid a tough economy and tighter oversight. And her success argues for a reexamination of the big-studio model. Taking more time to make fewer movies at a lower budget makes high-quality control more possible. (Thompson, 2009)

A sampling of the Fox 2000 output under Gabler includes Joel Schumacher's *Phone Booth* (2000), a low-budget thriller starring Colin Farrell that took in nearly $100 million worldwide; James Mangold's *Walk the Line* (2005), the Johnny Cash biopic starring Joaquin Phoenix and Reese Witherspoon, which

received five Oscar nominations and the best actress award for Witherspoon; David Frankel's *The Devil Wears Prada* (2006), 'a talky chick flick' starring Meryl Streep that took in $327 million worldwide; and Tim Hill's *Alvin and the Chipmunks*, a CGI comedy based on the classic cartoon that grossed $360 million worldwide and spawned a sequel.

Fox remained a player in the animation field after Chris Meledandri departed for Universal in 2007 by appointing Vanessa Morrison president of Fox Animation Studios. Morrison had come up through the ranks to become the only woman to head an animation studio. Morrison oversaw the production of two 3-D hits directed by Carlos Sladanha, the second *Ice Age* sequel, *Dawn of the Dinosaurs* (2009), and *Rio* (2011). *Dawn of the Dinosaurs* became the no.1 animated film of 2009 at the global box office, outperforming Pixar's *Up* and DreamWorks' *Monsters vs Aliens*. *Rio*, about a nerdy macaw who leaves the comforts of his cage in a small Minnesota town to find his mate in Rio de Janeiro, was no. 1 at the box office on opening weekend, but ticket sales dropped off afterward, perhaps portending waning audience interest in 3-D, at least in the USA.

Universal Pictures

Ron Meyer, co-founder of Creative Artists Agency, was first hired by Edgar J. Bronfman Jr in 1995 to become CEO of Universal Pictures and survived multiple changes of company ownership to become the longest-serving head of a major studio in the period. Meyer oversaw Universal's film studio, production facilities, theme parks and resorts. Beginning in 1998, the actual running of the studio was placed in the hands Stacy Snider, who made a mark as production chief at TriStar and was a rising executive star. Under Meyer and Snider, Universal adopted 'a strategy that is starkly different from other top film studios', reported the *New York Times*. 'Mr Meyer has determined that Universal should stay well behind the leaders, allowing the flashiest and most expensive projects – and typically the biggest payoffs – to go elsewhere. "We gauge ourselves to be in the middle,"' Meyer said (Cieply and Barnes, 2007).

Playing it safe with lower-cost productions such as Stephen Sommers's *The Mummy* (1999), a spoof of the 1932 Universal horror movie starring Boris Karloff, and Roger Michell's *Notting Hill* (1999), a romantic comedy starring Julia Roberts and Hugh Grant, put the studio in the black by 2000. *Notting Hill* was produced by the London-based Working Title Films, Universal's new producing partner. The company became aligned with Universal in 1998, when Seagram acquired PolyGram Records from Royal Phillips Electronics. Included in the package were PolyGram Film Entertainment and its semi-autonomous film units, including Working Title. Working Title had a reputation for making 'upscale and often edgy, quirky movies', such as Stephen Frears's *My Beautiful*

Laundrette (1985), Joel and Ethan Coen's *Fargo* (1996) and Mike Newell's *Four Weddings and a Funeral* (1994). Connecting up with Universal, Working Title delivered an array of pictures in addition to *Notting Hill* that included Beeban Kidron's *Bridget Jones: The Edge of Reason* (2004), Joe Wright's *Pride and Prejudice* (2005), Kirk Jones's *Nancy McPhee* (2005), Joel and Ethan Coen's *Burn after Reading* (2008), Ron Howard's *Frost/Nixon* (2008) and Kevin Macdonald's *State of Play* (2009).

In 2000, Universal had a good year, releasing a string of hits that included Ron Howard's *How the Grinch Stole Christmas*, starring Jim Carrey, Jay Roach's *Meet the Parents*, starring Ben Stiller and Robert De Niro, and Steven Soderbergh's *Erin Brockovich*, starring Julia Roberts. *Grinch*, based on the Dr Seuss children's classic, did the best. It was produced by Imagine Entertainment, a Universal producing partner founded by director Howard and producer Brian Grazer in 1986. Grazer started out as a producer of TV movies. He met Howard at the end of Howard's seven-year stint as the star of *Happy Days* and hired him to direct *Night Shift* (1982) and *Splash* (1984) before founding Imagine. Linking up with Universal in 1987, Imagine's first efforts included Howard's *Parenthood* (1989), starring Steve Martin, and Ivan Reitman's *Kindergarten Cop* (1990), starring Arnold Schwarzenegger. Imagine's first breakout hit was Howard's *Apollo 13*. It grossed over $300 million worldwide and resulted in a new lucrative financing-distribution deal with Universal. Imagine went on to deliver two Tom Shadyac hits, *The Nutty Professor* (1996) and *Liar, Liar* (1997), before *Grinch*. Today, Imagine is the longest-running producing partner in Universal history.

The year 2001 was a year of sequels for Universal; in particular *The Mummy Returns*, *Jurassic Park III* and *American Pie 2*. Imagine added some lustre to its roster by delivering Howard's *A Beautiful Mind*, a biopic starring Russell Crowe about a gifted mathematician suffering from schizophrenia. It was nominated for eight Academy Awards and won four, including Best Picture for Grazer and Best Director for Howard.

In 2002, Universal released Doug Liman's *The Bourne Identity*, starring Matt Damon, the first of a popular series based on Robert Ludlum's spy thrillers. Other pictures released under Snider's watch include Tom Shadyac's irreverent comedy, *Bruce Almighty* (2003), starring Jim Carrey and Morgan Freeman, Gary Ross's Depression-era racehorse drama, *Seabiscuit* (2003), starring Tobey Maguire, and Steven Spielberg's thriller about the killing of Israeli athletes at the 1972 Olympics, *Munich* (2005). Although *Munich* was an Oscar contender, it won none and came up far short at the box office.

Stacey Snider resigned as studio chairwoman in early 2006 to run DreamWorksSKG at Paramount. Snider reportedly took a pay cut to accept the job, but wanted the opportunity to work with Spielberg. She had also 'expressed

frustration' after General Electric acquired the studio and instituted 'tight financial controls' and a 'rigorous corporate review policy', which made her job more difficult in her opinion (Waxman, 2006). Ron Meyer chose two insiders in 2006 to replace Snider as co-chairs: Marc Shmuger, the vice chair of Universal Pictures since 2000, and David Linde, the former co-president of Universal's speciality division, Focus Features. In 2007, the pair put Universal squarely in the family-film business by luring Chris Meledandri away from Fox Animation. They made him an equity partner in a new venture called Illumination Entertainment to produce two or three animated and live-action features a year for Universal distribution. Unlike Pixar and DreamWorks Animation, which were located on sprawling campuses and employed large cadres of workers, Meledandri set up shop in an industrial section of Santa Monica and employed thirty-five people. The plan was to outsource the animation by contracting with a rendering shop in Paris. To contain costs further, he intended to use first-time directors and vocal talent with less star power. Its first release, *Despicable Me*, was a big hit.

Universal, meanwhile, had two good years; they included such hits as *The Bourne Ultimatum* and *Knocked Up* in 2007 and *Mamma Mia!* and *The Incredible Hulk* in 2008. But in 2009, several high-profile flops, such as *Land of the Lost*, *Public Enemies* and *Funny People*, more than neutralised the hits and left Universal in the red. Universal's strategy of seeking profit without dominating the market saw the studio slip to last place among the majors.

NBC Universal's chief Jeff Zucker took a hard look at the record and fired Shmuger and Linde. In their place, Meyer promoted two studio executives, Adam Fogelson, president of marketing and distribution, and Donna Langley, the president of production. The management shake-up occurred even while GE was negotiating the sale of NBC Universal to Comcast. After the merger Ron Meyer retained his position as CEO of Universal Studios, and Adam Fogelson and Donna Langley retained theirs as co-chairs of Universal Pictures. Only now, they reported to Steve Burke, Comcast's chief executive, who replaced Jeff Zucker at NBC Universal.

Universal's condition improved beginning with *Despicable Me* in 2010 and *Hop* in 2011, two cartoon hits from Illumination. Steve Burke, who had once overseen Disney's consumer products and theme park divisions, echoed Robert Iger and wanted Universal to produce the kinds of pictures that could be exploited and promoted across every NBC Universal division. As reported by *Variety*, the studio scrapped risky projects and looked to build a roster of safe bets with brand recognition and broad appeal – for example, movies based on Hasbro toys, and projects that it could turn into theme park attractions (Kroll, 2011). As it happened, the creatures in *Despicable Me* and *Hop* were the first home-grown costumed characters Universal could integrate into its parks in a long time.

CONCLUSION

Responding to mandates from their corporate parents and stockholders to increase revenue, Hollywood fled to the safety of tentpoles and franchises targeted at young people and families. Warner, emboldened by the phenomenal early success of the *Harry Potter* and *Lord of the Rings* pictures, was the first studio to aggressively exploit the blockbuster strategy. But Hollywood did not march in unison into the new millennium. Paramount and Universal, for example, were more risk averse initially, but by the decade's end every studio was in the tentpole business. Although the costs of producing and marketing such pictures were enormous, they were the only types that could perform on a global scale and generate significant returns. To protect their downsides, studios secured financing from outside investors, reduced studio overheads and leveraged their bargaining power to negotiate tougher deals with talent agents.

To enforce these austerity measures, a new breed of studio chief has emerged – executives who built their reputations outside of Hollywood. They included Jeff Robinov at Warner Bros., Brad Grey at Paramount Pictures and Rich Ross at Walt Disney Studios. As Peter Bart of *Variety* reported, 'A producer was explaining to me the other day what it feels like to make a movie at Disney. "I feel like an alien", he said. "No one is left at a management level who is grounded in the movie business"' (Bart, 2012). The new managers harboured little sentimental attachment to the movies and felt secure in the comfort zone in building their annual slates. As Richard Branson, the billionaire founder of the Virgin Group, explained, 'The moment you start working for big corporations, if people try something and it goes wrong, they're likely to lose their jobs. Therefore they're far less likely to take risks – which is why Hollywood is so fear-driven' ('Virgin Territory', 2012). But Branson's is only a partial explanation. The sure thing was a good hedge against a dying DVD business, the fragmentation of the audience and the unknown impact of the internet and social media on Hollywood marketing practices.

3

Distribution: Open Wide

The Hollywood majors dominate the distribution sector of the industry just as they do the production. Over 500 pictures are released theatrically in the USA each year, of which about a hundred come from these companies. But these pictures are the top grossers and routinely capture more than 80 per cent of the domestic box office. Factoring in the releases of their speciality arms, the percentage is even higher.

The principal business of the Hollywood majors is distribution. The studios finance movies in order to acquire their worldwide distribution rights in all media formats in perpetuity. Studios profit from distribution by levying a schedule of fees on the pictures they release as they go through the pipeline, first to theatres and then to home video, video-on-demand (VOD) and so forth. The fees range from 10 to 50 per cent of the gross receipts, depending on the market and the extent of the financing put up by the studio. Distribution revenue pays the fixed costs of operating a global sales network first. It then goes to pay off the studio's investment in the picture. The overflow constitutes profits. Profits from one picture are used to offset a studio's losses on another.

For accounting purposes, studios carry movies on their books as separate items, the payouts for which are dictated by the contracts between the profit participants. In simple terms, here's how it works. The total take on a picture from ticket sales is the 'box-office gross'. On average, the distributor collects from the exhibitor about half of the box-office receipts from a picture as film rental, the so-called 'distribution gross'. If a star or director has a 'first dollar gross deal', the amount is deducted off the top of this revenue stream. From the remainder, the studio deducts the distribution fee and reimburses itself for the money it spent on prints and advertising (P&A), including marketing and promotion. Afterwards, the revenue stream, minus the first dollar payouts and distribution fee, goes to pay off the production loan of the picture plus interest. Once breakeven is reached, the picture is in profit, at which point the remaining revenue ('net producer's share') is divided among the producers and cast members who had negotiated net-participation deals, as well as the studio and other investors according to previously negotiated deals. Similar payout

arrangements cover a picture as it goes through the distribution pipeline to pay TV, home video, etc.

Going into the new millennium, Hollywood had an arsenal of techniques to exploit its tentpoles and franchises and wring top dollar from the market. These were time-tested techniques that had served the industry well since the 1960s. Market research, saturation booking and massive advertising and promotion campaigns were just a few of the tools the majors used to recoup their investments in blockbusters and establish value for their output in ancillary markets. But as this chapter illustrates, the internet has undermined the process in ways that are posing extraordinary challenges to the major Hollywood studios.

HISTORICAL BACKGROUND

The modern motion picture studio as a financier/distributor has its roots in the *Paramount* decrees of 1948, which forced the five vertically integrated majors to divorce their theatre chains. The restructuring was designed to increase competition in the marketplace. However, by allowing the *Paramount* defendants to retain their distribution arms, the court, wittingly or not, gave them the means to retain control of the market. The reason, simply stated, is that decreasing demand for motion picture entertainment during the rise of commercial television foreclosed the film distribution market to newcomers. Distribution then as now presents high barriers to entry. To operate efficiently, a distributor requires a worldwide sales force and capital to finance a slate of twenty and more pictures a year. Since the market absorbed less and less product during the 1950s, which saw moviegoing decline by 50 per cent, it could support only a limited number of distributors – about the same as existed at the time of the *Paramount* case. Without new competition, the majors retained their grip on the market and continued to collect the lion's share of film rentals in the domestic market.

Hollywood rekindled interest in the movies after the postwar recession by differentiating its product from television; it made big-budget blockbusters in colour, widescreen formats and stereophonic sound. To make such pictures, the majors dismantled the studio system and adopted unit production. After the *Paramount* decrees and the rise of television, the mass production of motion pictures ceased; it was no longer practical for studios to keep large numbers of actors, directors, screenwriters and other production personnel under long-term contract. The most efficient means of operating under these circumstances was to organise production units to tailor-make individual motion pictures. In this way, the personnel best suited to a project could be hired and let go. A studio, as a result, would not be burdened with high fixed salary costs, which was the largest component of studio overhead. By the 1970s, the majors functioned as

Steven Spielberg's *Jaws* (1975), a landmark summer movie

bankers supplying financing, as landlords renting studio space and as distribu-
tors who controlled access to the most profitable feature films worldwide.

Since budget costs for these pictures increased by the year, Hollywood
devised new ways to promote its wares. Marketing their blockbusters individu-
ally, the majors targeted frequent filmgoers under thirty, exploited tie-ins to
presell a movie, and devised ways to capture the lion's share of the box-office
practices that have endured to this day. Steven Spielberg's *Jaws* became a model
for blockbusters when it was released by Universal Pictures in the summer of
1975. It opened in 464 theatres backed by a massive promotion effort and,
within a week, the picture grossed $14 million, outpacing the record set by *The
Godfather* the first week of its release. Within two weeks, *Jaws* had reached
breakeven, which was 'faster than any other film in history for a motion picture
with such a large production cost', said David Daly (1980, p. 125). By August,
Jaws was playing in 1,000 theatres and soon set a new industry high for the
biggest-grossing film. Afterwards, almost every important picture with broad
appeal followed the pattern set by *Jaws*. Today, a new picture is typically released
during one of the peak box-office seasons; it is booked in thousands of theatres;
and it is supported by a massive media blitz and merchandising campaign.

THE OPENING DAY TEMPLATE

Here, in outline, are the principal ingredients to go into the opening day template. As a reminder, a new release 'has only a short window of time to establish itself in a very competitive marketplace, and that initial performance – perhaps its opening weekend in theaters – may well determine its long-run commercial success in the aftermarkets: video/DVD, cable, television, foreign markets, and IPTV' (Greenwald and Landry, 2009, p. 84). Marketing, therefore, has twin goals: to create a unique brand for a new release and to create a must-see attitude for the opening weekend.

Market Research

Market research plays a crucial role in the planning. As *Variety* put it, 'There's no such thing as a sure thing in Hollywood. While moguls of the past could boast of their gut instincts, today's showbiz decisionmakers face increasingly fragmented auds, ever-rising costs and competition on new fronts. To hedge their bets, they've come to rely more and more on market research' ('The Market Research Issue', 2011). At Warner Bros. market research is conducted mostly inhouse, using its '4 Star' computer program. As described by Daniel Fellman, president of Warner Bros. Pictures Domestic Distribution, the program,

> tracks every Warner project, as well as our competitors' projects, in development, production or release. Our customized system can display the box office history of any actor, producer, director or film in seconds; we can analyze a marketplace, release schedule, daily grosses, reviews, demographics, trailers, TV spots, print ads, posters, Web sites, and year-to-date box office performance. Whatever information is needed regarding talent, box office receipts or research to aid in the decision making process, it's in there. It's also persuasive when talking with film-makers and making a case for critical decisions, such as a release date. (Fellman, 2004, p. 366)

The studios generally employ specialist firms such as Nielsen's National Research Group, MarketCast and Online Testing Exchange and Screen Engine for marketing assistance and might spend $1 million and more for their services, a relatively small investment compared to what the studios spend on TV ads alone. Studios originally used these firms simply to evaluate finished newspaper ads, television commercials or radio spots before committing money to them. Later, they used these firms to get feedback from focus groups from the picture itself – from rough cut to the finished polished cut. 'The process by which Hollywood conducts market research on its movies has changed little over the past 20 years. Groups of potential ticket buyers are gathered, shown footage and asked, "What do you think?" ' (Graser, 2011b). The results of these tests provide

marketing executives with a roadmap of how to tailor the advertising campaign and sometimes lead to changes in the films. A famous example was when a former Nielsen NRG exec 'analyzed the results of the screening of *Fatal Attraction* and advised Paramount to reshoot the ending so Glenn Close's character is killed, rather than committing suicide' (ibid.).

On the opening weekend, researchers track the box office and measure audience awareness and interest in the new release. Four demographic quadrants are measured – young male, older male, young female, older female. Exit interviews reveal whether a film has legs or if it is doomed. In either case, the results will lead to a review of the advertising spend. New media platforms such as Facebook, Twitter, Google searches, blogger chatter and website traffic are also monitored, but market research 'have yet to determine the power of a tweet and the impact of the "like" button on Facebook. Just because individuals are buzzing about a project doesn't mean they're going to buy a ticket to see it,' reported *Variety* (ibid.).

Defining the Audience

Defining the audience for the picture, the studio has three age groups to consider: (1) twenty-four and under, (2) twenty-five to thirty-nine and (3) forty and up. The most coveted demographic for Hollywood is the twenty-four-and-under group, comprising teenagers twelve to seventeen and young adults eighteen to twenty-four. Often called Generation Y, the Millennials or Echo Boomers, they comprise a third of the population and buy nearly half of the tickets. Although the group has 'tons of leisure time, more discretionary income than ever and an insatiable appetite for entertainment', according to the *Los Angeles Times*, 'they're the most difficult to corral with elusive, often unexpected tastes and a penchant for ever-evolving technology. They're sophisticated, demand authenticity and bristle at even the slightest hint of condescension' (Piccalo, 2006).

Movie Ratings

To replace the outmoded Production Code, which was a form of self-censorship that prevailed from the 1930s until the late 60s, in 1968 the Motion Picture Association of America (MPAA), under Jack Valenti, instituted a full-scale rating system that classified films according to their suitability for different age groups. Administered by the MPAA's Classification and Rating Administration (CARA), the ratings are G ('general audiences'), PG and PG-13 ('parental guidance'), R ('restricted') and NC-17 ('no children'). Ratings have an impact on marketing and determine who can or will attend a film. A film's rating determines 'what sort of channels commercials can appear on, what time of day the movie can run and even determine[s] what theaters will agree to book it' (Thilk, 2010).

As Stephen Greenwald and Paula Landry have written,

Ratings have an impact on marketing, as they influence who can or will see a film. Once the target audience for a film is identified and defined, the film's rating must be compatible with drawing an audience from the group. A film intended for young children must have a G, PG, or PG-13 rating. If a film is in danger of not receiving a PG or PG-13, the producer and distributor may need to recut the edited version of the picture to receive the appropriate rating from the MPAA. (2009, p. 150)

The preferred film rating to attract the twenty-four-and-under group is PG-13. There has been a ratings creep in recent years as the R rating, once the studios' mainstay, went into decline. PG-13 films replaced Rs as the largest sector of the market. 'You're leaving tens of millions of dollars on the table with an R rating,' said one studio marketing head. 'Only people 17 and older can buy tickets to R-rated films.' While the MPAA's descriptions of each rating have remained fixed, 'there is evidence that today's PG-13 is more like yesterday's R', he added. 'Last summer, a Harvard study found that current films with PG-13 ratings and below had more violence, sex and profanity than films for the same ratings 10 years prior' (Snyder, 2005). The challenge facing any tentpole producer is to figure out how to push the boundaries of the genre's mainstay ingredients while staying within CARA's evolving understanding of PG-13.

Saturation Booking

A saturation opening weekend backed by a massive advertising blitz became standard practice for any tentpole or franchise picture, in part because it had the power to generate substantial box-office returns quickly and before any negative review or weak word-of-mouth could impact attendance. The explosion of big opening weekends was also due in part to the rise of huge multiplexes that allowed new releases to play on six or more screens simultaneously. Pictures that appeal mainly to a more mature cohort and art-type movies with little commercial potential are typically given limited or platform releases (see Chapter 6).

Some of the landmark openings of the new millennium are as follows.

- Warner's *Harry Potter and the Philosopher's Stone* (16 November 2001) opened on a record 8,200 screens in 3,672 theatres and took in $90 million the first weekend.
- Sony's *Spider-Man* (3 May 2002) opened on fewer screens, 7,500, but grossed $115 million the first weekend, which marked the beginning of Hollywood's $100 million weekends.

- Sony's *Spider-Man 3* (4 May 2007) opened on over 10,000 screens in 4,252 theatres, a new record. It also scored the biggest opening weekend in North America, with $148 million; the biggest opening day of all time with $59 million; and biggest worldwide opening weekend with $375 million.
- Disney's *Pirates of the Caribbean: At World's End* (25 May 2007) opened on over 11,000 screens, in 4,362 theatres – the widest release of all time – and took in $142 million in four days, breaking the record for the biggest Memorial Day weekend.
- James Cameron's *Avatar* (18 December 2009) from Fox opened in 3,452 theatres, of which 2,023 showed the film in 3-D, and overtook Cameron's own *Titanic*, to become the all-time highest-grossing film at the box office. *Avatar* took in a lukewarm $73 million on opening weekend, in part because its two hour forty-one-minute running time decreased the number of screenings that could be shown in a day and because a major blizzard on the East Coast over opening weekend kept people away from the multiplex. But the picture had staying power to become 'the first all-audience tent pole and the widest 3D release to date, both domestically and overseas'. (McClintock, 2009a)

Saturation booking has never lost its potency. After 2010, pictures regularly set new opening day and opening weekend records.

Release Periods

The standard times to release a tentpole or franchise picture is the Thanksgiving–Christmas holiday season and the summer, especially Memorial Day weekend and 4 July. The summer season actually begins the first Friday in May, and over the course of four months it generates the most box office, between 40 and 50 per cent of the annual take. However, there are only so many weekends to go around, and studios jockey for release dates far in advance to ward off the competition. As Robert G. Friedman described it,

> Today competition has increased dramatically, with two or three new movies opening most weekends pushing against the second weekend of the previous openings, so that perhaps six movies are competing for the audience's awareness and choice selection. And the audience is unforgiving: There are first-choice movies, and the rest are also-rans, a list that changes every week. (Friedman, 2004, p. 284)

For example, in the 2007 summer box-office derby, Sony's *Spider-Man 3* opened in early May to secure the pole position; *Shrek the Third* was scheduled to open

just two weeks later; and *Pirates of the Caribbean: At World's End* a week after that.

Every studio has a worldwide sales network and handles the distribution of its pictures independently. As recently as 2000, Hollywood staggered the release dates of its biggest movies around the world, beginning with the USA. This meant, for example, that audiences in Paris could not see a picture until it had completed its run in the USA. Such a strategy allowed the director and stars to help launch the picture at consecutive premieres. Increasingly, the majors have opted to release their blockbusters simultaneously worldwide, or nearly so. There were three main reasons behind the decision: international piracy, a growing foreign box office and the transnational circulation of promotional buzz. When New Line released the first installment of the *Rings* trilogy, *The Lord of the Rings: The Fellowship of the Ring* in 2001, pirated copies of the picture could be bought on the streets of Asian capitals within a day. To leave counterfeiters little time to do their work, New Line opened the third installment of the trilogy, *The Return of the King*, in twenty-eight countries over five days in December 2003. In 2004, Warner launched *The Matrix: Revolutions* day-and-date worldwide using 20,000 prints, again as a hedge against international piracy. Moreover, distributors want to capitalise on the buzz that a film generates during its opening weekend, a buzz that sometimes reverberates around the world via the internet.

'The summer blockbuster season once seemed to be a uniquely American phenom. Long summer vacations in Europe and a preponderance of theatres without air conditioning meant that BO in key Euro markets evaporated at precisely the time of year in which Hollywood released its biggest blockbusters Stateside,' observed *Variety* (Bing, 2004). But in recent years, European vacations have shrunk and international theatres chains have built multiplex theatres on a par with US movie houses. The new conditions reshaped the international release calendar and, by 2011, 67 per cent of the majors' box office came from outside the USA.

Marketing Tools

Tentpoles and franchise pictures have yielded the best returns on investment for the majors. Despite their seemingly bigger risks, the most expensive pictures have generated the most profits on average. The marketing budget for such pictures is the single largest item outside the actual production cost, and nearly all the money – approximately 80 per cent – is spent on the theatrical opening. 'The amount spent to open a film is disproportionately large because the theatrical launch of a film is the engine that drives all downstream revenues. Accordingly, the money spent up front marketing a film, creating awareness, develops an overnight brand that is then sustained and managed in most instances for more

than a decade,' explains Jeffrey C. Ulin (2010, p. 384). A new release has to prove itself within a short window of time, essentially the first week with two weekends.

TV advertising, broken down into network (35.8 per cent), cable (25.9 per cent), spot (5.5 per cent), syndicated (3.4 per cent) and Spanish-language (2.4 per cent), is the biggest outlay and generates 70–75 per cent of all movie awareness for consumers (Friedman, 2010). Newspaper advertising (14.7 per cent) is next, followed by internet display, outdoor, radio and magazines. Outlays for internet marketing on such sites as Facebook and YouTube are small compared to traditional media spends, anywhere from 5–20 per cent of the marketing budget. The actual amount depends on whether or not the target audiences are big users of new media.

TV is the marketing workhorse because it delivers large audiences quickly. 'And because each film is essentially a new product that needs to create awareness among consumers, and has a short shelf life on theater screens, reaching a maximum number of moviegoers just before release is crucial to juicing box office' (Marich, 2011). TV and radio ads of different lengths can be aired locally and nationally. In addition to effecting economies of scale by linking the size of a market to a station's TV or radio signal, commercial spots have the advantage over the print media in two ways: they can be spaced out, unlike the amusement pages of newspapers which place film ads back-to-back; and they can be targeted at a specific audience by being aired at certain times of day or during certain kinds of programmes. But TV advertising in particular does not come cheap. The price of a primetime thirty-second spot on one of the four American networks is around $100,000; on Thursday nights, which is key for movies that usually open on Fridays, the price can go up to $200,000. Super Bowl commercials average $3 million for a thirty-second spot. Because the networks are losing viewers, more ad money is being channelled to cable's narrowcasting programming to achieve audience awareness.

More recently, YouTube and Facebook have become must-buys for entertainment marketers wishing to target the younger audiences. For example, after Google acquired YouTube in 2006, Google 'rolled out literally dozens of ways for large and small advertisers to use YouTube, from big homepage ads to pre-rolls and overlays, paid placements and search ads' (Learmouth, 2010). But measuring the impact of such ad placements proved problematic. As Debra Aho Williamson, an eMarketer analyst, reported in the *New York Times*, 'there are concerns that social network users do not view ads, no matter how carefully the ads are placed' (Stelter, 2008).

A studio devises the media strategy for the launch at least two months before opening day. Robert G. Friedman, a former top executive of Paramount

Pictures, has described the strategy as follows: 'In determining the media buys, spending levels are set based on how much the picture is expected to gross: costs are driven by projected performance. The warning becomes, Don't outspend your revenues, but don't underspend your potential.' After the first weekend, the marketing people assess the audience response by doing exit interviews. The level of advertising is recalibrated based on the results. 'If it's not a good movie, gets poor reviews and opens poorly, it can't be saved. If it's a good movie, gets good reviews and opens poorly, it might be saved. If it's not a review-driven movie, such as an action or teenage movie, and opens poorly, it probably can't be saved' (Friedman, 2004, pp. 290, 295).

The theatrical trailer is 'the backbone of all broadcast materials', said Friedman (ibid., p. 285). It creates the first visual impression of the movie for the theatre and internet audience. Trailers are prepared after the rough cut, when the marketing picks up. To meet the deadlines, studios typically farm out the job to any number of production houses, which test, polish and tailor individual trailers to targeted audiences. In-theatre trailers (or launch trailers) run from one to three minutes; teasers run from ninety to 120 seconds. Tentpole releases typically require a teaser trailer six months or so prior to release and a launch trailer two months prior. Trailers for the biggest event movies, such as the *Batman*, *Lord of the Rings* and *Harry Potter* pictures, are placed in theatres even earlier and have become big events themselves. Once trailers are placed in theatres, distributors negotiate with exhibitors to get them screened as close as possible to the start of the main attraction, when the audience has settled in. Studios spend roughly $1 million to place a trailer.

POSITIONING A PICTURE IN THE MARKET
Unit Publicist
Once a picture is greenlit, a unit publicist is hired to handle public relations during filming. With a staff consisting of feature writers, photographers and perhaps an art editor, the unit publicist compiles a press information kit containing the 'official' information about the film – news releases, production notes, biographies of the stars and crew, feature stories in several languages and a packet of stills in colour and black and white. The unit publicist also compiles an electronic press kit containing interviews with the star and director and film clips. Both kinds are sent to journalists a month or so before the release to familiarise the press with the movie and to delineate and control how the picture should be perceived and interpreted. By developing the appropriate language and image, the studio hopes that the media will 'read' a picture in a predetermined way. In other words, the studio wants a picture to be judged on terms that it would establish.

To whet the appetites of movie exhibitors, studios trumpet their upcoming releases at two industry trade shows, ShoWest in Las Vegas in March and ShoEast in Orlando in the autumn. The conventions are attended by the top exhibitors and other industry professionals, who gather twice a year to view upcoming releases and to schmooze with movie stars. The conventions might also spotlight a 'state of the industry' address by the head of the MPAA.

To whet the appetites of entertainment-page editors, feature-story writers and reporters from TV stations and from foreign media outlets, studios offer press junkets. A press junket, essentially a free trip, is an efficient marketing tool the studios use to secure stories in the media as opening weekend nears. As a result of studio belt-tightening, most press junkets now take place in New York or Los Angeles, and no longer in exotic foreign locales. Representatives from foreign media likely belong to the Hollywood Foreign Press Association – a group of about ninety writers and freelance journalists representing some fifty-five countries, who write for publications ranging from the *Daily Telegraph* in England to *Le Figaro* in France, *L'Espresso* in Italy and *Vogue* in Germany, as well as the *China Times* and the pan-Arabic magazine *Kul Al Osra*. The organisation presents the annual Golden Globes awards in January.

The invited guests are given press kits upon arrival. For print journalists, the publicity staff stages press conferences and round-table interviews with the stars and director. For television journalists, the staff sets up a TV studio and tapes the interviews for use back home. Reporters from the major TV and news outlets receive special treatment – any number of one-on-one interviews of varying duration. Stars and directors are contractually required to offer such interviews, which can mean that a star might sit for a predetermined number of interviews over the course of one or two days. The studio pays all travel expenses for the invitees and puts them up in the best hotels. (Some major newspapers do not allow their reporters to accept studio-paid junkets.) The purpose of these junkets is to make journalists feel indebted and under a moral obligation to do a story or series of stories upon their return.

Comic-Con

Studios now realise that,

> You cannot successfully and fully market any comic book or similar genre movie in this day and age without a viral campaign on the Net starting ten months to a year prior to release if your intention is to build a franchise and a market brand ... Fans of comics, movies, science fiction and fantasy, manga and anime, animation, horror, etc. must be engaged early on and 'courted' for they have the capability to make or break a movie by their support or lack thereof. Studios now bring their filmmakers

and stars to the bigger comic book conventions to pay homage to the fans they know they must ultimately win over. There are currently so many dozens of key fan-sites on the Internet with millions of people trolling them all day and late night. It is a bonded community where word spreads like lightning. (Ulin, 2010, p. 387)

Comic-Con International remains the premiere convention for comic book, science-fiction and fantasy fans. The four-day event held every July at the San Diego Convention Center marks the beginning of many films' marketing efforts. The studios 'bring armies of reps from across all of their divisions, including film, TV, online, videogames and consumer products' to impress the fans and jump start word-of-mouth ('Hollywood Plays It Safe at Con', 2010). As *Variety* has noted,

> Hollywood has had time to finesse how it talks to the Comic-Con crowd. Lucasfilm essentially created a playbook for studios in 1976 when it presented a slideshow of photos of actors in costume and concept art from *Star Wars*, as well as distributing a comicbook of the property from Marvel to drum up buzz for the pic's release the next year. 'People made phone calls back then; they wrote letters and postcards. That's how word-of-mouth spread,' joked Stephen Sansweet, director of content management and head of fan relations for Lucasfilm. 'It's much different now.'

Today, dedicated fans 'whip out their cell phones and use Twitter to spread the word instantly on what they thought about the movies Hollywood took to Comic-Con' ('Fanning Fanboy Flames', 2010).

But Comic-Con can be a treacherous place. 'The swarm of dedicated fans – many of whom arrive at the convention in Japanese anime drag or draped in Ewok fur – can instantly sour on a film if it doesn't like what it sees, leaving publicity teams with months of damaging Web chatter to clean up' (Barnes and Cieply, 2011).

Premieres

The last step in the launch is the premiere. A premiere is an expensive publicity stunt designed to attract media attention. Most events are now staged either in Los Angeles or New York. In Los Angeles, two theatres have attracted most of the regular premieres, the Village Theatre, located in Westwood Village near UCLA, and Grauman's Chinese Theatre, a Hollywood landmark; in New York, it's the historic Ziegfeld Theatre on West 54th Street. Big pictures are given 'destination premieres'. Disney set the pace. In 1998, Disney staged a gala premiere for Jerry Bruckheimer's *Pearl Harbor* on an aircraft carrier in Hawaii. The price

tag was said to be $5 million. In 2006, Disney and Pixar spent $1.5 million to launch *Cars* at Lowe's Motor Speedway in Charlotte, North Carolina. NASCAR co-sponsored the event. And for much of the past decade, the studio has regularly spent lavishly to stage over-the-top premieres at Disneyland to launch its *Pirates of the Caribbean* franchise.

As a reflection of the growing importance of the international market to the majors, more and more Hollywood films are opening overseas. For example, *Harry Potter and the Philosopher's Stone* had its world premiere in London, as did the final installment of the franchise in 2011. Sony held the world premiere of *Spider-Man 3* in Tokyo on 16 April 2007 and opened the picture in Japan on the first of May, three days ahead of its US release. The first two *Spider-Man* pictures had each grossed around $60 million in the country. The Tokyo premiere was supposed to attract special media attention and set *Spider-Man 3* apart from Disney's *Pirates of the Caribbean: At World's End*, which was slated to open three weeks later.

Pictures conceived with worldwide appeal are given premieres in all the major international markets. Hollywood regularly used the Toronto Film Festival to promote the films of its speciality arms, such as Sony Pictures Classics, Fox Searchlight and Focus Features. The same held had true for the Cannes Film Festival, but the majors themselves largely avoided the event, fearing that if one of their expensive pictures flopped with critics and festival aficionados, the flop would be heard round the world, as they say. More than 4,000 members of the foreign press attend the festival. But a sea change in the business elevated Cannes to a key position in the distribution chain; by 2004, the festival – which takes place in May – was being used as an international showcase to launch a summer day-and-date campaign in the global market. Warner Bros.' *Troy* (2004), a sword-and-sandal spectacular starring Brad Pitt, was one of the first American tentpoles to use the festival in this manner. In 2006, any fear of Cannes evaporated when Sony's *The Da Vinci Code* went on to gross more than $750 million worldwide after the festival – 71 per cent of that outside the USA – despite having received withering reviews online right before its festival premiere. Now, studios regularly enter their biggest coming attractions out of competition at the event 'to gain an early edge on the ever-important international market and to generate word-of-mouth' (La Porte and Mohr, 2006). The dates of the festival in May and the beginning of the summer tentpole season are perfectly aligned. In 2011, Hollywood played the following high-profile pictures at the festival: Disney's *Pirates of the Caribbean: On Stranger Tides*, DreamWorks' *Kung Fu Panda 2*, Paramount's *Transformers: Dark of the Moon*, Pixar's *Cars 2* and Universal's *Cowboys and Aliens*.

Oscars

At one time, mainstream blockbusters such as *Saving Private Ryan*, vied for the top picture at the Academy Awards. Being nominated or winning such an award could provide an 'Oscar bump' in ticket sales and add value to the picture in home video and other ancillary markets. In recent years, Academy members have gone for quality and bestowed top honours to mid-budget pictures championed by the critics. In 2008, for example, the Academy's five nominees for best picture, which included *No Country for Old Men* and *There Will Be Blood*, had pulled in less than Michael Bay's sci-fi thriller, *Transformers*. The trend towards critically acclaimed features began in the 1990s, when Harvey Weinstein of Miramax Films beat the drum for such arthouse favourites as *The Crying Game* (1992), *Life Is Beautiful* (1997) and *Shakespeare in Love* (1998) to capture the top honours at the awards ceremony (see Chapter 6). The Oscar race, according to studio distributors, is therefore not a significant factor in the commercial life of comic book or similar genre pictures.

MERCHANDISING, TIE-INS AND PRODUCT PLACEMENT

Promotional tools such as merchandising, tie-ins and product placement have been used to generate interest in movies at least since the 1930s. Walt Disney pioneered them all. Disney quickly grasped the potential of these tools, which not only provided him with a source of production funds, but also a means to promote his cartoons and the Walt Disney brand name.

> By the mid-1940s, the Disney name was selling about $100 million worth of trinkets a year. Disney boldly diversified into television, commercials, music, comic strips and amusement parks at a time when other studios could think of nothing but celluloid. He also established lucrative alliances with the giants of American business, from Coca-Cola to Sears, Roebuck. ('America's Sorcerer', 1998)

All the studios have consumer products divisions, whose job is to license outside companies to manufacture and market such products as toys, clothing, novelisatons and soundtrack albums based on a movie's movie themes, characters or images. Deals are struck well before the release or even the start of production. Studios typically receive advance payments for the rights and royalties based on wholesale revenues. Merchandising serves two functions: it promotes the brand of the movie and it creates a revenue stream. Tie-ins are a form of cross-promotion that links a pre-existing product with elements of a film's brand. A product placement is just that; it's when a well-known product is shown on the screen.

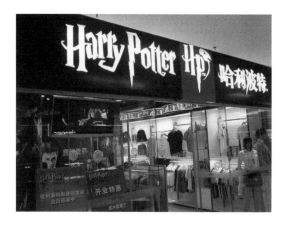

This store in Shanghai is
devoted to Harry Potter
merchandise

The current vogue of film-based licensing began with George Lucas's *Star Wars*, which generated around $400 million in merchandising spinoffs – about double its box-office take. The merchandise included everything from *Star Wars* posters, T-shirts, toys, souvenir programmes, costumes, masks, lunch boxes, digital watches, bubble-gum trading cards, to nightgowns, hosiery and even children's wading pools. Lucas had unprecedented control over the *Star Wars* brand. When Lucas was negotiating with 20th Century-Fox to make the first *Star Wars* movie, he opted to take a modest fee in return for all sequel and merchandising rights. These rights eventually generated billions and enabled Lucas to build his Lucasfilm production company, the Industrial Light & Magic special effects house and a computer-game division. After *Star Wars*, it became standard practice to support franchises and tentpoles with massive merchandising campaigns which generated revenues that often rivalled their box-office take.

Take the case of *Harry Potter*. J. K. Rowling was concerned about how her books would be adapted to the movies and Warner allowed her to retain some artistic control over the franchise, including the merchandising. Hundreds of Harry Potter products reached the market. They included video games, software, gifts, wand-type toys, candy and dolls. The video games alone generated over $1.5 billion. Lego reported that its *Harry Potter* line was 'some of its best-selling merchandise' and planned 'to continue making new Potter-themed toys even after the new films are no longer released' ('Harry's Magic Numbers', 2011). In 2007, *Advertising Age* pegged the worth of the brand at $15 billion.

MCA, Disney and Warner, meanwhile, had taken merchandising to its next level by operating mall-based chains stores to sell merchandise based on their films. Disney, for example, opened its first Disney Store in 1987 in Glendale, California. Afterwards, it opened an average of sixty stores a year and eventually owned more than 700 stores worldwide. During the 1990s, they generated

enormous profits from merchandise based on Disney's animated features such as *Beauty and the Beast*, *Aladdin* and *The Lion King*, and from the initial home video releases of the Disney Classics. Disney sold the chain in 2004 after demand for animated-character merchandise declined and then reacquired part of it in 2008. Afterwards, the company announced its intent 'to drastically overhaul its approach to shopping malls' with the help of Steve Jobs of Apple. Disney intended to rebrand its stores Imagination Park and spend $1 million per store to install high-tech, interactive entertainment hubs to attract customers. The makeover was part of Disney chief Bob Iger's plan for all of Disney's future upcoming tentpoles: 'to sell everything from toys to T-shirts, games and soundtracks and, eventually, design theme park attractions around' (Graser, 2010b).

Thus concludes our survey of traditional marketing techniques. They remain techniques of choice by the major studios and nicely complement their production efforts. But, going into the new millennium, the internet became a phenomenon to be reckoned with.

INTERNET-DRIVEN MARKETING
Websites
Official websites had become an integral part of movie marketing by the mid-1990s. They were nothing more than the internet equivalent of a Sunset Strip billboard for a film. Studios simply purchased a URL and uploaded a trailer and a few stills, video clips and press notes to publicise a new release. Studios generally hired outside companies to build their sites. At the start, studios created websites for the biggest films, but by 2003, nearly every film was being promoted online. The more elaborate sites featured all sorts of materials long associated with special edition DVDs, such as 'behind-the-scenes' trivia, documentaries on the making of, directors' diaries, interviews with directors and stars via live-time chat rooms, technical data and sometimes even games and contests. Chat rooms allowed fans to deliver their opinions and became a marketing staple for franchise pictures. A frequently updated director's blog could keep potential moviegoers coming back for more. Websites also allowed moviegoers a chance to purchase merchandise online. Compared to other conventional media, websites were a bargain and accounted for only a tiny fraction of the marketing budget of the average Hollywood film. They had the added advantage of remaining in place after the theatrical launch and after the picture moved into ancillary markets.

Lucasfilm's official site for the rebooted *Star Wars* saga demonstrated how to effectively promote an upcoming picture while developing a database of potential customers. It did so by immersing viewers in the story's environment, with

7,000 pages devoted to the history and lore of the series' fictional universe. Lucasfilm reported in 2003 that the site had 'registered four million members, who can receive online newsletters, post messages in the site's forums and gain access to video clips, among other benefits in exchange for providing a name, email address and demographic information' (Hutsko, 2003).

Viral campaigns and The Blair Witch Project

As already noted, a studio cannot successfully launch a comic book or similar genre franchise without a viral campaign on the web well in advance of the release. According to Jeffrey Ulin, viral campaigns are 'Internet-driven campaigns using Web sites, blogs, and teasers. The goal of these campaigns is that the film or an element within will simply "catch on"' (2010, p. 385).

The Blair Witch Project (1999) official website provided a classic study of how to create a viral buzz. Directed by Daniel Myrick and Eduardo Sanchez, *Blair Witch* was a micro-budget horror film, purportedly a documentary using found footage of three student film-makers who mysteriously disappeared many years ago while searching for a legendary witch in the Maryland woods. It was picked up for distribution by Artisan Entertainment after a midnight screening at the 1999 Sundance Film Festival. Artisan had only a limited amount of money for promotion and decided to exploit the web. Artisan renovated the original site, and launched it on April Fool's Day 1999. Targeting the fringe, the site treated *The Blair Witch Project* as a real event; it presented 'documents' about the Blair Witch Mythology, an interactive timeline, the 'back story' on the missing student film-makers, interviews with the sheriff and search party, and video and audio clips of the found footage. The film-makers seeded the myth by appearing on John Pierson's *Split Screen* cable show with eight minutes of footage they claimed was found in the woods. Artisan premiered its trailer on the insider Ain't It Cool News website and produced a mockumentary for the Sci-Fi Channel entitled *Curse of the Blair Witch*.

The internet was soon swarming with unofficial *Blair Witch* sites, web boards, mailing lists, newsgroups, trailer sites and general excitement about the movie.

> There were massive Internet-based debates over whether or not it was a real documentary ... MTV News covered the proliferation of fan sites nearly two months before its July 16 release. The torrent of online talk about the movie aroused the curiosity of the offline press who then began to report it. This pre-release hype created the anticipation for the movie's opening. (Weinraub, 1999b)

Artisan created even more excitement by making the film hard to see. The film debuted in just twenty-seven theatres and broke house records. The following

week, the release expanded to 1,000 theatres and soon after to 2,000. At the time of its release, the website had been viewed more than 30 million times. The picture went on to gross $140 million in the USA and $250 million worldwide. In proportion to production costs, it is one of the most profitable movies in history. But, as *Variety* points out, 'The 1999 sensation caused by the mysterious episodic footage of *The Blair Witch Project* has never been duplicated, and these days film marketers opt to place their juiciest movie content on third-party platforms that already have big Web traffic' ('New Media Can't Yet Carry the Day', 2011).

Fan Sites

The majors have long been accustomed to controlling the flow and access to information about a picture. 'Publicists not only pick and choose which journalists get invited to screenings, they often dictate which writers and photographers are assigned to do stories. Their job is to control and manipulate the media, and the media are often very willing partners' (Weinraub, 1997b). However,

> almost as soon as the Web emerged as an essential new medium, fan-generated movie sites like Film Threat, Dark Horizons and especially Harry Knowles' Ain't It Cool News appeared out of the ether. Unpretentious, unabashedly opinionated and willing to review films cloak-and-dagger style, from test screenings and purloined scripts, these 'fanboy' sites quickly garnered equal amounts of adoration from young readers and ire from studios. (Barker, 2006)

Harry Knowles's website, operated by a twenty-five-year-old college dropout in Austin, Texas, became a force to be reckoned with. By 1997, a year after he set up his site, 1,200 movie fanatics were sending him reports on test screenings, which he posted on his site. His site averaged 2 million hits a month. Studios employed private research firms to conduct the test screenings and revealed the results only to the companies who paid for them, but, with Knowles, anyone with access to the web could get an instant report. Knowles was being accused of 'interrupting the process. They're taking an unfinished product and judging it. And that's unfair to the director, to the people working on the film and to the consumer,' said Chris Pula, the head of theatrical marketing at Warner Bros. 'The real threat is that Knowles's web site – with its early film reviews and gossip about casting decisions and movies in trouble – is starting to set the journalistic agenda in Hollywood. The advance buzz about a movie has an effect on stories, and even reviews – and Knowles is affecting the buzz,' he added (Weinraub, 1997b).

When more than 20,000 fan sites sprung up in anticipation of the *Star Wars* reboot, Lucasfilm took legal action in 1999 to block the online distribution of a fan's alternative cut of *Episode I: The Phantom Menace*. After fans deluged Lucasfilm with angry emails, the studio apologised for the 'miscommunication' in a letter posted on the web. When alternative websites sprung up after Warner opened its official site to launch the *Harry Potter* franchise, some of which were selling advertising, Warner sent cease-and-desist letters to the people running the sites, many of them teenagers. 'The bigger websites fought back,' reported the *Economist*, 'writing ominously that forces "darker than He Who Must Not be Named" were trying to spoil their fun. So began the Potter wars. Led by Heather Lawver, a 16-year-old from Virginia who showed a gift for media management, the insurgents forced the studio to back down' ('The Harry Potter Economy', 2009). Studios no longer try to close down or co-opt fan sites; instead, they try to work with them.

The Case of *Lord of the Rings*

New Line spent more than $270 million to make the *Lord of the Rings* trilogy. The films were shot simultaneously to effect economies of scale, which was risky. If the first picture flopped, New Line could stand to lose most of its investment. Like the *Harry Potter* books, J. R. R. Tolkien's three-part fantasy epic had 'a near-religious following, and cult members zealously protect the franchise'. New Line realised if it somehow alienated the fan base, which comprised mostly males in the early teens to the early thirties, its members could post poisonous internet messages to the vast communities on the internet and kill the venture (Thompson, 2007).

New Line had to somehow convince the 'Tolkienites' that their beloved epic was not going to be pillaged by the Hollywood machine. The task was given to Gordon Paddison, New Line's vice-president of worldwide interactive marketing and business development, who formulated a successful internet assault 'based on a concept of open engagement' (Solman, 2007). New Line launched the official *Lord of the Rings* website in May 1999, six months before the start of shooting. At first, New Line wanted to control the information and, in ten languages, the site offered an interactive map of Middle Earth, chat rooms, interviews with cast members and behind-the-scenes news 'about how the director Peter Jackson and his crew members are creating Tolkien's world of hobbits, elves, wizards, orcs, dwarfs and black riders' (Lyman, 2001).

Almost immediately, more than 400 unofficial Tolkien websites sprung up, reaching 300,000 by the time of *Fellowship*'s opening. They could have undermined the entire internet campaign, but Paddison decided to embrace the upstarts rather than fight them. Paddison has stated, on *Lord of the Rings*,

we were able to embrace both malcontents and potential filmgoers and turn both groups into evangelists for the product at a time when studios were still suing people or taking Web sites away from them. It was based on a concept of open engagement. I remember going to Comic-Con for many years and hearing the most derogatory things said about our audience. Everything was negative about our most profitable and dedicated consumers. And that's really what Internet marketing started out as. It was feeding the unwashed. (Quoted in Solman, 2007)

Paddison and Peter Jackson decided to be totally open with the Tolkien websites, going so far as to adopt forty of them. Jackson developed close relationships with web masters and explained the choices he was making in the filming, thereby squelching 'false rumors about the production before they made it onto the Internet' (Lyman, 2001). Paddison continuously updated the official website with exclusive images, interviews and news, which included an advance snippet of the film in April 2000. It was downloaded over 1.7 million times the first day and 6.6 million by the end of the first week. (For a comparison, the trailer for *Star Wars: Episode I: The Phantom Menace* was downloaded a million times on its first day online.)

Assessing the impact of Paddison's handiwork, the *New York Times* said,

When a movie is almost magically embraced by the Web – sometimes with the connivance of the distribution company – a strange relationship forms among the cybercommunity of fans, the film-makers and the studio marketers. The online ferment includes nitpicking about casting choices, complaints about script changes and gossip across the globe about every nuance of the production. However, when everything clicks, a network of eager Internet evangelists evolves to promote and support the film. (Ibid.)

Having begun by soothing the cybercommunity of fans, Paddison made converts of all four demographic quadrants – young male, older male, young female, older female. 'The three films together were a cultural event and the stuff of movie lore, bringing in billions in BO and merchandise' (Hayes and McNary, 2008).

Preparing for the Future

Studios continue building compelling sites for their pictures, but the trend today is to steer moviegoers to social networks such as Facebook and Twitter and the video-sharing site YouTube to generate word-of-mouth. As Tim Bajarin, President of Creative Strategies, said, 'The big difference today is the social network. One of the most powerful methods for spreading information is word of

mouth, and the incredible explosion of that use, from spreading information and inviting people, especially within this young group, is one huge difference' (quoted in Goo, 2006).

To learn more about the impact of digital media and technology on moviegoing, Google, Microsoft, Facebook, Yahoo and other online media companies sponsored a study in 2009 by Stradella Road, a marketing consulting firm founded by Gordon Paddison. As reported by Ben Fritz in the *Los Angeles Times*, Stradella's research revealed the following:

- For teenagers, it's all about socialization. 56% go to the movies in groups of three or more and 33% in a quarter or bigger. Those same habits translate online, where they spend more time than any other group on Facebook or MySpace, using IM, and texting. They're the least likely, however, to use search engines to find specific information. To get teenagers, in other words, marketers have to be where they're talking.
- 18–29 year-olds are just as comfortable, if not more, with online media than teenagers. In fact, they go online for information more than any other group. They use social networks – but don't chat – nearly as much and spend significantly more time actually reading online content. And they're particularly interested in review aggregation sites like Rotten Tomatoes and Metacritic.

 Unlike teens, however, they usually go out in couples, not with several friends at once. So information, much more than communication, is key online.
- 30somethings … have plenty of money to go to the movies but not nearly as much time as others, particularly if they have young kids. They're young enough to know how to use most technology, but a lot less likely than those younger to use newer online options like social networks and video.

 On the other hand, they're the most likely to have broadband Internet and a cell phone and to not only own a DVR, but to use it to skip commercials. They're tough to persuade, in other words, but when they do go to the movies, technology still plays a critical role.
- 40somethings: They're in what Paddison called 'a transitional period for technology usage.' Translation: They use the Internet a lot, but they're not comfortable with every new device and still enjoy old-fashioned print media.

 Like 30somethings, they spend a lot of time online, although they're even less comfortable with some new technologies. … Many of them have kids and go to the movies as families. But since their children are older, their kids are a lot more likely to influence which movies they see. In other words, if you're thinking about how to get 40somethings to the movies, you should probably scroll back up and re-read that section on teenagers.

- 50 and up: Once the kids leave the house, adults become 're-engaged,' meaning they go to the movies in couples, like 20somethings do. No surprise that they're not nearly as engaged on the Web as their juniors, but they do use it for very specific tasks. 97% use the Web for information gathering, virtually the same as those in their thirties and forties.

The big difference is that moviegoers over 50 are less likely to watch online video, actively use social networks, or blog. They might look for specific information, like a showtime or review, online, but they're still casually influenced the way that their parents were: through old fashioned media and through non-digital friends. (Fritz, 2009)

CONCLUSION

This chapter vividly illustrates Hollywood's hold on the business. The majors are the only entities that have the resources to finance and market motion pictures worldwide on their own and on a consistent basis. The majors have enjoyed this status since the *Paramount* decrees broke up the old vertically integrated monopoly, beginning in 1948. During the 1960s, the majors relied mostly on newspapers to market their pictures; beginning in the 70s, they turned to television; and in the 90s to the internet. Stradella Road's research has shown that most people learn about new movies through television commercials and movie trailers. But media consumption tastes are changing, and the mass-marketing approach long favoured by Hollywood to reach its core audience could suddenly become obsolete. This audience has become fragmented and more unpredictable. In efforts to be more with it, studios have put up Twitter accounts and Facebook pages to generate word-of-mouth, but these were fledgling efforts at best. Keeping abreast of social networking trends and internet usage as ways to reach an audience will prove to be an ongoing challenge.

4

Exhibition: Upgrading Moviegoing

Although the names of the companies have changed since the 1948 *Paramount* decrees, the exhibition market in the USA continues to be dominated by a few national chains. At present, the top five chains by number of screens are the Regal Entertainment Group (6,605), AMC Entertainment (5,203), Cinemark Theatres (3,864), Carmike Cinemas (2,236) and National Amusements (426). National Amusements is privately owned by Sumner Redstone (80 per cent) and his daughter Shari Redstone (20 per cent), and is the parent company of Viacom, the conglomerate that controls Paramount Studios.

Theatres are protected in the distribution chain. The theatrical window for a new motion picture by industry agreement is four months to allow time for a worldwide rollout, but forces are working to challenge its premiere status, as will be explained later. The theatrical run is the largest single revenue source for most Hollywood pictures. A successful release emblazes the title in the minds of moviegoers and increases its value in ancillary markets, hence the hoopla leading up to opening day.

A PROTECTED WINDOW

The standard rental agreement between the major distributors and exhibitors is the 90/10 deal. The agreement essentially divides the box-office take based on a sliding scale after the exhibitor deducts the 'house nut' – a negotiated amount to cover theatre overheads. The division begins with a 90/10 split, with 90 per cent of the take going to the distributor for the first two weeks of the run, and then goes down in two-week increments until the average split is 50/50. The sliding scale allows the distributor to take a lion's share of the box office immediately to take advantage of the advertising push and to capture as much revenue as possible before interest in the new release drops off. But because a distributor's take from the box office averages 50 per cent over the life of the run, exhibitors have tried to replace the traditional split with a flat rate known as an 'aggregate' settlement, whereby the box-office take is divided 50/50 throughout the entire theatrical window. Such a division would simplify the complex terms now in place and protect exhibitors 'from losing their shirts as most

movies now open huge on lots of screens and then burn out faster than Donald Rumsfeld's poll numbers', said *Variety* (Goldsmith, 2004). But given the fact that the majors are the principal suppliers of big-budget tentpoles and franchises, the balance of power will likely remain with distributors. As Dade Hayes and Jonathan Bing point out, 'Exhibitors have become little more than the keepers of infrastructure and capacity, controlling little beyond seating, ticket prices and concessions. They are a key component in the scale and immediacy of opening weekend, but they no longer engineer the hits' (Hayes and Bing, 2004, p. 97).

It seemed, for a while at least, that the movies were recession-proof. The total domestic box office increased from $7.75 billion in 2000 to a peak of $10.6 billion in 2010. Admissions, which is to say the number of tickets sold, reached a high of 1.57 billion in 2002, then declined to 1.34 billion by 2010. Although the box office increased 15 per cent over the past five years, when adjusted for inflation the tallies for 2001, 2002, 2003 and 2004 all exceeded the 2009 figure. The recent increase in the box office was mainly the result of the premium ticket prices exhibitors charged for 3-D films. The major studios are obviously worried about this trend, but exhibitors are even more. They feel threatened by movie piracy and by consumers that are opting to wait and watch new Hollywood releases on their home entertainment centres. Consequently, the exhibition sector is resolutely focused on efforts to sustain theatrical exhibition as a distinctive and spectacular experience.

EVOLUTION OF EXHIBITION

The exhibition market entered a new period of growth during the 1980s. By then, the movies had followed the migration of shopping centres to the suburbs. As central cities declined, these new developments offered consumers enclosed environments, one-stop shopping, safety and plenty of free parking. To generate traffic volume, mall developers included theatres in their construction plans. (The space was typically leased to exhibitors who outfitted the interiors with concession stands, seating and projection and sound equipment.) The physical design of these theatres was perhaps the most noticeable change in contemporary exhibition. Compared to the older picture palaces downtown, these new structures were plain and utilitarian, but they were clean and comfortable.

The number of screens grew steadily from around 12,000 in the 1960s to over 23,000 by 1990. Although new theatre construction continued apace during the 80s, the future of exhibition was assured, ironically enough, by new forms of competition. Observers at one time predicted that home video and pay TV would kill the conventional theatre. But, on the contrary, the new ancillary markets generated increased interest in the movies. Because the demand for more films was met by the majors and a growing number of independents, theatres

enjoyed not only a larger picture selection, but also an enhanced status in the distribution chain. In the minds of consumers, the success of a film on the big screen determined its value on pay TV and home video.

The expansion of the US theatrical market during the 1980s, together with the Reagan administration's laissez-faire attitude towards antitrust matters, prompted the majors to test the terms of the *Paramount* decrees and 'take another fling with vertical integration' (Gold, 1990). The Justice Department went along with the move, arguing 'that the movie business has changed drastically and the concerns of 40 years ago are no longer valid'. In the department's view, 'the popularity of video cassettes and cable television mean that studios can no longer monopolize the movie market simply by controlling theaters' (Yarrow, 1987).

Columbia Pictures moved into exhibition first by acquiring the Manhattan-based Walter Reade chain in 1985. In 1986, MCA, the parent of Universal Pictures, bought a half-interest in the Toronto-based Cineplex Odeon Theatres, which operated over 1,600 screens in Canada and the USA. That same year, Gulf+Western, the parent of Paramount Pictures and the owner of the 430-screen Famous Players circuit in Canada, purchased the Mann, Trans-Lux and Festival chains, totalling 500 screens. In 1986, TriStar Pictures, the Columbia Pictures partner, purchased the venerable Loews Theaters, with 300 screens. And, finally, in 1987, Warner Communications acquired a half-interest in Gulf+Western's movie theatres. Only Walt Disney Company, among the majors, held back.

According to Charles Acland,

> The current US film industry was profoundly altered by the return to the exhibition business by major studios … As a result, such corporate entities became increasingly interested in the entire lifespan of a film as it moves from format to format. This ownership shake-up prompted a sector-wide reassessment of the particular nature of the service offered by movie theaters, with many settling on the need to upscale the cinemas themselves and to reshape the moviegoing experience to be distinctive and desirable enough for people to leave the comfort of the living-room couch and proximity to the refrigerator. The result was the multiplex building and refurbishing of the 1990s. (Acland, 2008, p. 85)

The first-generation mall theatre 'may have saved the movies' by following shopping centres to the suburbs, but 'the salvage job was short on pizazz', said Richard Corliss (1988). The new megaplexes, as the theatres were now called, were something else. Flush with cash from Wall Street and private equity funds, theatre chains spent billions to upscale the moviegoing experience. Their goal

The AMC Grand in Dallas

was twofold: to lure people away from their state-of-the-art home theatres and to wring more money from concessions, the proceeds from which were retained by exhibitors.

AMC's Dallas Grand led the way. Built in 1994, the Grand was an immediate hit and provided the basic template for megaplexes ever since: '14 or more screens, stadium seating, arm rests that hold drinks and can be tilted up to convert individual seats into a cozy love-seat tandem, a digital sound system and a ceiling-to-floor, wall-to-wall screen' (Fabrikant, 1999). The Grand started a megaplex building boom. For example, Muvico Theatres, a Florida-based chain, built themed complexes. As described by Bruce Webber in the *New York Times*, Muvico's Palace Theater in Boca Raton was 'designed in an ornate Mediterranean style' and had 'the ambience of a Las Vegas hotel' with valet parking, a lobby with enormous chandelier-style lamps, a supervised playroom for small children and 'a vast concession stand for a quick meal of pizza or popcorn shrimp before the show'. For patrons with more discriminating tastes and who were willing to pay twice the regular ticket price, the theatre also offered reserved-seat tickets, a separate entrance and 'a bar and restaurant, where the monkfish was excellent and no one under 21 was allowed'. 'Patrons were allowed to take their food and drink into one of the adjoining six theater balconies, all with plush wide seats and small tables with sunken cup holders' (Webber, 2005).

The megaplex boom topped out at over 36,000 screens in 1999, up from 23,000 in 1990. An unintended consequence of the building spree was the obsolescence of thousands of older multiplexes and a wave of bankruptcies, beginning in 1999, during which the investors in these companies lost an estimated $1.7 billion. Nine of the largest theatre chains in the country filed for Chapter 11 bankruptcy protection, among them, Regal Cinemas, United Artists Theatres, Loews Cineplex, Carmike Cinemas, General Cinema and Edwards Theatres. *Variety* described the event as 'one of the most unusual cases of mass bankruptcy in corporate America' (Goldsmith, 2004).

Unlike the first wave of multiplex construction, which incorporated theatres into malls to increase evening traffic, the new megaplexes were free-standing and became destinations in their own right. People shunned the older shoe-box theatres closer to home and were willing to travel a distance to enjoy the amenities and comforts they provided. Mall theatres could not easily be retrofitted to incorporate stadium-style seating and higher floor-to-ceiling screens. In such cases, exhibitors had two choices: they could keep them running at a loss until the lease expired or they could close them and write off the expense while constructing megaplexes at more desirable locations. None of this happened fast enough to reduce the glut of superfluous movie screens on the market.

Publicly traded theatre chains saw the value of their stocks plummet. To meet the crisis, the chains declared bankruptcy. Chapter 11 of the law allowed them to simply wipe out the leases on their unprofitable theatres and start anew. But the law also made them vulnerable to takeovers by private equity firms which specialised in acquiring distressed companies at fire-sale prices. Acquiring a bankrupt chain and taking it private, an equity firm improved its balance sheet by closing underperforming theatres and by firing employees. It would then place the chain back on the market by executing an initial public offering (IPO) and reaping the profits from the sale. 'The offering is their so-called exit strategy, or how they get their payback,' explained *Variety* (Goldsmith, 2006). Take the case of Regal. Philip F. Anschutz, the Denver billionaire, put up $500 million to buy up the bonds of the bankrupt chain for next to nothing and acquired control of the company. After closing more than 300 theatres with 1,800 screens, Anschutz took the company public with an IPO in 2002. The offering fetched a premium and Anschutz ended up with more than half the shares (Markels, 2003). The bankrupt AMC, Cinemark and Loews Cineplex were rescued in similar ways.

National Amusements confronted a financial crisis of another sort. National had built a string of multiscreen luxury theatres known as Showcase Cinemas, but, unlike other major chains, National owned the land under its theatres and was not forced to seek bankruptcy protection. As described by Shari Redstone, Sumner Redstone's daughter who ran the family company, 'The real estate part of our business tended to shore up any shortfall on the exhibition side by limiting the payment of rent and maximizing the cash flow' (Redstone, 2004, p. 388). Trouble started during the 2008 world financial crisis, when the banks failed to renew Sumner Redstone's credit. Burdened with $1.46 billion in bank debt backed by the value of his theatre chain, Redstone was forced to sell nearly $1 billion of his Viacom and CBS stock and unload thirty-five theatres. The theatres were sold in 2010 to Rave Motion Pictures, a Dallas-based chain founded by Thomas J. Stephenson Jr. The acquisition

created the nation's fifth-largest theatre chain with about 1,000 screens in twenty states.

GENERATING SPECIAL REVENUE

Exhibitors have found ways to supplement their box-office take by expanding concessions, by adopting new advertising platforms and by going digital. Expanding concessions went hand in hand with megaplexing. Concession sales account for 20 per cent of a theatre's revenue on average, but nearly half its profits. The moviegoers who buy the most popcorn and candy are teenagers and young adults, the frequent moviegoers.

Theatre Advertising

Theatre advertising is naturally being tailored to attract this age cohort. Partnering with national advertising brokers such as Screenvision Cinema Network, a private company, and National CineMedia, a consortium formed by Regal, AMC and Cinemark, theatres have installed digital projection systems for the preshow ads to replace the old-fashioned slide presentations. They have also installed TV screens at concession stands that display ads, and have placed ads on the food and beverage packaging itself. In 2003, advertisers spent about $250 million to reach theatregoers; by 2009, they spent $584 million. The growth in revenue 'is significant for the mature, perennially product-dependent exhib biz because the vast majority of it goes directly to their coffers instead of being split with Hollywood' (Hayes, 2008). This couldn't have happened without audience acquiescence. In 2006, Arbitron tracked the preshow biz on behalf of the Cinema Advertising Council and found that 'Consumers are showing increasing acceptance of movie theater advertising, especially among younger viewers and frequent moviegoers who now see on-screen commercials as part of the entertainment experience' (Arbitron Cinema Advertising Study, 2007).

The preshow ads were not without controversy. The studios had originally claimed the preshow ads diminished the moviegoing experience and a consumer group had filed a class-action suit against Loews Cineplex in 2003 alleging that the chain 'purposefully deceived moviegoers as to the actual starting times for feature films, with the goal of generating a captive audience for advertisements'. The chains were reluctant to eliminate the practice, because doing so would drive up ticket prices. To make the preshow ads more palatable, exhibitors attempted to make them more entertaining. For example, Screenvision in 2010 'unveiled its plans for a redesigned 20-minute "advertainment" block ... Instead of the usual assortment of trivia, banner ads and snack-bar enticements, the new advertising preshow will rely more on celebrity and sponsored entertainment.

NASCAR, for instance, has signed on to deliver exclusive video, which marketers can sponsor' (Barnes, 2010d).

Going Digital

By going digital, exhibitors planned on preserving their premiere status in the distribution chain. Digital cinema, which allowed movie audiences 'to view pristine, razor-sharp images throughout the length of a film's run', was being touted as 'perhaps the most important technological change in cinema since the introduction of the talkies in 1927' ('Digital Movies Not Quite Coming to a Theater Near You', 2000). Hollywood was already applying digital technologies to edit its movies or to create special effects and state-of-the-art sound, but the revolution did not impact exhibition until 1999, when George Lucas projected his *Star Wars: Episode I: The Phantom Menace* digitally in a few theatres in and around New York and Los Angeles. As John Belton has noted,

> The potential for a totally digital cinema – digital production, postproduction, distribution, and exhibition – caught the attention and imagination of the media. At the supposed turn of the millennium, the one-hundred-plus reign of celluloid was over; film was dead; digital was It. *The New York Times, Wall Street Journal, Los Angeles Times*, and several national news magazines heralded the dawning of the new digital age, proclaiming that it was no longer a matter of whether it would happen but when. (Belton, 2002)

Digital cinema was the weapon *de jour* that exhibitors used to combat the growing popularity of home theatres and video games – product substitutes that threatened to undermine filmgoing. Home ownership became an obsession for Americans, the result of easy credit from banks and soaring real estate prices, which made owning a home a good investment. Once luxury items available to early adapters of technology willing to pay $100,000 to build mini-theatres in their homes, home theatres with flatscreen TVs and multichannel sound systems came within easy reach of consumers by 2002. As the price of components dropped, the lower end of the market surged, and, by 2004, a third of American households had home theatre systems – 'whether or not they have the "media rooms" and leather armchairs to complete the tableau', reported the *New York Times*.

> Thanks primarily to the DVD, home theatre technology – or at least some semblance of the experience – is now available to far more people ... DVDs use surround sound with five individual soundtracks, plus one for the subwoofer ... Manufacturers like Sony, Panasonic and RCA have bundled these components [for

An upscale home digital
theatre

a home theatre system] into consumer-friendly systems with the uninviting
moniker, 'home theatre in a box'. (Rendon, 2004)

For families with children, home theatres had become a convenient and afford-
able product substitute for the movies.

Home entertainment centres likely contained a game console. As Tom
Chatfield observed,

> Games consoles, too, are becoming not only a favourite device for play, but fully
> fledged media hubs that are used by the whole family, thanks to their ability to
> stream television services, play music and DVDs, offer social networking services
> and even record sound, video and motion. We've come a long way since the old
> days of teenage boys hunched over flickering screens in their bedrooms. (Chatfield,
> 2008)

Starting out as an amateurish hobby, video games matured into an industry and,
by 1999, combined annual hardware and software sales were far exceeding the
box-office take. More than 40 per cent of American homes had a video game
console by 2006. This was the year Microsoft's Xbox 360, Sony's PlayStation 3
and Nintendo's Wii made their public debuts. People of all ages were spending
about seven hours a week playing PC games, but teenagers and young adults
were spending close to twenty hours at the consoles (Glover, 2011). Video game
tentpoles regularly sold 5 million plus copies. For those consumers reluctant to
pay the $60 going price for a new title, Redbox began offering video game
rentals at most of its 21,000 machines as of 2009. The titles were available day-
and-date with their release to stores at a cost of $2 a day.

Digital cinema would make moviegoing special, it was hoped, and allow for
an easy conversion to 3-D. As an added advantage, digital cinema would enable
exhibitors to generate incremental revenue from speciality content, such as

simulcasts of the Metropolitan Opera, World Cup matches and rock concerts. Digital cinema appealed to the majors because the technology would save them well over a billion dollars a year on the cost of making and distributing 35mm prints. And digital cinema could reduce the threat of piracy if the proper technological safeguards were put in place.

The conversion went slowly, however. As reported in *Wired*,

> Going fully digital requires elaborate coordination and synchronized movement. Studios, film-makers, theater owners, and manufacturers must each put one foot forward at precisely the same moment – but there are a number of financial, technical, and political obstacles that stand in the way. Who will pay to update the theatre projection equipment … has been the biggest sticking point to date. (Jardin, 2005)

According to John Fithian, president of the National Association of Theater Owners, the only way digital projection will get into the theatre is if 'those who are making the savings pay for it' (Belton, 2002). State-of-the-art digital projectors were expected to cost as much $150,000 initially. And because it was a new technology, the effective life of the projectors was uncertain. The cost to convert the nearly 20,000 theatre screens of the major chains would be formidable, especially in the wake of the bankruptcies that had hit the exhibition sector. The studios, on the other hand, could expect to save $2 million and more by distributing one their films on hard drives rather than as prints. The inequity would be even greater if theatres were expected to invest in satellite dishes or high-speed transmission lines to receive the digital files.

The issue was thought to be resolved in 2007, when AMC, Cinemark and Regal formed Digital Cinema Implementation Partners, with the purpose of setting technical standards for the conversion and raising funds to purchase the projectors. Texas Instruments took the lead in projector development by using the Digital Light Processing (DLP) technology and by licensing its technology to Barco, Christie, NEC and other manufacturers. In 2008, the consortium secured a commitment from JP Morgan Chase to raise $1 billion to finance the upgrade. Under this plan, the Walt Disney Company, 20th Century-Fox, Paramount and Universal agreed to finance the upgrades by paying the consortium a 'virtual print fee' of around $1,000 per screen for each movie they distributed digitally to the participating theatres. However, the plan stalled when the credit market collapsed in 2008, but by 2010 it was back on track. JP Morgan had raised the capital on behalf of the consortium to boost the number of digitally equipped screens in North America to 14,000, from around 8,000 screens in 2009. By 2010, Warner Bros. and Sony Pictures had also agreed to pay virtual

print fees to the consortium. Independent theatres were not a party to the deal and had to somehow finance the $75,000 plus installation cost on their own if they wanted to go digital. Since many of the smaller, second-run theatres could ill afford the cost, they were in danger of closing down.

John Belton has noted that the digital projection 'revolution' is a false revolution:

> Digital projection is not a new experience for the audience. What is being offered to us is simply something that is potentially equivalent to the projection of traditional 35mm film … Digital projection as it exists today does not, in any way, transform the nature of the motion-picture experience. Audiences viewing digital projection will not experience the cinema differently, as those who heard sound, saw color, or experienced widescreen and stereo sound for the first time did. Cinerama, for example, did transform the theatrical experience, producing a dramatic sense of audience participation. It was as if the audience, surrounded with image and sound, had entered the space of the picture. This sense of participation was exploited in Cinerama publicity photos that depicted spectators, sitting in their theatre seats, going over Niagara Falls, water skiing, or sitting in Milan's La Scala opera house. (Ibid.)

3-D

On the other hand, digital 3-D promised to offer such a transformative experience. The first 3-D wave, which began with the release of Arch Oboler's *Bwana Devil* in 1952, required two projectors to show and Polaroid glasses to view. The trend was brief and relied mainly on visual gimmicks to lure people away from their TV sets. The potential of digital 3-D was different in every respect. Writing in the *New York Times*, Brooks Barnes reported

> The latest 3-D technology is supposed to be new and improved; at least that is how Hollywood has sold it to audiences. Digital projectors deliver precision images, eliminating headaches and nausea, while plastic glasses have replaced the cardboard. Most important, say filmmakers, new equipment allows movies to be built in 3-D from the ground up, providing a more immersive and realistic viewing experience, not one based just on occasional visual gimmicks. (Barnes, 2010a)

Before digital cinema, 3-D could be found in IMAX-equipped theatres in museums and science centres. In 1990, IMAX unveiled its first 3-D system at Expo '90 in Osaka, Japan. Named the IMAX Solido, it used 70mm film, two projectors, a huge silvered screen on a wide-field dome and required viewers to wear high-tech glasses that separated the left-eye and right-eye images. The film,

An Imax 3-D theatre

Echoes of the Sun, was computer generated, and was seen by 1.3 million people in six months. IMAX installed its first 3-D IMAX theatre in Vancouver later that year. In 1994, it installed its first commercial 3-D venue in the USA as part of a new twelve-screen multiplex operated by Sony Pictures on New York's Upper West Side. The 3-D programme comprised an underwater nature film and a wilderness documentary, both around thirty minutes in length. 'IMAX Solido may very well be the most awesome motion picture of all time,' said the *New York Times* (Grimes, 1994). IMAX introduced a smaller 3-D system using 70mm film in 1997 called IMAX 3-D SR, which projected on a flat screen in existing IMAX theatres. To create the 3-D effect, viewers wore either polarised or electronic glasses.

In 2000, IMAX unveiled the technology to convert 2-D computer-generated animation to its 3-D system, with the release of its forty-seven-minute *CyberWorld*. The first Hollywood feature converted to its 3-D system was Robert Zemeckis's *The Polar Express: An IMAX 3D Experience* in 2004. A computer-generated animated film from Warner Bros., *Polar Express* was released in 3,600 2-D theatres and fifty-nine 3-D IMAX theatres (Kehr, 2010). The picture grossed close to $50 million of its $180 million domestic gross on IMAX screens.

Disney was the first Hollywood studio to push the adoption of digital 3-D when it released *Chicken Little* in 2005. Other studios were quick to embrace

the new technology, but had to wait until enough theatres converted to digital projection to ensure a wide rollout for a new 3-D release. This only happened when Digital Cinema Implementation Partners secured the financing from JP Morgan Chase.

The key technology that enabled digital theatres to show 3-D movies was developed by RealD, a California research and development company founded in 2003. In 2005, RealD introduced a 3-D system that eliminated the need to use two projectors. Its single-projector solution utilised Texas Instrument's DLP projectors and required viewers to wear low-cost passive glasses. While RealD worked with the major chains to make the conversion, Dolby Laboratories, the audio technology company, sought out small and mid-sized chains and independent theatres for its single-projector 3-D system, which was licensed from a German concern. Unlike RealD's system, which required a silver screen to project on, Dolby's used a regular cinema screen, which was thought to be a cost advantage. But RealD was first on the market and maintained its lead; as of March 2010, it had upgraded over 2,700 screens worldwide, while the Dolby had installed its system on less than 400 screens.

IMAX, meanwhile, introduced its own brand of 3-D in 2008. It used a pair of 2K digital projectors and a flat screen, and could be fitted into conventional multiplexes outfitted with IMAX's new digital projection system. At the same time, IMAX developed the technology to convert live-action 2-D films to IMAX 3-D. The company touted the MPX digital technology as sharply lowering the cost of acquiring an IMAX system without sacrificing the image and sound quality of the 'IMAX Experience'. Studios could now expect to pay $500 for a digital IMAX print instead of $60,000 for a 2-D analogue version. And IMAX exhibitors could expect to programme more digital media remastered (DMR) pictures as a result of the lower print cost and thereby enjoy more revenue.

To win over exhibitors who had their doubts about IMAX's financial stability, the company devised a joint venture scheme whereby the company assumed the expense of the digital theatre system, which cost about $500,000, if a theatre paid to retrofit an auditorium, reconfigure the seats and enlarge the screen. The joint ventures allowed IMAX to collect nearly half of the box-office gross, plus a cut of the concession sales. IMAX fans complained that the digital screens in the multiplexes were considerably smaller than the vaunted IMAX screens in museums. Roger Ebert stated that the company should call the new MPX system 'IMAX Lite, IMAX Junior, MiniMAX or IMAX 2.0'. Nonetheless, the digital system allowed the company to expand. In December 2007, AMC agreed to convert 100 screens in thirty-three markets into IMAX's MPX theatres; in March 2008, Regal agreed to convert thirty-one screens in twenty markets. As of 2011, there were over 200 IMAX theatres with 3-D capability.

Among the pictures released in IMAX 3D were *Harry Potter and the Half Blood Prince*, *Cloudy with a Chance of Meatballs*, *A Christmas Carol* and *Avatar* in 2009 and *Alice in Wonderland*, *How To Train Your Dragon*, *Shrek Forever After* and *Toy Story 3* in 2010. By then, the company had staged a turnaround in its financial condition and was poised to expand in international markets, particularly China.

CONCLUSION

The transformation of the exhibition sector from multiplex to megaplex grew out of the economic boom of the 1990s, when easy credit made it possible for millions of Americans to buy high-end homes they couldn't otherwise afford. New homeowners typically transformed their TV rooms into home theatres with flatscreen TVs, surround sound and other high-tech accoutrements, including video game consoles. The DVD was the essential component of the system. Teenagers would always be going to the movies; the challenge facing exhibitors was how to lure families out of their homes. The megaplex, with its stadium seating, floor-to-ceiling screens and creature comforts, did the job. An unintended consequence of the multiplex boom was the obsolescence of conventional mall theatres, forcing the largest theatre chains into bankruptcy, the end result of which was a consolidation of the exhibition sector.

The megaplex retained its allure when exhibitors upgraded their screens to digital projection. The upgrade mostly benefited the majors, who saved millions by no longer having to handle physical prints. The majors initially passed on the cost savings to the largest theatre chains by helping them finance the conversion to digital. Smaller chains and independent houses had to find financing on their own if they wanted to go digital. Contrary to the media hype, digital projection itself did not revolutionise the moviegoing experience, as John Belton has argued, but digital projection made it possible for theatres to show films in 3-D, which they did.

Exhibitors and distributors have a symbiotic relationship, meaning they need one another to survive and prosper, but because the majors shouldered the risks of production financing and produced a constant flow of blockbusters, they continue to drive the business. Try as they might to generate additional revenue by converting to digital projection, by upgrading their concessions and by selling more advertising, exhibitors will remain totally dependent on a constant flow of popular movies from Hollywood for their livelihoods.

5

Ancillary Markets: Shattering Windows

At one time, feature films played in motion picture theatres almost exclusively. Beginning with the rise of commercial television in the 1950s, new media have extended the life of movies by creating ancillary markets. Hollywood fought them all initially, but inevitably found ways to absorb them as additional revenue streams. By the 90s, the distribution cycle for most titles went like this: a new film was first shown in theatres to allow for a protected worldwide rollout; it was then released to home video, video-on-demand (VOD), pay TV and, finally, to free TV.

In this model a motion picture is exploited in one window at a time, with the exception of home video, which remains open almost indefinitely. At each point in the distribution cycle, the price of the picture to the consumer drops. The process is known as 'price tiering' and can be explained as follows: movies are first shown in theatres to 'high-value' consumers, people who are the most eager to see new films and are thus willing to pay the top price for a ticket; movies are then released to 'lower-value' consumers at prices that decline with time. Thus a person willing to wait long enough could conceivably get to see a favourite film for 'free' on cable or network television. Distributing pictures in this manner allowed studios to tap every segment of the market in an orderly way and at a price commensurate with its demand.

This regimented distribution cycle broke down during the new millennium, the result of declining DVD sales, the demise of the retail video store and changing viewing habits brought about by new digital platforms that offered consumers the choice to watch movies anytime, anywhere, on any device. It would be hard to overestimate the impact of declining DVD sales on the

1 Theatrical	Release date to month 4
2 Home Video	Month 4–6
3 PPV/VOD	Month 6–9
4 Pay TV	Month 12–18
5 Free TV	Month 24–36

Table 5.1 The Traditional Distribution Windows in 2000

studios' bottom line. Until 2006, the peak year of the DVD market, Hollywood studios expected their pictures to break even during the initial theatrical release and looked to home video for the profits. Expectations changed afterwards; the studios' new goal was to discover ways to offset the DVD deficit, a difficult task given the resistance of the National Association of Theater Owners (NATO) to any change in the distribution cycle that might threaten the theatres' protected status.

EVOLUTION OF THE DISTRIBUTION CYCLE
Home Video
Home video became the main engine of growth for the majors beginning in the 1980s. At first they resisted the new technology by taking the equipment manufacturers to court, claiming that videotaping films from broadcast television violated their copyright. The Supreme Court ruled against them, however, saying that VCR owners have the right to make copies for personal use. VCRs soon became standard equipment in most American homes and the studios began to market their films to a growing home video audience. By 1989, revenue from the sale and rental of videocassettes was more than double the domestic box office.

Originally, the majors believed that the only logical way to market videocassettes was direct sales, reasoning that people wanted to buy and 'library' cassettes in much the same way as record albums. However, the average consumer preferred to rent films from video and convenience stores. In its struggle to extract the most revenue from the burgeoning rental market, the majors formulated a successful pricing strategy for its software. For the first six months after a new title went on sale, it would be priced relatively high on the assumption the overwhelming majority of transactions would consist of sales to video shops for rental purposes. Then, as demand began to ebb, the same title would be reissued at a much lower price to generate direct sales to consumers. Although the strategy enriched the coffers of the studios and lowered the risks of production financing, the bricks-and-mortar shops dominated the business.

By 1995, the VHS home video market had matured; 86 per cent of the 100 million households in the USA with televisions had VCRs. With the advent of the DVD in 1997, the home video market got a new lease on life. Within four years some 15 million households had DVD players, and with the price of machines dropping, they would soon render the VCR obsolete. New titles on DVD were released to consumers four to six months after the theatrical release, the same as for videocassettes. But as consumers switched to DVDs, direct sales outpaced movie rentals as a revenue source and home video became a seller's market. In 2000, for example, consumers spent over $10 billion to rent

videocassettes and DVDs. Of that amount, the studios kept only about 25 per cent, or around $2.5 billion. But of the $10.8 billion that consumers spent to purchase videocassettes and DVDs, the studios kept a full 75 per cent – or $8.2 billion. By then, home video accounted for around 40 per cent of the total revenue for a major studio release. By 2007, home video sales from new releases and from library titles accounted for nearly half of a studio's total revenue; the other sources being theatrical (21.4 per cent), free TV (12.9 per cent), pay TV (8.4 per cent), licensing (6.6 per cent) and pay-per-view (PPV) (2.0 per cent).

Home video generated extraordinary profits for the majors. As Stephen R. Greenwald and Paula Landry point out,

> Studios historically have reported film revenue from home video and DVD distribution on a royalty basis. This means that for every dollar of gross receipts to the distributor from these sources, only a fraction, equal to the royalty rate, is reported as gross receipts to profit participants. Then, the distributor will charge a distribution fee on that amount of receipts. (Greenwald and Landry, 2009, pp. 159–60)

The practice originated in the days when studios outsourced the manufacture and distribution of their videocassettes. After the studios assumed these functions, they retained the accounting practice even though it was unfair to their producing partners and profit participants.

DVD sales and rentals peaked at just over $24 billion in 2006 and have declined ever since. At the peak, nearly 23,000 video stores were in business in the USA; by 2010, fewer than 10,000 stores remained open, the result of competition from Netflix and Redbox. In that year Blockbuster, the largest video chain in the world, filed for bankruptcy protection, and Movie Gallery, the second-largest, closed up shop. It was predicted that within a few years, only around 4,000 stores would survive. High-definition DVDs were supposed to revive the business, but a format war between Sony's Blu-ray and Toshiba's HD-DVD, beginning in 2006, kept customers at bay until a unified market had been created. The format war ended in February 2008, when Toshiba acknowledged defeat. Although Blue-ray disc sales picked up afterwards, they failed to reverse the trend. As reported by the *Economist* in 2011, 'the overall home-entertainment market stands at 78% of its peak level, even before adjusting for inflation. Few think the drop is over. And nobody appears to believe that the market will recover the heights of five years ago. "In retrospect, that was a bubble," said market analyst Tom Adams of *IHS Screen Digest*' ('Unkind Unwind', 2011).

Pay TV

Another important revenue stream for the major studios is pay televison, which came into its own in 1975, when Home Box Office (HBO), a Time Inc. company, staked its future on RCA's domestic satellite SATCOM I and offered recent, uncut and uninterrupted films, sports events and other specially produced programming to its cable subscribers. After successfully fighting FCC regulations designed to protect 'free' broadcast television, HBO programmed a continuous supply of differentiated programming, that is, product available nowhere else on television. For this service, HBO charged a monthly fee rather than a separate fee for each attraction. Today, pay TV encompasses premium channels like Showtime/The Movie Channel (owned by Viacom) and Starz/Encore (owned by Liberty Media), in addition to Time Warner's HBO/Cinemax channels.

Pay TV has long been a lucrative revenue source for the majors. To protect the window, studios have offered their new releases to the premium channels about twelve months after they opened in theatres. In dealing with the majors, pay TV services contracted for the entire annual output of a studio. The output deals allowed a service to show each film a fixed number of times on all platforms during the duration of the contract, which could last as long as eight years. Output deals worked for the studio because they offered 'the security of knowing it has a constant income stream regardless of the performance fluctuation of its slate. When financing a picture, it is not an insignificant element that the studios can count on a secure sale.' Output deals work for the pay service because of its need 'to fill up a 24/7 schedule, catering to an audience that is constantly expecting something new, and to an extent different than they may have selected on their own. The great benefit of a dominant pay service is that it shows everything' (Ulin, 2010, pp. 261, 262).

Free Television

The free television window today includes network TV, cable TV and syndication, and opens around two years after the pay TV window. Although the networks steadily lost ground to cable channels, superstations and VCRs, beginning in the 1980s, they still delivered the largest television audience. Studios license their pictures to free television in packages comprising twenty-five and more titles. Packages usually contain a few top hits and many lesser titles. At first, they were licensed sequentially to network TV first, then to cable TV and, finally, to local stations, but over time packages simply went to the highest bidders.

BLOCKBUSTER AND THE RISE AND DECLINE OF THE VIDEO STORE

Blockbuster was the handiwork of Wayne Huizenga, an entrepreneur who built his Waste Management disposal business into a Fortune 500 company. In 1987, Huizenga bought Blockbuster, a nineteen-store video chain in Dallas, and eventually grew it into a retailing giant with more than 3,500 stores in forty-eight states. In 1994, Blockbuster was acquired by Viacom for $8.4 billion. By then, there was 'a Blockbuster store within a 10-minute drive of most American neighborhoods' (Fabrikant, 1995b). Viacom had engaged in a bitter struggle to take over Paramount and needed Blockbuster's cash flow to finance its bid. Besides the rental revenue that it split with the studios, Blockbuster made much of its money collecting late fees from its customers.

To grow the business, Viacom chief Sumner Redstone expanded Blockbuster abroad and negotiated a revenue-sharing sales plan with major film distributors, which enabled Blockbuster to purchase new releases at a lower wholesale price in return for a share of the profits from the rentals. This arrangement meant that Blockbuster could greatly enlarge its inventory of hit titles to stimulate consumer demand.

In 2004, Viacom restructured its business to concentrate on producing content and therefore reassessed its ownership of Blockbuster. The video division lost nearly $1 billion in 2003 on revenues of $5.9 billion and its market value had dropped from $8.4 billion, the price Viacom paid for it ten years earlier, to less than $3 billion. The following year, Viacom sold the company to a group of equity investors. Under new owners, Blockbuster hoped to win back customers by offering an online DVD rental business similar to Netflix's mail service. Then, in 2007, it introduced an on online streaming service, à la Netflix. It did this simply by acquiring Movielink, a VOD service launched by the Hollywood majors back in 2002. And, finally, Blockbuster introduced a 'No Late Fees' programme, and, with the help of Warner, Fox and Sony, started offering new titles twenty-eight days ahead of Netflix and Redbox. The help came at a cost, of course. To take advantage of the 'Blockbuster window', the company had to 'charge five times the price for a movie that Redbox charges, a cost difference that some analysts do not think is much of an advantage at all' (Sanati, 2010).

Unable to fend off the likes of Netflix and Redbox, Blockbuster filed for bankruptcy protection in 2010. The chain had been reduced to around 3,000 stores in the USA and plans were in place to close up to half of them. Blockbuster was sold at bankruptcy auction in April 2011 to Dish Network, a satellite television company. The following September, Blockbuster again challenged Netflix by introducing a streaming and DVD-by-mail service called Blockbuster Movie Pass to Dish Network subscribers. 'The announcement

A Blockbuster store closing

came as Netflix stumbled with an unpopular price increase and other missteps that sent the company's shares tumbling 50 per cent in two months' ('Blockbuster to Introduce Streaming via Dish Network', 2011). This controversy raised doubts about the road ahead for both Blockbuster and Netflix.

Netflix

Netflix was co-founded in 1997 by Reed Hastings, a former software executive, now the CEO of the company. Based in Los Gatos, California, Netflix went head to head with Blockbuster and the retail home video business. Netflix acquired DVDs as soon as they went on sale to the public and, for a modest monthly fee, offered subscribers a huge library of movies on DVD by mail, which eliminated a trip to the video store, and allowed them to keep the films as long as they wanted. The plan soon caught on, and the company went public in 2002.

By 2007, broadband internet connections had become widely available to US households, so Netflix began to shift its emphasis to online streaming. As *Variety* described it, Netlix wanted to 'overhaul the nature of its business – eschewing the mail for more cost-effective streaming video – and possibly to rewrite showbiz's long-held rules for film and TV distribution'. 'It's not hard to understand why,' it added. 'To send and have a DVD returned, Netflix pays 90 cents – but it costs the service a nickel to stream a movie' (Lowry, 2010). Netflix initially gave away its streaming service to existing customers, a move that lowered subscriber turnover and helped fund future content acquisitions.

Netflix introduced a streaming only subscription video-on-demand (SVOD) service in November 2010, which allowed subscribers unlimited downloads of movies and TV shows for $7.99 a month. The regular DVD plan, which cost almost twice as much, allowed subscribers to have three discs out at a time, sent through the mail, plus unlimited downloads. 'For studios that only a few years ago were selling new DVDs for $30, that represents a huge drop in profits,'

reported the *New York Times* (Arango and Carr, 2010). To protect their flagging DVD sales, Warner Bros., Fox and Universal struck deals with Netflix which allowed the company to stream more old movies and TV shows if it waited twenty-eight days after the release of a new DVD before making it available to subscribers. Netflix's profits and revenues nearly doubled by 2010, along with its online streaming audience. Its service worked not only on Windows PCs, but also on myriad devices, including game consoles and internet TV set-top boxes like Roku and Apple TV.

Initially, Netflix's catalogue of internet titles abounded in older movies, but relatively few newer titles. The obstacle was pay TV. Premium channels like HBO and Showtime had exclusive subscription rights to its pictures on all platforms, including the internet, with the result that they refused to let Netflix stream movies during the periods it controlled the rights, which could be as long as eight years.

In 2008, Netflix partially solved the problem by striking a deal with Starz, a premium channel owned by John Malone's Liberty Media, which had output deals with Disney and Sony Pictures. For the price of $30 million per year, Netflix acquired the streaming rights to Starz's library during the pay TV window. It was a bargain because only a few tech-savvy young people were watching online video at the time. As the online audience grew, however, distributors began to drive harder bargains when negotiating deals. In 2010, Netflix was forced to spend substantially more – nearly $1 billion – to acquire the streaming rights of the fledgling premium channel Epix for five years. A joint venture of Paramount Pictures, Metro-Goldwyn-Mayer and Lionsgate, Epix had hoped to go up against HBO and Showtime, which had long dominated the premium pay TV business. Epix debuted in October 2009, armed with more than 3,000 titles from the libraries of the three studios. As part of the Epix deal, Netflix acquired the right to stream the new releases of the three studios ninety days after they premiered on the premium channel.

After four years of sustained growth, Netflix ran into trouble with its customers. In July 2011, Reed Hastings introduced a new pricing structure which separated its streaming and DVD-by-mail services and charged subscribers $8.00 a month for the streaming service and $8–18 for the DVD, depending on how many discs a customer rented. The decision required customers to manage two separate accounts and represented a 60 per cent increase over the original plan. Nearly 400,000 customers immediately deserted the company, and Netflix's stock price fell by half. In September, Hastings introduced a revised plan, which was also rejected by the public. In the end, he kept the price increase and left the two services as they were under one website. 'Rather than ignore change,' said Sidney Finkelstein,

Hastings wanted to increase the viability of the newer streaming business by removing it from the traditional business that it was meant to usurp. Unfortunately, he also decided to aggressively increase prices, complicate the customer experience and then partially backtrack on the whole thing when an onslaught of bad press ensued. In an instant, Netflix went from beloved icon of innovation to just another big, bad company ripping off customers, and the company's stock is down almost 70 per cent.

Finkelstein added,

Unfortunately, Netflix has even bigger problems than customer outrage at price increases. It has no proprietary technology, is facing numerous well-financed competitors like Amazon, Google and the cable and satellite companies and no longer has sweetheart deals to buy content from movie studios, which were eager for another player to step in. It may turn out that Netflix becomes the next Blockbuster in good times, and bad. (Finkelstein, 2011)

Redbox

The fastest-growing new entrant to the DVD rental business during the 2000s was Redbox, which originated as an experiment by the McDonald's restaurant chain to expand beyond burgers. By installing vending machines in its restaurants offering recent movies for $1-a-night, McDonald's hoped to attract more customers, especially in the evening. McDonald's partner in the venture was Coinstar, a coin-counting machine company with a presence in the front end of grocery and discount stores. Mitch Lowe, a founder of Netflix, introduced the concept to McDonald's when he joined the company's business development group in 2002. Lowe was appointed chief operating officer (COO) of the venture in 2005, and grew Redbox from a handful of DVD rental kiosks to 31,000 locations in supermarkets, Wal-Mart stores, shopping malls and fast-food restaurants nationwide.

Redbox followed a traditional small-business model, buying discs wholesale and making a profit on repeat rentals. Although it charged only $1 per rental, it could still make money because of its low overheads. Redbox targeted families on a budget, and offered them easy access to the latest mainstream DVDs where they shop. Netflix had the competitive advantage of having 100,000 titles ready to go, compared to the 200 titles in Redbox machines. Netflix, however, had to pay postage twice for every DVD it rented out. It did best when customers chose ambitious subscription plans and were slow to return discs. Redbox did best when it rented each disc as many times as possible before interest in the movie waned.

A ubiquitous Redbox retail kiosk

In an effort to prevent Redbox rentals from cannibalising DVD sales, the majors held back their new releases to Redbox for twenty-eight days after they arrived in stores. Redbox countered by filing antitrust suits against Warner Bros., Universal and Fox in 2008. They settled in early 2010; Redbox agreed to abide by the twenty-eight-day window, a victory for the three studios, but, in return, the studios allowed Redbox to purchase DVDs directly from the studios themselves instead of from retailers and at a reduced price. Leery of waging their own legal battles, Sony and Paramount signed revenue-sharing agreements with Redbox while making their DVD releases available the same day they hit the retail stores. Walt Disney, all along, allowed third-party distributors to sell to Redbox as they saw fit.

Coinstar acquired Redbox outright in 2009, buying out McDonald's and the other investors for $175 million. Although Redbox had captured about a third of the DVD rental market by 2011, its business seemed to have peaked, as video streaming took hold. Pressures from these new competitors and from the major studios could threaten the future of low-cost vending-machine rentals.

DISRUPTING THE DISTRIBUTION CYCLE

Yet, Hollywood somehow had to find ways to make up for declining DVD sales. In so doing, it conducted a series of experiments to wring more revenue from ancillary markets – experiments that threatened to alter the traditional distribution cycle that protected exhibitors.

PPV/VOD

Pay-per-view had been around since the 1950s and for most of its life had been associated with special events such as championship boxing and rock concerts. By the 1990s, cable TV subscriptions had plateaued and the industry was searching for new ways to generate revenue. Adding movies was an obvious option. To

accomplish this, cable operators invested billions to upgrade their systems and to install set-top boxes in homes. The upgrade allowed cable operators to offer subscribers near-video-on-demand, with a choice of PPV movies beginning each half hour. But PPV never got off the ground. Home video was still generating billions a year in rentals and sell-throughs and the majors protected this valuable asset with a thirty- to sixty-day window.

But conditions changed in the new millennium; on-demand services, which allowed consumers to view movies when they wanted and not on a predetermined schedule, took on a new allure. Comcast, the largest cable operator in the country, led the way. To protects its on-demand channels from Redbox and Netflix, in 2005 Comcast began spending billions to acquire older titles from the majors for its new on-demand service, MoviePass. Comcast offered the service free to subscribers as a way to entice them to install the improved set-top boxes. Within a year, 30 million cable homes were able to order up movies on-demand.

Comcast then tried to expand to new titles, but needed to reassure the studios that VOD would not cannibalise other release windows. Comcast ran tests in selected markets to determine if the release of a new picture on VOD would cut into the simultaneous release on DVD. Warner Bros. conducted similar tests as well and discovered that it didn't. The tests showed that consumers who intended to buy a new release on DVD would do so whether or not it was shown on VOD, and VOD customers were typically not interested in purchasing a DVD.

Warner Bros., in 2006, was the first major studio to release all of its films simultaneously on DVD and VOD. Other studios followed suit and, by 2008, the window took on new life. Though not as lucrative as a DVD sale, which returned as much as $17 to a studio, a VOD purchase returned around $5 and more. Disc rentals from Redbox, in comparison, returned around 30 cents from each $1 transaction. Studios released their weaker titles in the new window at first, believing they 'were less likely to be purchased by consumers', but blockbusters were soon included as well. Comcast, for its part, was offering more than 100 titles a year day-and-date with DVD releases by 2010 (Graser, 2010d).

In March 2010, the majors and top independents partnered with Comcast, Cox Communications, Time Warner Cable and other cable operators to launch a $30 million advertising campaign called 'The Video Store Just Moved In'. 'It's the first time rival studios have come together to push consumers to rent more movies via their cable boxes,' noted the *New York Times*. *The Blind Side* topped the VOD roster that year. By 2011, VOD accounted for about a quarter of the $8 billion consumers spent on video rentals.

Premium VOD

The majors believed there was even greater promise in premium video-on-demand. After successfully petitioning the Federal Communications Commission to approve a new copy-blocking technology, 20th Century-Fox, Sony Pictures, Universal Pictures and Warner Bros. partnered with Direct TV, the satellite service, to test premium VOD, which would allow consumers to watch select new movies at home using special set-top boxes two months after their theatrical release – in the middle of the traditional theatrical window – for $29.99 a shot. Since a studio's cut would be 80 per cent of each transaction, premium VOD was thought to be the most effective way to offset the decline in DVD sales.

Direct TV launched the premium service on 21 April 2011with a select group of pictures, despite strong objections from the National Association of Theater Owners, which maintained its stand against any plan that directly competed with the existing theatrical window. 'Even a slight nudge toward additional home viewing might help to break frequent movie-goers of their habit', it claimed, 'and jeopardize the $10 billion-a-year box office – just as they are being enticed by big 3-D events like *Avatar*' (Cieply, 2010b).

The studios countered by noting that 90 per cent of the box office is generated the first four weeks of release. Studios had tested the theatrical window twice before: in 2009, Sony Pictures made *Cloudy with a Chance of Meatballs* available for rent to owners of internet-connected Bravia televisions a month before it was available on DVD; and, in 2010, Disney released the *Alice in Wonderland* on DVD a month earlier than usual. Both times, NATO held back and some theatres even refused to play the films. Oddly, independent distributors like IFC Films and Magnolia Pictures had been making new films available on VOD day-and-date with the theatrical release for some time without raising the hackles of exhibitors. But their pictures had only limited theatrical potential, and the day-and-date release was just a way to increase awareness in ancillary markets. A theatrical release, no matter how limited, garnered reviews, which provided publicity hooks to attract viewers. NATO was more concerned with the impact on blockbusters.

Despite the brouhaha over premium VOD, consumer response to the test was tepid, in part because the initial titles offered on the service 'were not particularly popular at the box office' and because both Direct TV and the studios themselves failed to promote the new early release service aggressively (Fritz, 2011). The jury was still out on premium VOD according to some studio chiefs, and the plan was to repeat the experiment at a later time on the major cable systems, which were capable of generating a larger audience sample than Direct TV's satellite service.

Digital Video-on-Demand

Still to be exploited was digital video-on-demand (DVOD), the preferred route to younger consumers who wanted to access movies anytime, anywhere, on platforms ranging from internet-connected televisions to personal computers, tablets, video game consoles, smartphones and other devices. Besides Netflix's Watch Instantly service, improved broadband technology supported Apple's iTunes, Amazon on Demand, Microsoft's Xbox Live Marketplace, Wal-Mart's Vudu, Sony's PlayStation Network and Best Buy's CinemaNow, which offered consumers movies-on-demand and download-to-own. The majors all adopted the same goal: 'being ubiquitous on whatever device you want to watch movies and TV episodes on' (Graser and Autt, 2010).

Buying movies in digital form proved to be unpopular at first because they were both expensive and downloadable only to a single device, unlike a disc which can be moved from a DVD player, to the car or to the bedroom. Ever desperate to recoup home video sales, the majors, in 2011, backed Warner Bros. Home Entertainment's free cloud-based service called UltraViolet. With UltraViolet, consumers could access digital copies of films they purchased from a server 'in the cloud'. UltraViolet was a technology available on Flixster, Warner's recently purchased social network for movie fans, which 'allows people to buy a movie once and watch it anywhere – on a computer, mobile device or Web-ready television'. According to the *New York Times*'s Brooks Barnes, 'The strategy is to make owning more compelling than renting by loading digital portability into purchases' (Barnes, 2011a). The profit margins told all; Kevin Tsujihara, president of Warner Home Entertainment Group, explained that 'a transactional VOD rental [on pay TV] is seven times more profitable to Warner than a kiosk or rental subscription; and a sellthrough transaction is 20 to 30 times more profitable than a kiosk or rental subscription' (Gruenwedel, 2012).

CONCLUSION

Motion picture theatres have enjoyed protected status in the distribution chain ever since network television became the first ancillary market for feature films. The arrival of pay TV and home video did nothing to alter this status. New movies moved through the distribution chain like clockwork, and Hollywood profited from the added revenue. Declining DVD sales and competition from product substitutes threatened to disrupt the distribution cycle. To recoup losses from the home video market, studios looked to new sources of revenue. They buttressed VOD on cable by offering cable operators new releases day-and-date with their home video release. Next, studios briefly experimented with premium VOD by offering new releases to satellite customers midway through the theatrical run at premium prices. More recently, studios backed Warner Home

Entertainment's experiment which allowed consumers to purchase or rent movies by streaming them from a cloud. This web-based service offered piracy protection and, especially, convenience. As the *Economist* has conjectured,

> Every time Hollywood has offered people a more convenient way to get its films, sales have leapt. Bringing movies into the home via television, VHS and DVD built the industry into what it is today. The internet may look unfamiliar and dangerous, but it could be the ultimate home-entertainment weapon. No trip to a thinly stocked retailer, no late fees, no waiting for a package in the post; instead, on-demand access to any film you want, from the latest blockbuster to the most obscure art-house tear-jerker. Because distribution costs mostly go away, online sales are more profitable too. The internet is the industry's best hope for future revenue growth. The rightful successor to the DVD is not Blu-ray or anything else. It is the web. ('Hollywood and the Internet', 2008)

However, to fully exploit the commercial potential of the web, Hollywood will somehow first have to deal with the 'I want it for free' consumer, to say nothing about piracy risks.

6

Independents: 'To the Rear of the Back End'

The independent film market is headquartered in New York City and is run by numerous small distributors who typically acquire their pictures as pickups at film festivals. The term 'independent' has meant different things at different times in film history. During the 1950s and 60s, it designated mainstream films financed by a major studio and made by outside producers, be they former studio directors and stars, creative producers or talent agents. During the same period, the term was also used to describe the works of avant-garde film-makers whose films played mainly in museums and film festivals. And from the start, an independent film meant a self-financed film without any support from a distribution company. Michael Barker, co-president of Sony Pictures Classics, ventured this definition of the term: 'Such films – not movies', he said, are 'character- and script-driven works, usually gritty, avoiding spectacle and often written and directed by the same person, like John Cassavetes's *Woman Under the Influence.*' He added, 'No matter the provenance or budget, the films appear to share certain characteristics. "I tend to think of it as a film that gives artistic freedom to filmmakers, and the distribution grows slowly into wide release"' ('The Meaning of "Indie"', 2005). By the 80s, a typical independent feature of this sort cost well under $1 million on average and utilised small crews (non-union), lightweight equipment, direct sound, location shooting and often nonprofessional actors. Thousands of independent pictures were being submitted annually to the Sundance Film Festival, and only a lucky few found their way into theatres. By the 90s, journalists and film-makers were applying the term to the prestige releases of the majors' speciality divisions, companies such as Sony Pictures Classics, Miramax, Fox Searchlight and Focus Films, even though a picture like Anthony Minghella's *The English Patient* (1996), which won multiple Oscars including Best Picture, cost Miramax $32 million to produce.

From 2000 to 2005, independent films regularly accounted for around 25 per cent of the domestic box office, but by the end of the decade the figure had fallen to around 18 per cent. The independent film scene had changed in fundamental ways, which led to closing of the speciality divisions of the majors and

the demise of scores of indie outfits. The indie films that found distribution confronted escalating advertising costs, competition for theatre space from the tentpoles of the majors, and a foreign audience indifferent to most American indie films. James Schamus, the head of Universal's Focus Feature speciality unit, has aptly placed the independent film sector 'to the rear of the back end' of the film industry (Schamus, 1988, p. 91).

GROWTH OF THE INDIE MARKET

Today's independent film market has its roots in the go-go days of the 1980s. The growth of new television technologies generated a huge demand for content, which a new generation of film-makers was ready to fill. Independents like Atlantic Release, Carolco, New World, Hemdale, Troma, Island Alive, Vestron and New Line entered the business knowing that even a modest picture could recoup most of its costs from the pre-sale of distribution rights to the burgeoning pay-cable and home video markets. Pay TV, with its four national movie channels operating around the clock, created an enormous demand for fresh material. The sale of pay TV rights yielded anywhere from a few hundred thousand dollars to a million and more. Although these sums were insignificant compared to what a Hollywood blockbuster could fetch, such ancillary income for a low-budget picture might make the difference between profit and loss. And deals could be struck even for pictures that received little or no theatrical exposure. After pay TV reached a plateau, home video took off and provided independents another shot in the arm. However, the lure of presales had created a product glut by the late 80s. Marginal films – those judged unlikely to recoup print and advertising costs – were shelved; others were lucky if they got any playing time. Without national exposure or a theatrical run, few films found takers in the ancillary markets. As a result, many of the small independent outfits went bankrupt.

New Line Cinema

The survivors included New Line Cinema, Samuel Goldwyn Co. and Miramax. New Line was founded in 1967 by Bob Shaye, a twenty-five-year-old graduate of Columbia University School of Law. Based in New York City, New Line started out distributing foreign and art films to college campuses. It soon expanded into mainstream distribution with midnight movies (John Waters' *Pink Flamingos*, 1972), soft porn (*The Best of the New York Erotic Film Festival*, 1973), kung-fu pictures (*The Streetfighter*, 1974, starring Sonny Chiba) and art films (Pier Paolo Pasolini's *Medea*, 1969). In 1977, New Line expanded into film production. The plan was to 'make and distribute low-cost, low-risk films and carefully target them at specific audiences' ('Niche was Nice: New Plan –

Expand', 1992). With financing from New York's Chemical Bank and private investors, New Line capitalised on the renewed interest in horror and slasher films and financed a modestly priced *A Nightmare on Elm Street* (1984), a property that was rejected by rival studios. Featuring the creepy, razor-nailed Freddy Krueger, *Nightmare*, directed by Wes Craven, grossed over $25 million at the box office, spawned a successful franchise and propelled New Line to the top of the independent ranks.

New Line went public in 1986, a first for an independent studio, and raised $45 million in capital. Afterwards, the company released around a dozen pictures a year. In 1990, New Line scored another big hit when it picked up Steve Barron's *Teenage Mutant Ninja Turtles* after it had been rejected by 20th Century-Fox. New Line acquired the film for $3 million; it grossed more than $130 million to become the most successful independent release in US history. The profits from the *Nightmare* and *Ninja Turtles* pictures enabled New Line to form a subsidiary called Fine Line Features in 1990 to produce and distribute sophisticated fare for adults. Headed by marketing whiz Ira Deutchman, Fine Line carved a niche for itself by releasing American independent ventures such as Gus Van Sant's *My Own Private Idaho* (1991), Robert Altman's *The Player* (1992) and *Short Cuts* (1993), Jim Jarmusch's *Night on Earth* (1992) and Whit Stillman's *Barcelona* (1994), along with British ventures such as Derek Jarman's *Edward II* (1991), Hanif Kureishi's *London Kills Me* (1992), Charles Sturridge's *Where Angels Fear to Tread* (1992) and Mike Leigh's *Naked* (1993).

Sam Goldwyn

Following a different tack, the Samuel Goldwyn Co. evolved into a vertically integrated speciality company. Founded in 1980 by the son and namesake of Samuel Goldwyn as a distributor for the Goldwyn library of Hollywood film classics, the company expanded into the first-run art-film market by releasing British imports such as Bill Forsyth's *Gregory's Girl* (1982), Richard Eyre's *The Ploughman's Lunch* (1985), Alex Cox's *Sid and Nancy* (1986), Stephen Frears's *Prick Up Your Ears* (1987) and Kenneth Branaugh's *Henry V* (1989). After branching out into production briefly in the 80s, in 1991 Goldwyn acquired Landmark Theatres, a 125-screen art-house chain. The rationale for this acquisition was simple enough: if Goldwyn pictures stumbled, the company could make some money from whatever hits were playing in the art-film circuit.

In June 1995, Samuel Goldwyn Co., the industry's last true independent, disclosed a $20 million loss for the previous year. Brought down by a $62 million debt load from the acquisition of its Landmark Theatre chain and a string of costly film and TV failures, the company was put up for sale. In December 1995, Goldwyn was acquired by Metromedia International Group, an international

telecommuncations business run by billionaire John W. Kluge, the owner of the mini-major, Orion Pictures. Unable to successfully meld the film and television libraries of Goldwyn and Orion into his business, Kluge sold the two companies to Metro-Goldwyn-Mayer in April 1997 for $573 million.

Miramax

Miramax, the most famous company of the group, was founded in 1979 by Bob and Harvey Weinstein. Adopting a straight acquisition policy from the start, Miramax 'nurtured new talent, helped introduce American indie films to a broader audience and brought European and Asian filmmakers to US viewers' (Graser and McNary, 2010). Miramax emerged from the fringes of independent film distribution in 1989 when it released three big hits, Jim Sheridan's *My Left Foot*, which starred a then relatively unknown Daniel Day-Lewis; Steven Soderbergh's *sex, lies, and videotape*, which garnered writer-director Soderbergh the Palme d'Or at Cannes; and Giuseppe Tornatore's *Cinema Paradiso*, which won an Oscar for Best Foreign Language Film.

The ability of the Miramax brothers to generate free publicity became legendary. To ignite interest in a new release, a favourite tack of the company was to challenge the rating assigned to it by the Motion Picture Association of America and take advantage of the ensuing free publicity. Arguably the company's most creative efforts were devoted to the marketing campaign for *The Crying Game*. Miramax succeeded in making people want to see the film without knowing why. A British release with no major stars about the British–IRA conflict made the picture seemingly a hard sell to Americans. But it did have an unusual plot twist, involving the trans-sexual identity of a lead character, which Miramax exploited to create a *cause celebre* that rivalled the famous publicity campaign for Alfred Hitchcock's *Psycho* (1960). *The Crying Game* became a crossover hit. It also became a great critical success, receiving six Academy Award nominations, including best picture, and winning the Oscar for best screenplay for the writer and director, Neil Jordan. 'The industry was staggered by the response,' reported *Variety* (Fleming and Klady, 1993).

Acquiring a hit picture, Miramax was not above re-editing it to make it more accessible to American audiences. The controversial practice earned Harvey Weinstein the sobriquet 'Harvey Scissorhands', but the success of *Cinema Paradiso* (1988), *Farewell My Concubine* (1993) and *Like Water for Chocolate* (1992) was attributed to his snipping. Trimming fifteen minutes from the running time of *Like Water for Chocolate* helped it recoup its $2.5 million investment in a remarkably short time and set a new box-office record for a foreign-language film in the USA. Much of the box office came in from Spanish-language theatres in Latino neighbourhoods.

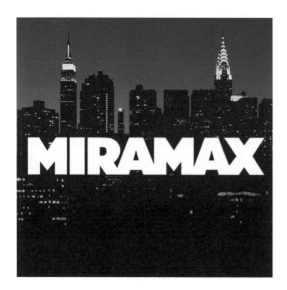

Miramax, the 'logo that brings audiences in on its own'

To protect itself from the volatility of the art-film market, Miramax released English-language pictures primarily and branched out into the genre market in 1992 by forming a new subsidiary, Dimension Pictures. Releasing such horror films as *Hellraiser 3: Hell on Earth* (1992) and *Children of the Corn II: The Final Sacrifice* (1992) allowed Miramax to break out of the art-house ghetto and profitably exploit the home video, TV and foreign markets. As will be explained below, the vitality of these three companies – Miramax, New Line and Goldwyn – convinced the majors to tap into the independent market by establishing speciality divisions of their own, beginning in the 1990s.

EXHIBITION

New York and Los Angeles are the main exhibition hubs for Indiewood films. New York is home to the Film Forum, IFC Center, Angelica Film Center, Lincoln Plaza Cinemas and Landmark Sunshine Theatres. Los Angeles supports fewer screens, among them the Nuart, the Landmark and the Laemmle Theatres art-house chain. Nationwide, around 400 screens programme specialised fare the year round. Among them are two theatre complexes operated by Robert Redford's Sundance Group, seventy-two screens in thirty-nine markets operated by AMC, and 224 screens in twenty-two markets operated by the Landmark Theatre Corporation.

Landmark, the largest art-house chain in the USA, is part of 2929 Entertainment, a holding company owned by Todd Wagner and Mark Cuban, two Dallas-based entrepreneurs who sold their internet company, called Broadcast.com, to Yahoo in 1999 and netted $5.7 billion. Landmark was founded in 1974 by Stephen Gilula, who acquired the Nuart Theatre in West

Los Angeles and houses in San Diego, Pasadena and Berkeley. Landmark adopted a 'repertory-style format' at first, but, after home video ate away business, switched to its current first-run exhibition policy. 'Landmark helped spawn the independent film movement,' said Anne Thompson, but it was a precarious business and the company experienced ownership changes beginning in 1982. Wagner and Cuban acquired the chain in 2003 after it exited bankruptcy. They upgraded and expanded the chain, first by installing digital projectors in some of their theatres well before the major chains made the conversion and, second, by providing 'a movie-going experience for adult audiences that they can't get at home'. Setting the new standard were three new multiplexes the company opened in Los Angeles, Denver and Baltimore. The largest was the twelve-screen multiplex located in the Westside Pavilion shopping mall in Los Angeles. It cost $20 million to build and featured such amenities as upscale concessions, wine bar, stadium seating with leather sofas, and reserved seats, placing it on a par with the luxury theatres specialising in mainstream fare (Mohr, 2007a).

FILM FESTIVALS

Indie film-makers secure distribution for their pictures four ways: by preselling their projects in the package stage if they contain 'name' elements; by selling their completed pictures at film festivals and markets; by negotiating one-on-one with distributors; or by going down the route of self-distribution. Most take the film festival route, but only a small percentage of submissions make the cut and an even smaller number are picked up by a distributor.

There are now nearly 1,000 film festivals in North America, and the number is growing. With only a few exceptions, these festivals are retailers in the sense that they bring films to their regions that have had their premieres at one of the top international film festivals, such as Cannes, Venice, Berlin, Tokyo and Shanghai. These festivals are classified by the International Federation of Film Producers Association as competitive, which is to say, they are juried festivals for invited pictures that receive their world premieres at the festival. These top-tier events confer prestigious awards and they are attended by an international press contingent, enthusiastic audiences and industry reps from around the world.

Sundance and Toronto have long remained the major launching pads in North America for independent pictures. Sundance is the leading showcase for 'hot young indie talent' and Toronto for Oscar contenders. Recently they have been joined by New York's Tribeca Film Festival and Austin's South by Southwest Festival. Launched in 1976, the Toronto International Film Festival is the largest film festival in North America and an important marketplace for speciality product. The noncompetitive event is held in September to lead off the Oscar race and screens more than 300 films from around the world over ten days. About

half of the films selected receive their world or North American premieres at Toronto. The festival is attended by over 250,000 people. 'Toronto has always been the best launching pad for a movie of any festival in the world,' said Tom Bernard, co-president of Sony Pictures Classics.

> It's like a big press junket that the newspapers have paid for themselves. So we can bring in our talent, screen our movies with very favorable audiences and make the talent available for newspapers all over North America. The Sundance festival is more of an industry audience. The New York festival is much more, well, they're patrons of the arts, not your mainstream filmgoer. But the Toronto audience is real moviegoers. They get every nuance, and they love movies. (Lyman, 2000)

Some of the pictures that originally put Toronto on the map were Jean-Jacques Beineix's *Diva* (1981), Hugh Hudson's *Chariots of Fire* (1981), Lawrence Kasdan's *The Big Chill* (1983), Michael Moore's indie documentary *Roger and Me* (1989), Robert Duvall's *The Apostle* (1997), Roberto Benigni's *Life Is Beautiful* (1998) and Sam Mendes's *American Beauty*.

The Tribeca Film Festival was founded in 2002 by Jane Rosenthal, her husband Craig Hatkoff and her business partner Robert De Niro to help revive Lower Manhattan after the 9/11 terror attacks. The event is held in April and screens around 120 mostly new works over ten days. Tribeca has two competitions – world narrative and world documentary – and passes out $100,000 in prize money. In 2009, the festival hired Geoffrey Gilmore, the long-time director of the Sundance Film Festival, to head the festival. Gilmore was charged with finding or creating 'distribution channels for the many independent films that are seen at festivals but often fail to get a commercial release' (Cieply, 2009b). One of Gilmore's first efforts was to find VOD outlets on cable and online for Tribeca's pictures.

South by Southwest, which takes place in March each year, is an outgrowth of the popular SXSW music festival. Like Tribeca, it showcases American indie and international cinema of all different genres. And like Tribeca, it has competitions for films that receive world premieres at the festival. Although SXSW began showing films in 1994, it did not attract much notice in the indie field until 2011, when important buyers from around the world showed up to consider the offerings. Submissions were up considerably in 2011 and it is likely the festival will grow in stature.

Sundance

The Sundance Film Festival, located in Park City, Utah, has functioned as the premiere showcase for American independent cinema since its founding in

Sundance Film Festival, the preeminent showcase for American independent cinema

1978. The festival was originally called the US Film Festival and was located in Salt Lake City. Robert Redford's Sundance Institute acquired the festival in 1985 and moved it to its present, smaller location. The festival took its present name in 1989. Geoffrey Gilmore served as director of the festival from 1990 to 2009, when he resigned to take charge of the Tribeca Film Festival in New York and was succeeded by John Cooper.

At the start, Sundance was what *Variety*'s Todd McCarthy called 'a homey, unstressful affair at Park City that lured unslick and often unwashed film makers, and only those critics and journalists deeply committed to regional, largely uncommercial cinema' (quoted in Weinraub, 1998). The films originally shown in competition were restricted to American independent pictures having their world premiere at Sundance. Grand Jury Prizes were awarded in two categories, dramatic and documentary. The competition later encompassed world cinema and shorts. Around sixteen films competed in each category annually. The competition eventually recognised excellence in directing, acting, cinematography, editing and screenwriting as well. Early on, the audience participated in the competition, selecting by ballot the Audience Awards in the major categories. The award came to be seen as a harbinger of commercial potential. Rounding out the festival were new films from around the world that were shown out of competition. By the 1990s, over 1,000 dramatic features were being submitted for consideration annually, and around a hundred were screened. With the advent of digital cinema, annual submissions regularly numbered nearly 4,000. Today, the annual festival attracts more than 20,000 filmgoers as well as hundreds of journalists, critics and media people hungry for stories. To extend Sundance's reach, Robert Redford's Sundance Institute launched the Sundance pay channel in 1994 as a brand to showcase top indie films.

As A. O. Scott put it, 'The classic indie legends of the late 80's [sic] and early 90's [sic] [at Sundance] involved film-school graduates (or dropouts, or rejects)

who maxed out their credit cards, borrowed equipment, conscripted friends and launched their careers with scrappy, personal movies' (Scott, 2004). Here are some of the festival highlights in the dramatic category. In 1985, the Coen brothers debut film *Blood Simple* received the Grand Jury Prize, and Jim Jarmusch's *Stranger Than Paradise* won a Special Jury Prize. In 1989, Steven Soderbergh's *sex, lies, and videotape* won the Audience Award and went on to win the Palme d'Or at Cannes and great commercial success at the hands of Miramax. In 1992, Quentin Tarantino's *Reservoir Dogs* was picked up by Miramax; it earned more than $2 million at the box office and established Tarantino's reputation as a 'significant American auteur'. In 1993, Robert Rodriguez's *El Mariachi*, a micro-budget Mexican/US co-production, won the Audience Award and was picked up for distribution by Columbia Pictures. It was released subtitled and earned about $2 million in theatres. In 1994, Kevin Smith's *Clerks*, another micro-budget picture, won the Film-makers' Trophy and was snatched up by Miramax; it grossed more than $3 million theatrically. There followed Ed Burns's *The Brothers McMullen* and Todd Solondz's *Welcome to the Dollhouse*, which won Grand Jury Prizes in 1995 and 1996, respectively, and Darren Aronofsky's *Pi*, which won the Directing Award in 1998. In 1999, Daniel Myrick and Eduardo Sanchez's *The Blair Witch Project*, a low-budget horror film playing out of competition, set a Sundance record by earning $249 million worldwide. The documentary highlights include Michael Moore's *Roger & Me* (1990), Errol Morris's *A Brief History of Time* (1992), Steve James's *Hoop Dreams* (1994), Terry Zwigoff's *Crumb* (1995) and Morgan Spurlock's *Super Size Me* (2004).

What started out as showcase for artists inevitably became a market. The transformation began in 1989, when *sex, lies, and videotape* became a surprise commercial hit grossing $65 million. The transformation was complete in 1994, when a film by a Sundance alumnus and another by a foreign director – Quentin Tarantino's *Pulp Fiction* (Miramax) and Mike Newell's *Four Weddings and a Funeral* (Gramercy) – each grossed over $200 million worldwide. The belief that there were potential gold mines to be found at Sundance led the majors to move forcefully into the independent film market by either buying exiting independent companies or opening speciality divisions of their own. Thus, studio executives, independent distributors, talent agents and producers' representatives descended on Park City prepared to buy. Winning an award often meant an instant distribution deal. By 1997, Sundance shifted from being a place to discover films to a place for commerce. In that year, twenty-five of the 104 films that played the festival already had their distribution in place by Miramax, Fine Line, Gramercy, Fox Searchlight and others. The average purchase price for negative pickup deals hovered between $400,000 and $800,000. Some films

fetched $1 million and more. Fox Searchlight paid $10.5 million to acquire *Little Miss Sunshine* in 2006, a record for Sundance, but it paid off; the picture grossed more than $60 million domestic.

The *Little Miss Sunshine* deal was brokered by a new type of player in the business, the sales agent – in this case, John Schloss, the New York lawyer who founded Cinetic Media in 2001 to search out small movies with commercial potential and sell them at Sundance and other film festivals. In return for its services, which sometimes included financing, the company took a percentage of the money paid to a film-maker when her picture was picked up for distribution (Kennedy, 2005). Having said that, the vast majority of the pictures shown at Sundance every year found no takers. However, some did appear on cable or pay TV and others went directly into home video.

The intense competition to get into Sundance inevitably led to an alternative festival. This occurred in 1995, when a group of young film-makers who were rejected by Sundance – Jon Fitzgerald, Shane Kuhn and Dan Mirvish – founded Slamdance. Slamdance takes place the same time as Sundance and in the same location, Park City, Utah. Like Sundance, Slamdance initially showed films in competition in two categories, narrative features and documentary, as well as an out-of-competition lineup. Unlike Sundance, which employed programmers to select the entries, Slamdance's 'founding philosophy was that the festival selections would be programmed largely by filmmakers and always by committee' (Rabinowitz, 2009). Slamdance received 450 submissions in 1996, mostly micro-budget entries costing under $200,000 to produce. That year, *The Daytrippers*, an offbeat comedy produced by Steven Soderbergh and directed by Greg Mottola, won the festival's first Grand Jury Prize – and later, an invitation to Cannes. In 1997, Slamdance became a year-round operation with offices in Los Angeles. In 2010, it received a record 5,000 submissions.

Slamdance and Sundance have coexisted peacefully. Like its upscale counterpart, Slamdance helped launch the careers of prominent mainstream directors, such as Christopher Nolan and Marc Forster – directors of the *Batman* trilogy and the James Bond feature, *Quantum of Solace* (2008), respectively. Its other alumni and their films include Jared Hess's *Napoleon Dynamite* (2004), Greg Mottola's *Superbad* (2007), Seth Gordan's *Four Christmases* (2008), Gina Prince-Bythewood's *The Secret Life of Bees* (2008), Rian Johnson's *The Brothers Bloom* (2008) and Marina Zenovich's *Roman Polanski: Wanted and Desired* (2008).

As noted earlier, Sundance had been invaded by the speciality divisions of the majors by 1997 in search of another *Pulp Fiction* or *Four Weddings and a Funeral*. In 1999, it was invaded by a second group, dot.coms like AtomFilms.com, ReelPlay.com, iFilm.com and others, which set up shop at the festival in search

of short films to stream from their websites. The buying frenzy soon abated, however, when the dot.com bubble burst on Wall Street in 2000. The speciality divisions remained good customers until 2008, when the recession convinced the majors to exit the low-return independent business and concentrate on their franchises. Sundance responded to the pullback in 2009 by offering five festival entries for rent on YouTube and by initiating Sundance Festival USA, a programme which brought eight film-makers and their festival entries to eight art theatres around the country for one-night screenings plus Q&A sessions with the film-makers. The screenings were held during the festival itself and were designed to give people around the country a taste of Sundance.

THE AMERICAN FILM MARKET

The American Film Market (AFM) is the largest trade fair in the world devoted to independent films. Unlike Sundance and Cannes, which contain markets in addition to public film programmes, trade fairs are devoted exclusively to the buying and selling of films. First held in 1981, the American Film Market takes place every year in November at the Loews Santa Monica Hotel. (The Cannes International Festival, held in May, is the other international trade fair.) The nine-day event is sponsored by the Independent Film and Television Alliance, the trade association representing 150 companies worldwide that produce, finance and distribute independent pictures and television programmes. (Its mainstream counterpart is the Motion Picture Association of America, which represents the interests of the major studios.) Throughout much of its history, AFM originally traded mostly action movies and erotic thrillers produced by low-end indies that were designed for the Asian and South American markets. But the quality has improved in recent years as companies such as Lionsgate, 2929 International, Summit Entertainment, Focus Features, New Line Cinema and the Weinstein Company availed themselves of its services.

Jonas Rosenfield, President of the AFM from 1985 to 1998, and his organisation professionalised the way films were bought and sold. As reported by the *Los Angeles Times*, 'He joined the trade association at a time when the independents were a particularly unruly bunch, flush with cash from a rising video business so lucrative that it was possible to justify almost any modestly budgeted film. It was also a world of scam artists and people of mixed financial reputation.' Rosenfield standardised the business,

> so that banks could provide financing based on clear legal understanding. The association created model contracts for movie sales, compiled books of information so buyers and sellers would have ready access to market information in 50 or so countries, created a system to evaluate the credit ratings of buyers,

created a title-verification service to help buyers determine if a film is pirated, hired a full-time representative in Europe and established an arbitration system to settle disputes between producers and distributors. Those changes helped make the American Film Market the largest film market in the world in dollar volume of sales. (Saylor, 1998)

The trade fair allows independent producers to sell their completed pictures to local distributors around the world and also allows indie producers to cobble together deals with local distributors to presell their projects, typically negotiated one territory at a time. In 2011, the AFM screened 415 films for consideration by the 8,000 distributors, exhibitors, financiers and sales agents who attended the event from over thirty-five countries.

RELEASE STRATEGIES

As Mark Gill, former head of Warner Independent Pictures (WIP), said, independent films often contain,

difficult subject matter, unconventional storytelling, an unfamiliar cast or a combination of these things … [F]inding audiences for these films is labor-intensive rather than capital intensive. Instead of blanketing the airwaves and print media with advertisements, as the major studios do for movies with mass appeal, independent film companies must be clever about how to find and lure customers.

Unlike the mainstream movie audience, indie filmgoers take critical reviews seriously. 'There's no fooling the art audience,' added Gill, 'if you get a bad review, you're dead' (Thompson, 2008b).

Most indie pictures – be they speciality pictures, film festival favourites or foreign films – are given a slow release and are targeted at a more mature age cohort. There are two types of slow releases – limited and platform. A limited release is designed for prestigious foreign and independent films lacking significant commercial potential. Such films open in a few theatres in New York and Los Angeles with the aim of gaining critical attention from journalists and generating positive word-of-mouth among metropolitan audiences. On occasion, a limited release will strike a chord with critics and audiences and break out to a wider release and even more, as evidenced by *Slumdog Millionaire*, as discussed later. But as James Schamus has said,

For the vast majority of films an exhibition run in cinemas is simply an advertising campaign that lends an aura of cinematic legitimacy to the 'back end' ancillary exploitation of the film on various forms of television and other media – video

rental and sales, pay and basic cable, broadcast television and satellite transmission, aeroplane and cruise ship projection. This 'back end' long ago became the front end in terms of financing and ultimate revenues. (Schamus, 1998, p. 94)

A platform release is designed mainly for speciality pictures with 'name' elements that can more easily be exploited. Such films open on as many as a hundred screens in New York, Los Angeles and select markets. If the picture performs well, it is given an even wider release within a few weeks. Examples of successful films that received a limited release are *My Big Fat Greek Wedding* (2002), *Pan's Labyrinth* (2006) and *No Country for Old Men*.

Indie and speciality films are traditionally released after Labor Day so as not to go head to head with the summer popcorn pictures of the majors. An autumn release is also strategic; it's the beginning of the awards season leading up to the Academy Awards in March. However, too many indie pictures jockeying for Academy Award attention can overwhelm the market. Distributors, as a result, sometimes release upscale, character-driven pictures in the summer as a counter-programming strategy to provide adults with an alternative to studio blockbusters.

The awards season kicks off in the late autumn, when various organisations such as the New York Film Critics Circle, Los Angeles Film Critics Association, Hollywood Foreign Press Association (Golden Globes) and National Society of Film Critics announce their year-end awards. Going into the new year, the Golden Globes are awarded, followed by the announcement of the Oscar nominations, the awards of the British Academy of Film and Television Arts, Writers Guild, Directors Guild, Screen Actors Guild and, finally, the Oscar ceremony itself.

Members of the American Academy have been willing to bestow the top Oscar honours on the critics' favourites, most of which have come from the speciality divisions of the majors. It takes lot of money to build up Oscar contenders, given the escalating costs of advertising and publicity and the cost of new prints. Miramax perfected the strategy in the 1990s by mounting relentless lobbying campaigns as early as three months before the Oscar nominations were announced. By 2000, the majors and their speciality units dominated the awards season and used 'their deeper pockets to heavily market titles, which made it tough for truly independent distributors to compete' (McClintock, 2009b).

Take the case of Joel and Ethan Coen's *No Country for Old Men*, a Scott Rudin production released in the USA by Miramax Films following the departure of the Weinsteins from the company. Anne Thompson described it as 'a textbook case of a release campaign ripped out of the old Miramax Films playbook with

a contemporary Internet twist'. After playing the Cannes, Toronto and New York film festivals, *No Country* opened on 9 November 2007 in twenty-eight theatres to rave reviews. When some moviegoers objected to the film's ending, Miramax 'faced the challenge head on, building the debate into an ongoing Internet dialogue with blogger-critics'. Miramax also 'ran an aggressive marketing campaign aimed at the fanboys', including a 'violent red band trailer'. 'The movie's bookings expanded and contracted and expanded again. Some weeks there were no TV ads, just print. By Thanksgiving, *No Country* had grossed $18 million. Miramax pulled it back again, and then expanded during the Christmas holiday, when it earned another $10 million.' The film then went into 'full-tilt awards-season expansion as it reached 1,300 theaters Feb. 1' (Thompson, 2008c). Meanwhile, it picked up numerous awards from year-end critics' groups, which signified that *No Country* was not only an R-rated action thriller for young males, but a quality film for adults. At the Academy Awards, *No Country* picked up four Oscars, including best picture, directing, screenwriting and supporting actor. The film was still in release at the time and was able to take advantage of the box-office surge that followed the awards. *No Country for Old Men* grossed nearly $75 million domestic and even more internationally, a remarkable achievement for an offbeat film, but it still lost money because of the amount spent to publicise and distribute it.

Non-traditional Forms

Independent film-makers without any chance of securing regular theatrical distribution always have the option of going it alone by using guerilla marketing. As the *New York Times*'s Michael Cieply noted, independent producers have the options of,

> paying for their distribution, marketing films through social networking sites and Twitter blasts, putting their work up for free on the web to build a reputation, cozying up the concierges at luxury hotels in film festival cities to get them to whisper into the right ears … The idea behind this sort of guerilla release is to accumulate just enough at the box office to prime the pump for DVD sales and return the filmmaker's investment, maybe even a little profit. (Cieply, 2009a)

Such efforts typically come to naught, and at least two companies have offered help – Mark Cuban and Todd Wagner's 2929 Entertainment and IFC Films. Cuban and Wagner formed 2929 Entertainment in 2003 as a holding company for their media ventures. After cashing in their stock from the sale of their Broadcast.com to Yahoo, they decided to go into the movies and, in short order, they owned the HDNet and HDNet Movies cable networks, the Rysher

Entertainment film and television library, independent distributor Magnolia Pictures and the bankrupt Landmark theatre chain. Their goal was to build an integrated media company that challenged the way the film industry conducted its business.

As reported by Anne Thompson, Cuban and Wagner 'plan to bring big-media ideas of vertical integration to the art house world'. They envisioned producing low-budget digital movies through their HDNet network, distributing them through Magnolia Pictures, projecting them on Landmark's digital screens, selling them on DVD in Landmark lobbies and showing them on HDNet Movies (Thompson, 2004). In 2004, 2929 introduced a self-distribution initiative called Truly Indie. For a flat fee, the company offered film-makers the marketing and advertising support of its Magnolia distribution arm and access to its Landmark theatre chain for one week to launch a new picture. Landmark had planned to go digital, which would do away with print costs. Under this plan, film-makers would retain control of all rights to their films and collect all the proceeds after the fee was deducted. Truly Indie released around four pictures a year on average. Its biggest hit was Matt Tyrnauer's *Valentino: The Last Emperor* (2009), a documentary about legendary fashion designer Valentino Garavani, which grossed close to $2 million.

But the partners are perhaps best known for pioneering a controversial release strategy for independent pictures – day-and-date, meaning simultaneously in theatres, on DVD and on cable. Magnolia tested the waters with Alex Gibney's documentary *Enron: The Smartest Guys in the Room*, which premiered on 22 April 2005 at the Nuart Theatre in West Los Angeles and on HDNet Movies the same day. Several chains protested against the move by not booking the film. The strategy worked, nonetheless, and *Enron* grossed $4 million theatrically, mostly on the Landmark circuit. Cuban and Wagner tested the waters a second time with Steven Soderbergh's *Bubble* in January 2006. *Bubble* took in only about $150,000 the three weeks it was in theatres, but the practice persisted as Disney, Warner and other studios explored ways to make up for the decline in DVD sales.

Magnolia later introduced a VOD strategy that made new films available on HDNet before they reached theatres. Its biggest hit with the strategy was with Andrew Jarecki's *All Good Things* in autumn 2010. The film earned $4 million from HDNet and just $367,000 at the box office from thirty-five theatres, demonstrating the revenue-generating potential of the new window. 'Magnolia executives said they hoped that such an unusual strategy – which they have attempted with a handful of other movies – may be the magic bullet to save the struggling midmarket independent film industry' (Rampell, 2010). Magnolia's releases that received regular distribution were mostly pickups and included two

action pictures, Pierre Morel's *District B13* (2004) from France and Roger Donaldson's *The World's Fastest Indian* (2005) from New Zealand; Joon-ho Bong's Korean horror *The Host* (2006); and two much-talked about documentaries, Heidi Ewing's and Rachel Grady's *Jesus Camp* (2006) and Billy Corben's *Cocaine Cowboys* (2006). Apparently wishing to cash in on their movie investments, Cuban and Wagner announced on 20 April 2011that Landmark Theatres and Magnolia Pictures were for sale. They had one caveat; they wouldn't move forward 'unless the offer is very, very compelling'. No compelling offers were made and the pair took down the 'for sale' sign, at least for the time being.

Another company experimenting with VOD is IFC Films, which is owned by AMC Networks. IFC is a fully integrated media company that operates the IFC Center in New York and two cable networks specialising in indie fare, the Independent Film Channel and the Sundance Channel. The former was launched in 1994 as a basic cable channel running twenty-four hours a day; the latter, a pay channel, was acquired by AMC from the Sundance Institute in 2008 for $500 million. In 2006, IFC Films offered indie film-makers access to its cable channels via video-on-demand. VOD was being touted as the saviour of independent film-making. 'Just as the videocassette and the DVD brought untold billions into studio coffers,' said John Horn,

> video-on-demand distribution may deliver some much-needed economic relief to independent cinema, those often highbrow dramas and low-budget genre films made outside the studio system that have been struggling to turn a profit. It's likely that of the hundreds of movies headed to this year's Cannes festival, only a handful will attract an American theatrical distributor, but scores may land video-on-demand deals.

Movies were fetching $10 a viewing on VOD and an estimated 40 million cable households were carrying at least one such channel by 2009. Indie distributors especially liked the idea because it offered 'a cost-effective end run around most showings at the multiplex, where costs for even a limited national release can total $500,000' (Horn, 2009a).

The version of VOD that Horn described was not applicable to the speciality divisions of the majors or to the major studios themselves, since they mostly adhered to the traditional release windows for ancillary markets. Their films were sometimes available on VOD, 'but only well after a film's theatrical run has been completed and other windows of distribution have closed ... The studios have avoided this kind of video-on-demand deal, fearful that an early release on cable television will upset exhibitors and cannibalize DVD and pay TV income' (ibid.). As we shall see, the VOD that evolved in the indie sector

entailed the release of new pictures direct to cable, day-and-date with a limited theatrical run and an on-demand release before a theatrical run.

IFC Films was the first company to move aggressively into on-demand distribution. IFC Films started out producing art films – *Boys Don't Cry* (1999) and *Monsoon Wedding* (2001) – that were intended to air on the IFC channel. It then went into distribution, scoring big with two pickups, Alfonso Cuarón's *Y Tu Mama Tambien* (2001) and Joel Zwick's *My Big Fat Greek Wedding*. *My Big Fat Greek Wedding* was produced by Gold Circle Films, a production company formed by Norm Wiatt, the co-founder of Gateway Computers. The picture cost $5 million to make and about $20 million to distribute and grossed $380 million worldwide. IFC went on to release a dozen pictures a year, half of which received token theatrical distribution before they played on IFC's cable channel.

IFC and Sundance teamed up in 2006 to release festival favourites to independent theatres and to IFC's cable network day-and-date later in the year. The intent of the experiment was to turn VOD 'almost into a paid word of mouth campaign' by attracting early adopters, 'who would hopefully tell their friends they liked the movie' (Barnes, 2010b). The first release was Kevin Willmott's mockumentary *CSA: Confederate States of America* in March 2006. In 2010, IFC and Sundance teamed up a second time to release three features from the 2010 festival directly to cable and satellite systems day-and-date of their festival premieres.

By 2010, IFC had created three separately branded VOD distribution models: IFC in Theaters for pictures with 'name' elements that could easily be promoted and benefit from a limited theatrical run; Sundance Selects for prestige pictures that only played at film festivals and would never make it to theatres; and IFC Midnight for genre pictures. IFC and the cable system split the fees roughly 50/50. IFC deducted its marketing and distributions costs before it shared the proceeds with a film-maker.

Exhibitors held back initially. 'When we first started, only four or five theaters were on board – the others were just too scared about what VOD might do to their ticket sales,' said Jonathan Sehring, president of IFC. But independent theatres warmed up to the plan when it became apparent that VOD did not significantly affect business. Sehring stated at the end of 2010, that 'about 500 theaters are now willing to play films that are simultaneously made available on video-on-demand systems' (ibid.). By then, IFC Films was feeding about 120 indie features to VOD cable systems. IFC had its best year ever in 2009, when two of its releases, Steven Soderbergh's *Che* (2008) and Matteo Garrone's *Gommorrah* (2008), each earned over $1million from their theatrical and VOD runs.

The National Association of Theater Owners, the trade group representing the big theatre chains, did not actively fight such nontraditional distribution schemes, unlike the stance it had taken with the major studios. Independent films seldom if ever played in mainstream commercial houses. However, John Fithian, NATO president, offered this cautionary advice: 'Independent films will thrive in the digital age,' he said, but if VOD catches on, 'simultaneous release would seriously damage' the movie-theatre business. 'All movie products would become homogenized, would look the same. Movies made for cinemas would be no different than movies made for TV.' Eventually, movie screens 'would be nothing more than big television screens' (Sragow, 2006).

For a while, IFC Films had little competition at Cannes and other international film festivals, picking up such high-profile pictures as Lars von Trier's *Antichrist* (2009) and Ken Loach's *Looking for Eric* (2009) for day-and-date VOD distribution, but soon other companies joined the arena. Magnolia quickly introduced a VOD service on its HDNet and showed new films even before they reached theatres. Following Sundance's lead, New York's Tribeca Film Festival and Austin's South by Southwest also made films from their programmes available on VOD.

Next on the horizon was online distribution. In 2011, Sundance launched SundanceNow, 'an initiative that for the first time packages festival films under the Sundance name and offers them for simultaneous viewing on six of the Internet's biggest video platforms' – iTunes, Amazon.com, Hulu, Netflix, YouTube and Rainbow Media's SundanceNow. The deals allowed pickups to be shown simultaneously on competing sites.

Before 2008, distributors were regularly paying $3 million for any picture with the least bit of commercial appeal, but afterwards they were putting up no cash upfront or were providing low upfront minimum guarantees. A run on VOD generated some revenue, but not enough for a film-maker to recoup her investment in the picture. However, as Michael Cieply notes, 'a run on IFC's channels or those other services brings recognition that helps increasingly entrepreneurial filmmakers make money on DVDs – from foreign release, sales to airlines and, often, at screenings for political, religious or other groups' (Cieply, 2010c).

'Whether accessed via cable or the Internet, video on demand is likely to grow,' said the *Economist*. 'America's suburbs are becoming much more diverse places, with more ethnic minorities, more people with degrees and more gays … The potential audience for independent films is thus dispersing beyond the places where independent cinemas concentrated. Not everybody lives near an art-house cinema, but almost everybody has a remote control' ('Saved by the Box', 2009).

Foreign-language Films

During the 1950s and 60s, foreign films contributed to a vibrant film culture in the USA. They played in a growing number of art houses around the country and until 1970 accounted for as much as 7 per cent of the domestic box office. New arrivals were the subjects of feature stories in the press, mass-circulation magazines and highbrow periodicals. They were also promoted by museums and film festivals and helped establish film as a serious object of study in American universities. That was in the 60s. Since then, foreign films, especially subtitled foreign films, have played a marginal role in film culture and in the business. Every year, one or two imports generate interest among the art-house set, but, as A. O. Scott said,

> these successes seem more and more like outliers. A modest American box office gross of around $1 million is out of reach of even prizewinners from Cannes and masterworks by internationally acclaimed auteurs, most of whose names remain unknown even to movie buffs. This is less a sea change than the continuation of a 30-year trend. As fashion, gaming, pop music, social media and just about everything else have combined to shrink the world and bridge gaps of culture and taste, American movie audiences seem to cling to a cautious, isolationist approach to entertainment. (Scott, 2011)

As will be discussed below, Sony Pictures Classics has been the principal distributor of foreign-language films in the new millennium, but other companies such as Music Box Films and Roadside Attractions have had some successes as well.

Foreign-language films typically open in New York City on a limited release. Oscar contenders might play in Los Angeles and other cities. Foreign-language films have had to compete with British independent imports and American independent movies for playing time in a constricted market. Rising costs of prints and advertising, dwindling coverage in local newspapers, a shrinking cohort of dedicated viewers and declining interest in film culture among college students are other factors working against them.

Winning a coveted Oscar for Best Foreign Language Film does not necessarily translate into an 'Oscar bounce'. The winner, first of all, has to have inherent audience appeal and the capacity to make it on its own and, second, it has to be playing in theatres at the time of the nominations. As Michael Barker, co-president of Sony Pictures Classics, said, 'You have to be primed in the theaters at that moment ... because people really want to see what's going on in the moment, what's high profile at the moment.' Barker also noted a long-term benefit of an award or a nomination:

The one value that you can put on it every time is that it will increase the length of revenues on your picture over time – it's going to be 'a really long tail,' as they say … It will always be 'an Academy Award winner,' or it will always be 'an Academy Award nominee.' … When there's a new technology it becomes reissued again out of the pack, it makes the cut, so that's always valuable. ('Sony Pictures Classics', 2011)

In 2004, the Oscar race window was shortened to one month from two, which meant that after the nominations were announced, distributors of the nominees had only one month to organise an Oscar campaign and to get their films placed in theatres. Being nominated for the Oscar does not always guarantee theatrical distribution. Foreign films that go without may be seen only at film festivals.

THE RISE AND FALL OF THE SPECIALITY ARMS OF THE MAJORS

Hollywood entered the speciality market beginning in 1991. The affair lasted until the 2008 recession. The speciality divisions functioned as producer/financiers but mostly relied on pickups from Sundance, Cannes and other festivals to fill out their slates, which typically contained a mix of features and documentaries, both English-language and subtitled films. They were always on the lookout for potential crossover hits, of course, but another purpose of the divisions was to lend some class to their parent companies in the form of awards, particularly Academy Awards. The modest-budget film best fits this bill. David Bordwell has described this type of picture as occupying 'that middle range where independent cinema has to be. Ideally you have some stars, strong content, often from good books, and it needs to be offbeat enough to seem fresh, but it has to be still recognizably part of a familiar cinematic tradition, something challenging but not too challenging' (quoted in Rotella, 2010). The audience for such fare was an urbane thirty-five plus demographic including senior citizens sixty-five and over. A. O. Scott has described the audience as 'neither the global mass audience nor a coterie of cinephiles, but rather something – ideally something profitable, as well as Oscar-worthy – in between' (Scott, 2005b). The majors themselves made a point in shunning 'movies-in-the-middle', claiming that sophisticated films with offbeat themes lacked exploitable elements and were difficult to sell. Such pictures did not generate merchandising revenue, or spinoff prequels and sequels, or attract the youth audience. But Sony Pictures Classics, Fox Searchlight and Focus Features, the surviving speciality divisions, have given the lie to that stance by discovering and releasing artistically interesting films that have sustained the movies as a mature art form.

Sony Pictures Classics

Operating autonomously from Sony and with a lean and committed staff, Sony Pictures Classics 'carried the flag for modest-grossing foreign-language fare, art house films, and quirky personal offerings', as *Variety* put it (Miller, 2008). Founding the division in 1991, Sony simply hired Michael Barker, Tom Bernard and Marcia Bloom, the management team that ran Orion Pictures's classics division. Orion Pictures was an aspiring mini-major founded in 1978 by the management team that had formerly run United Artists. By building relationships with promising and proven auteurs and by demonstrating an uncanny ability to pick up inexpensive sleepers at international film festivals, Orion Classics briefly dominated the field, releasing Akira Kurosawa's *Ran* in 1986; Claude Berri's *Jean de Florette* and *Manon of the Springs* in 1987; Louis Malle's *Au Revoir les Enfants*, Wim Wenders's *Wings of Desire*, Gabriel Axel's *Babette's Feast* and Pedro Almodóvar's *Women on the Verge of a Nervous Breakdown* in 1988; Jean-Paul Rappeneu's *Cyrano de Bergerac* in 1990; and Agnieszka Holland's *Europa, Europa* in 1992. All made it to the top of *Variety*'s charts for foreign-language films. *Cyrano*, which starred Gérard Depardieu, was the top money earner. And *Babette's Feast* won an Oscar for Best Foreign Language Film. Not a bad record by art-house standards, but Orion Classics was wound up by the parent studio, which declared bankruptcy in 1991.

The Sony Pictures Classics team were regarded as savvy pickup artists who shunned bidding wars and paid only what the market would bear for acquisitions. Sony gave the team the same flexibility as Orion: 'Other companies look for home runs,' said Barker, 'we just go for singles and doubles' (ibid.). Starting out, however, Sony Classics hit a home run. *Howards End*, a Merchant-Ivory production starring Emma Thompson based on the E. M. Forster novel, earned more than $25 million in over 1,000 playdates and picked up three Oscars, among them the Oscar for best actress. Sony Classics's second release, Régis Wargnier's *Indochine* starring Catherine Deneuve, won the Oscar for best foreign film of 1992 and was the first of eight such awards won by the company. The others were Fernando Trueba's *Belle Époque* (1994), Ang Lee's *Crouching Tiger, Hidden Dragon* (2000), Florian Henckel von Donnersmarck's *The Lives of Others* (2007), Stefan Ruzowitsky's *The Counterfeiters* (2008) and Juan José Campanella's *The Secret in Their Eyes* (2010). *Crouching Tiger*, the martial arts fantasy, was an international co-production involving Sony Pictures Classics and production companies in Hong Kong, China and Taiwan. Starting out on a platform release, the film went on to play on over 2,000 screens and set a new record for foreign-language films, breaking $128 million. It was the first Chinese film to become a worldwide blockbuster.

Michelle Yeoh in Ang Lee's *Crouching Tiger, Hidden Dragon* (2000), the first Chinese film to become a worldwide blockbuster

Barker and Bernard had a long-standing relationship with Pedro Almodóvar and have released all of his features, beginning with *All About My Mother* (1999). *Volver* (2006) was Almodóvar's biggest hit in the USA, bringing in $13 million. Sony Classics also released such international hits as Walter Salles's *Central Station* (1998), Tom Twyker's *Run Lola Run* (1998), Wolfgang Becker's *Good Bye Lenin!* (2004), Michael Haneke's *Caché* (2005) and *The White Ribbon* (2009), Vincent Paronnaud and Marjane Satrapi's *Persepolis* (2007) and Woody Allen's *Midnight in Paris* (2011).

Disney and Miramax

The Walt Disney Company entered the speciality market in 1993 by acquiring Miramax Films. Disney paid $80 million to acquire Miramax's library of 200 art films and agreed to finance the development, production and marketing of Miramax's future movies. Operating as a fully autonomous division within Disney, Miramax placed its bets mainly on American independent ventures, which resulted in a string of Oscar-winning crossover hits that included Quentin Tarantino's *Pulp Fiction*, Anthony Minghella's *The English Patient*, Gus Van Sant's *Good Will Hunting* (1997) and John Madden's *Shakespeare in Love*. *Pulp Fiction*, the biggest hit, grossed $210 million worldwide. Miramax maintained its cachet in the prestigious foreign-film scene by releasing Michael Radford's *Il Postino* in 1995, which surpassed the record take of *Like Water for Chocolate*,

and then Roberto Benigni's *Life Is Beautiful* in 1997, which picked up three Oscars, including Best Foreign Language Film, and set a new highwater mark at the box office for foreign-language imports.

Miramax's total domestic box-office gross rose from $53 million in 1990 to over $327 million in 1999. At one point, the company's own subsidiary Dimension label, which specialised in producing and releasing horror movies, accounted for as much as 45 per cent of the take. The three *Scream* films, produced after Miramax was bought by Disney, became the most profitable franchise in the Weinsteins' history. Miramax's track record enabled Disney to recoup its $80 million investment in the company by 1996.

Miramax's continued success rested in large part on its marketing skills. Year in and year out, Miramax had one of its releases up for Oscar contention. The lobbying effort played out in massive advertising campaigns in trade publications, special screenings for Academy members and a raft of other ploys. Take the case of *Il Postino*. A drama constructed around the visit of exiled Chilean poet Pablo Neruda to a small Italian town, Miramax released the film in June 1995 'in the midst of a slew of action-adventure boys-with-toys films', as an alternative for adults interested in specialised fare. The early release also gave Miramax time to build word-of-mouth which helped it to eventually expand the release of the picture to 280 theatres nationwide – the most ever at one time for a foreign-language film. Three months before the Oscar nominations, Miramax sent out 5,000 videocassettes of the film to members of the Academy, enabling those who might have missed the film to see it and tell their friends about it. The studio also released a CD based on *Il Postino*, with Neruda's poetry read by such celebrities as Glenn Close, Madonna, Wesley Snipes and Julia Roberts. In addition, Miramax released two related books under its imprint with Hyperion. One was the Chilean novel on which the film was based, *Ardiente Paciencia* ('Burning Patience'), by Antonio Skarmeta. Miramax retitled it *The Postman*. The other was a collection of Neruda's poetry. 'The gentle romance saga was bypassed as Italy's official foreign-lingo Oscar entry (its director was English), but garnered five Academy Award nominations,' including the best actor nomination for Massimo Troisi, the star, who died of heart failure at the age of forty-one shortly after production ended. Several years later, Miramax spent more than $10 million on an Oscar launch for *Shakespeare in Love*, which 'started to resemble an expensive political campaign' (Weinraub, 1999a). It out-did Steven Spielberg's *Saving Private Ryan* in the best picture contention and won a total of seven Oscars.

Despite such critical and box-office successes, some of Miramax's 'more risque (and less successful) titles like *Priest* (1994), *The Advocate* (1993), *Clerks* (1994), and *Kids* (1995) have been at odds with Disney's squeaky clean image'

(Evans and Brodie, 1996). Although the Weinsteins had always bristled at Disney's corporate style, the seeds of the dissolution were sown in 2000, when the Weinsteins renegotiated a new contract with Disney. The new contract gave them an annual budget of $700 million and a promise that they would continue running Miramax as a fully autonomous division until September 2005. With this new muscle, the Weinsteins quickly expanded into books, television and *Talk* magazine, with Tina Brown as editor. The Weinsteins also began making big-budget movies, which departed from their independent roots. And the division's staff had ballooned to over 450 employees. Things began to unravel at the end of 2001; two of its expensive pictures – *Kate and Leopold* and the Oscar hopeful *The Shipping News* – flopped and *Talk* magazine suspended publication after having lost an estimated $54 million, half of which came out of Miramax's coffers. At year's end, the division had lost $37 million, 'although some at Disney suggest it was more than twice that' (Holson, 2005b).

Disney had always complained that it was losing money on the deal, while Miramax claimed that its releases outperformed Disney's live-action pictures. By 2005, Miramax had 'released more than 300 movies that generated $4.5 billion in American ticket sales and tallied 220 Academy Award nominations and 53 wins' (ibid.). The Weinsteins complained that Eisner had vetoed projects that later turned out to be hits – particularly the rejection of *The Lord of The Rings*, which made New Line a fortune. The break was inevitable after Disney refused to distribute Michael Moore's controversial antiwar film, *Fahrenheit 9/11* (2004). The Weinsteins took over the picture and arranged for Lionsgate Films to distribute it. Eventually Disney bought out the brothers at the end of their contract.

Disney studio head Dick Cook appointed Daniel Battsek, a company distribution executive, to run the speciality division. To sustain the diminished Miramax, Cook lured Scott Rudin from Paramount with a production-financing deal. A five-year career veteran at Paramount whose credits included Stephen Daldry's *The Hours*, Richard Linklater's *The School of Rock* (2003) and Mike Nichols's *Closer* (2004), Rudin was expected to 'deliver the kind of sophisticated, awards-attracting art film projects that seemed to flock to the Weinsteins' Miramax but have appeared to evade Disney' ('Paramount's Rudin Jumps Ship for Disney', 2005). Battsek scored a hit with his first acquisition, *Tsotsi* (2005), a South African movie about a Johannesburg gang leader that won the Oscar for Best Foreign Language Film. Miramax also released such hits as *The Queen* (2006), *The Diving Bell and the Butterfly* (2007) and, with Paramount Vantage, *No Country for Old Men* and *There Will Be Blood* (2007), but none of the pictures generated the publicity buzz or the box-office grosses of the former Miramax.

By 2009, Disney had lost interest in the speciality market and, in October, Disney gutted the division, cutting its staff by more than 70 per cent. In January

2010, Disney closed Miramax's New York and LA offices and put the unit up for sale. As the *Los Angeles Times* put it, 'Under Chief Executive Bob Iger, Disney has shifted away from the low-return specialty film business and focused the studio on "branded", broad-appeal family entertainment ... "Our current strategy for Walt Disney Studios is to focus on the development of great motion pictures under the Disney, Pixar and Marvel brands", said Iger' (Eller and Chmielewski, 2010).

Disney granted the Weinsteins an exclusive negotiating window to regain control of Miramax Films with its 700-film library. The asking price was around $700 million, but the Weinsteins could not raise the money. Here's why. After departing Disney in 2005, the Weinstein brothers formed a new venture, the Weinstein Company, and with the help of Goldman Sachs raised $1 billion in capital. Rather than focusing on film-making exclusively, the brothers ventured into women's fashions, online social networking and cable TV. The company released seventy movies from 2005 to 2009, nearly all of which underperformed. The exceptions were two horror movies, David Zucker's *Scary Movie 4* (2006) and Mikail Håfström's *1408* (2007) produced by its Dimension Films subsidiary, Michael Moore's documentary *Sicko* (2007) and Quentin Tarantino's *Inglourious Basterds* (2009). In June 2010, the company restructured its deal with Goldman Sachs by giving up ownership of 200 titles in its film library in exchange for the forgiveness of around $450 million in debt.

In July 2010, Disney finally found a buyer for Miramax – Filmyard Holdings, an investor group led by Los Angeles construction magnate Ron Tutor, which paid more than $663 million for the unit. Tutor planned to hire 'a seasoned movie executive to run Miramax' and 'to produce a few films a year to freshen the library to sustain its value' (ibid.). Meanwhile, the Weinsteins got back to basics and, in 2010, picked up three hits, Derek Cianfrance's *Blue Valentine* (2010), John Wells's *The Company Men* (2010) and Tom Hooper's *The King's Speech* (2010).

Reverting to their old form, the Weinsteins powered *The King's Speech* to a Best Picture win at the Academy Awards in February. The picture was produced by See-Saw Films, a London-based indie unit headed by Iain Canning, Emile Sherman and Gareth Unwin, who pieced together the $13 million budget 'from an intricate jigsaw of presales, equity, tax credits and debt'. The picture, 'a talky, action-free period piece about two middle-aged men' became 'one of the most successful purely independent movies ever', said *Variety*, with a worldwide gross over $427 million. 'The startling success of *King's Speech* is encouraging risk-averse distribs to look beyond their obsession with genre and youth, and consider afresh the appetite of older audiences for upscale drama,' it added ('Who Gets the "King's" Ransom?, 2011). Afterwards, the Weinsteins

Colin Firth in Tom Hooper's *The King's Speech* (2010), a Weinstein Company release and the winner of four Academy Awards, including Best Picture

announced that they would produce about eight movies a year and acquire six to nine more.

Fox Searchlight

Fox Searchlight was founded in 1994 by Tom Rothman, who had previously served from 1989 to 1994 as president of worldwide production for the Samuel Goldwyn Co. Before that, he served as a production executive under David Puttnam and Dawn Steel at Columbia Pictures. Rothman ran Fox Searchlight for sixteen months until he was promoted to president of the Fox Film Group. Rothman recruited Lindsay Law, president of PBS's *American Playhouse*, as his replacement. At *American Playhouse*, Law oversaw such films as *El Norte* (1983), *The Thin Blue Line* (1988) and *Safe* (1995), which were produced by the Playhouse's independent production unit.

Under Law's watch, Fox Searchlight struck it big by releasing *The Full Monty* (1997), a low-budget British comedy directed by Peter Catteneo 'about a group of unemployed steel workers in Sheffield who decide to start a striptease act not only to earn money but to give them some self-esteem. The men are down on their luck and their physiques are far, far from ideal' (Weinraub, 1997a). After a successful screening at Sundance, Fox Searchlight embarked on an aggressive marketing campaign to generate interest in a picture with an odd title and a cast of unknowns. Fox Searchlight held free screenings in cities across the USA and

targeted women twenty-five and older. Soon teaser ads asking 'What is The Full Monty?' began appearing in major newspapers. Fox Searchlight gave it a slow rollout and it gradually built up momentum. The final box-office tally came to $46 million domestic and $257 million worldwide.

Fox Searchlight went on to release Kimberly Pierce's critically acclaimed *Boys Don't Cry*, which earned Hillary Swank an Academy Award for her performance, and several box-office hits: Alexander Payne's *Sideways* (2004), Jonathan Dayton and Valerie Faris's *Little Miss Sunshine* and Jason Reitman's *Juno* (2007). *Little Miss Sunshine*, a quirky beauty pageant comedy starring Steve Carell and Greg Kinnear, was picked up at Sundance for $10.5 million (setting a Sundance record) and grossed nearly $60 million. *Juno*, a comedy about a teenager's unwanted pregnancy starring Ellen Page, became Fox Searchlight's biggest hit, earning $143 million at the box office.

However, not until it released Danny Boyle's *Slumdog Millionaire* in 2009 did Fox Searchlight walk away with the top honours at the Academy Awards. Fox Searchlight acquired the domestic rights to the picture from Warner Bros. after the studio shuttered its Warner Independent speciality division. Warner Independent had purchased the rights to *Slumdog* for $5 million in 2007, but Warner Bros. had doubts about its commercial potential. Danny Boyle's 'fictional account of a Mumbai orphan's surprising winning streak on India's version of "Who Wants to be a Millionaire"' had no Caucasian actors and much of the dialogue was in Hindi. Like *The Full Monty*, Fox Searchlight carefully nurtured the rollout, which began in November 2008, three months before the Oscar ceremony. The picture had earlier generated a lot of buzz at Telluride and had won the People's Choice Award at the Toronto Film Festival. Before its release, Fox Searchlight test marketed the picture in fifty cities using free word-of-mouth screenings. The resulting marketing campaign emphasised the picture's 'brighter, bouyant side: The trailer is filled with cheering crowds, running children and upbeat music from the Ting Tings' (Kaufman, 2008). *Slumdog* took in $36,000 per theatre from its ten-theatre limited release at the opening weekend. On Christmas Day it was played in 600 theatres, and on 23 January 2009 it went into national release. By Academy Award time, it had reached $88 million domestic and $60 million foreign. *Slumdog* won virtually every major award leading to the best picture Oscar; 'The wins', said John Horn in the *Los Angeles Times*, 'cemented the reputation of distributor Fox Searchlight, which has become Hollywood's top advocate for the kind of daring works that movie studios have all but abandoned' (Horn, 2009b). After the ceremony, Fox Searchlight expanded the release to 2,800 screens, the widest domestic release in its history. The final tally came to $141 million domestic and $224 million foreign, a feat few other independent pictures had achieved.

Dev Patel and Freida Pinto in Danny Boyle's *Slumdog Millionaire* (2008), a Fox
Searchlight release and the winner of eight Academy Awards, including Best Picture

Fox Searchlight sustained its reputation in the speciality market by releasing
Black Swan, Darren Aronofsky's ballet thriller starring Natalie Portman and
Vincent Cassel, along with Terrence Malick's origins-of-the universe project and
winner of the Palme d'Or at Cannes, *The Tree of Life* (2011), starring Brad Pitt
and Sean Penn.

Paramount Vantage

Paramount entered the speciality market in 1998 by forming Paramount
Classics, headed by David Dinnerstein and Ruth Vitale. The division did not live
up to expectations, so they were replaced in 2005 by John Lesher, a partner in
the Endeavor Talent Agency, who formed a new speciality unit, Paramount
Vantage. Lesher led off with a high-profile slate headed by Al Gore's documen-
tary *An Inconvenient Truth* (2006), Alejandro González Iñárritu's *Babel* (2006),
Sean Penn's *Into the Wild* (2007) and two Oscar-winning pictures co-produced
with Miramax, Paul Thomas Anderson's *There Will Be Blood* and Ethan and Joel
Coen's *No Country for Old Men*. The latter picture took the top honours, win-
ning for best picture, best directing, best writing and best acting in a supporting
role (Javier Bardem).

However, the two Oscar winners proved Vantage's undoing. The pictures each
cost around $25 million to make, a reasonable amount, but both Miramax and
Paramount Vantage spent extravagantly to promote and distribute them, and

both lost money. Such practices on the part of the speciality unit led Paramount to lay off most of Vantage's staff in 2008 and consolidate its production and marketing departments into the parent studio.

Focus Features

Universal Pictures had entered the speciality market in limited ways beginning in 1992, but not until 2000 did its efforts take hold. In 2000, Universal, under the new ownership of Vivendi, formed Universal Focus to market and distribute niche pictures in the USA. Its first release was *Billy Elliot* (2000), a low-budget British drama from the London-based Working Title Films 'about a boy who grew up in a tough mining town and followed his dreams to become a ballet dancer'. It took in a surprising $109 million worldwide (Pfanner, 2004). Under Jean-Marie Messier, Vivendi Universal went on an acquisitions binge (see Chapter 1) and in 2002 acquired two indie companies, USA Films and Good Machine. USA Films, itself a merger of October Films and Gramercy Films, was owned by Barry Diller's cable company, USA Network. Good Machine was

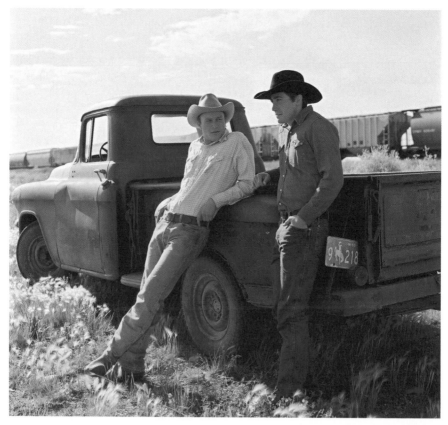

Ang Lee's *Brokeback Mountain* (2005), starring Jake Gyllenhaal and Heath Ledger

founded by James Schamus and two partners and was best known for producing Ang Lee's *Eat, Drink, Man, Woman* (1994), *The Ice Storm* (1997) and *Crouching Tiger, Hidden Dragon*. The latter picture became the highest-grossing foreign-language film of all time in North America. Messier shuttered Universal Focus and consolidated its speciality divisions into one unit, Focus Features, naming Schamus and partner David Linde co-presidents.

Focus Features survived Universal's mergers with General Electric in 2003 and with Comcast in 2009. Focus became known as a director's studio, financing, producing and distributing 'smart movies for low budgets', as *Variety* put it (Rotella, 2010). Its Oscar winners include Roman Polanski's *The Pianist* (2002), Sophia Coppola's *Lost in Translation* (2003) and Gus Van Sant's *Milk* (2008). Its other hits include Ang Lee's gay-themed Western, *Brokeback Mountain* (2005), the Coen brothers' comedy *Burn After Reading*, Bryan Bertino's horror film *The Strangers* (2008), Henry Selik's 3-D stop-motion animation hit *Coraline* (2009) and Lisa Cholodenko's family drama, *The Kids Are All Right* (2010).

Warner Independent Films

Warner Bros. entered the speciality market indirectly in 1995, when it acquired Ted Turner's TBS. The package included New Line Cinema and its speciality unit, Fine Line Features, which Turner had acquired in 1993. Fine Line continued on course by releasing David Cronenberg's *Crash* and Scott Hicks's *Shine* in 1996, Shari Springer Berman and Robert Pulcini's *American Splendor* in 2003 and Joshua Marston's *Maria Full of Grace* in 2004.

Warner made a more concerted entry into the speciality market in 2003, when it formed Warner Independent Films (WIP) and chose Mark Gill, a former Miramax executive, to head it. The move was supposed to make Warner Bros. a greater Academy Awards contender. In 2005, Warner formed a second speciality unit, Picturehouse Entertainment, a joint venture of New Line Cinema and HBO Films, both divisions of Time Warner. Fine Line Films was folded into the new venture. WIP's early successes included the Oscar-winning documentary *March of the Penguins* (2005) and the Oscar-nominated drama about the McCarthy era, *Good Night, and Good Luck* (2005). Picturehouse too became a tastemaker, releasing Guillermo del Toro's *Pan's Labyrinth* in 2006 and Olivier Dahan's *La Vie en Rose* in 2007, which took home five Oscars between them.

Warner began its retreat from the speciality market in February 2008 when it announced that New Line, the company that financed and produced *The Lord of the Rings Trilogy*, would be folded into Warner Bros. as a genre arm 'limited to the kind of smaller, low cost "genre" horror and comedy pictures upon which

it built its name' (Eller, 2008). The decision eliminated 600 jobs. Bob Shaye and Michael Lynne, New Line's co-founders, were let go as well. To replace them, Warner promoted Toby Emmerich, who had overseen New Line's inhouse productions since 2001, including *The Lord of the Rings Trilogy*.

In May 2008, Time Warner closed Warner Independent Pictures and Picturehouse, a decision that cost seventy more jobs. Gill had resigned as president of WIP in 2006, unable to conform to Warner's corporate culture, and the division went downhill afterwards. The closings were part of Warner's cost-cutting efforts. As Alan Horn, Warner's president and COO, explained:

> With New Line now a key part of Warner Bros., we're able to handle films across the entire spectrum of genres and budgets without overlapping production, marketing and distribution infrastructures … It made no sense for Warner Bros. to continue funding marketing and distribution infrastructures at Picturehouse and WIP – particularly since Warner has expanded its capacity to handle films by absorbing New Line's marketing and distribution operations. (McNary and Hayes, 2008)

Historically, the speciality arms of the majors were created so that they could focus their attention on the distinctive financing and marketing needs of independent films. Now, Warner Bros. was charting a new course, claiming that blockbusters, genre films and art-house fare could all be handled under one roof.

MINI-MAJORS

As might be expected, a few independent companies aspired to attain mini-major status in the new millennium by producing and distributing mainstream movies. Three stand out – Lions Gate Entertainment, Summit Entertainment and Relativity Media. Unlike their immediate predecessors from the 1980s – Orion Pictures, the Cannon Group and Dino De Laurentiis Entertainment – which financed their pictures mainly by preselling the distribution rights to ancillary markets before production began, the newcomers relied on Wall Street firms, hedge funds and private investors to support their operations. They seldom went head to head with the majors in the tentpole and franchise departments; rather, they carved special niches for themselves by releasing mid-range and sometimes offbeat pictures.

Lions Gate Entertainment

Lions Gate Entertainment, the largest of the group, was founded in 1997 by Frank Giustra, a Canadian mining magnate and investment banker based in Vancouver,

British Columbia, who named his company after the city's landmark bridge. Using his own money, bank loans and funds from a public offering, Giustra acquired Canada's largest studio complex, located in Vancouver, and other motion picture assets and 'set about acquiring art house films and releasing controversial movies that had been rejected by more traditional art house studios'. Such films included Bill Condon's *Gods and Monsters* (1998), Kevin Smith's *Dogma* (1999), Tim Blake Nelson's *O* (1999), Mary Harron's *American Psycho* (2000), Marc Forster's *Monster's Ball* (2001) and Gaspar Noë's *Irreversible* (2002).

In 2000, Jon Feltheimer, a former Sony Pictures executive, and Michael Burns, a Wall Street wunderkind, took over the company and moved its base of operations to Santa Monica. Their goal was to build a mini-conglomerate, with a production facility, television unit, foreign sales arm and a significant library of movies and television shows for release on video and DVD. (The company's film and television producing arm is Lionsgate [as one word] Films.) A film library was necessary to generate a steady cash flow – money which could be leveraged to secure production financing. Feltheimer built a film library of low-budget pictures and television shows by acquiring the 650-title library from Trimark Holdings for $50 million in 2000 and the 7,000-title library from Artisan Entertainment for $375 million in 2003. Artisan had built its film library with the proceeds from the cult horror hit *The Blair Witch Project*, which it acquired for $250,000 and parlayed into a $140 million windfall.

Feltheimer then announced that Lionsate Films would concentrate on 'more commercially oriented movies, but would not ignore artistically daring projects' (Waxman, 2003). Box-office hits included Sylvester Stallone's *The Expendables* (2010), the *Saw* horror franchise, which began in 2004, Michael Moore's documentary, *Fahrenheit 9/11*, and Paul Haggis's *Crash*. Lionsgate also released the critically acclaimed *Precious* (2009), directed by Lee Daniels, which won two Academy Awards, and a popular series produced by the playwright, Tyler Perry, targeted at African-American women: *Diary of a Mad Black Woman* (2005), *Madea's Family Reunion* (2006), *Madea Goes to Jail* (2009) and *Why Did I Get Married Too?* (2010). Lionsgate's television arm produced two Emmy-winning drama series, *Mad Men* (2007–) and *Weeds* (2005–12), and the critically acclaimed *Nurse Jackie* (2009–) series.

However, Lionsgate was a high-overhead company and regularly posted losses under Feltheimer's management. Battered by declining DVD sales and the fallout from the 2008 financial crisis, Lionsgate was forced to slash jobs and cut back on production. The company hoped for a turnaround in 2009 when it struck a deal to distribute five pictures a year from Ryan Kavanaugh's Relativity Media, but Relativity backed out of the deal in 2010 when it decided to open its own distribution arm.

Summit Entertainment

Summit was originally founded in 1991 by film producers Bernd Eichinger, Arnon Milchan and Andrew Vajna as a foreign sales company for their pictures. It took on new life in 2006 when it was taken over by Robert G. Friedman, a former Paramount executive, and Patrick Wachsberger, a veteran international sales agent. With $1 billion in capital from a group of investors that included Jeff Skoll's Participant Media and private equity fund Rizvi Traverse Management, Friedman and Wachsberger transformed Summit into a full-fledged studio with the goal of releasing a slate of twelve pictures a year 'with a focus on the midrange films that the majors are less likely to greenlight', said *Variety* (McNary, 2012).

Summit hit it big by producing and distributing *Twilight* (2008), based on the first of Stephanie Meyer's hugely popular teenage vampire novels. After Paramount passed on the project, Summit bought the movie rights to all four novels in the series. The first *Twilight* entry, directed by Catherine Hardwicke, starred Robert Pattinson, an unknown Briton who plays the tormented but tender vampire, and Kristen Stewart, cast as the sulky girlfriend. Budgeted at around $30 million, *Twilight* grossed nearly $400 million worldwide. The *Twilight Saga* franchise went on to become a pop-culture phenomenon.

Summit's regular fare comprised broad-based entries across a range of genres at moderate prices, such as the action thriller *Push* (2009), the bomb diffusion thriller *The Hurt Locker* (2008), the sci-fi mystery *Knowing* (2009) and the action comedy *Red* (2010). *The Hurt Locker* was Summit's first and only best picture Oscar winner, and overall at the box office Summit had more flops than hits.

The plights of both Lionsgate and Summit Entertainment were resolved in January 2012, when Lionsgate agreed to acquire Summit for $412.5 million in cash and stock. Describing the merger, Lionsgate said, 'We are uniting two powerful entertainment brands, bringing together two world-class feature film franchises to establish a commanding position in the young adult market, strengthening our global distribution infrastructure and creating a scalable platform that will result in significant and accretive financial benefits to Lionsgate shareholders' (Block, 2012).

Shortly after the merger, in 2012 Lionsgate launched a young adult franchise of its own, *The Hunger Games*, based on Suzanne Collins popular dystopian novel and intended as the first in a new film series. Later in the year, the combined company released the final installment of the *Twilight Saga: Breaking Dawn Part 2*. Combined revenues from the two pictures more than covered the cost of the merger and established Lionsgate as a rival to the majors, just as its founders originally envisioned.

Lionsgate's internet-driven marketing of Gary Ross's *The Hunger Games* (2012), starring Jennifer Lawrence, brought in an astounding $155 million on its opening weekend in North America to launch Lionsgate's planned four-picture franchise based on Suzanne Collins's *Hunger Games* trilogy

Relativity Media

As previously discussed in Chapter 2, Ryan Kavanaugh's Relativity Media, launched in 2004, pioneered 'the current phenomenon of Wall Street-backed funds investing in studio slates' (Siegel, 2008). With a $1 billion revolving line of credit from the Elliott Management hedge fund, Relativity provided slate financing for Sony and Universal. By 2010, the company had financed, co-produced or produced more than 200 features.

Relativity made its move to become an independent studio in 2009, when it acquired the genre label Rogue Pictures from Universal, which gave the company a film library. In 2010, it acquired Overture Films' distribution and marketing divisions from the Starz Network, a premium pay TV channel owned by John Malone's Liberty Media. After setting up other deals, Relativity set out to release twenty mid-budget pictures a year. To protect the downside of the venture, Kavanaugh intended to take advantage of foreign presales and tax rebates to lower his exposure, to avoid paying first-dollar grosses to stars and to reign in P&A by promoting his pictures on internet movie networks. Furthermore, Kavanaugh claimed to use sophisticated mathematical formulas in order to determine the profit potential of each film Relativity financed. The studio went on to produce two big hits in 2011, Neil Burger's *Limitless*, a sci-fi thriller starring Bradley Cooper and Robert De Niro, and Tarsem Singh's *Immortals*, a 3-D

sword-and-sandal epic starring Henry Cavill and Mickey Rourke. However, several of its pickups flopped, and the disappointments led Kavanaugh's principal backer, Elliott Management, to pull back on its financing.

CONCLUSION

American independent film persisted despite the series of crises that afflicted the market in the 1980s when the draw of presales to pay TV and home video glutted the market with unreleased pictures and caused numerous indie outfits to close up shop. The indie market revived during the 90s as Miramax and New Line, in particular, released crossover hits and convinced the majors to enter the business by absorbing the leading indie distributors or by forming speciality units of their own. The 90s were the heyday of the Sundance Film Festival, which came to be regarded by the majors and outside investors alike as a mother lode of potential product to exploit. In the new millennium, the events that wounded the majors, crippled the indies. The indie market yielded too few *Pulp Fiction*s and *Slumdog Milllionaire*s to suit the majors, which were now totally committed to blockbusters, resulting in the shuttering of speciality units and the firing of hundreds of employees.

Today, indie and foreign-language films play mostly in New York and Los Angeles and in film festivals. But what they lack in box-office clout they make up in awards and critical esteem. Declining DVD sales hit the independent market harder than mainstream Hollywood, simply because home video far outstripped any theatrical run. As a result, indie distributors have also searched for alternate sources of revenue, particularly from versions of VOD.

The independent sector has always harboured a few mini-majors. In recent years, Lionsgate, Summit and Relativity Media have come to the fore. Each devised a different strategy to crack the mainstream exhibition market. Lacking the deep pockets of the majors, they released mostly mid-budget pictures. Such pictures are tough sells. Lionsgate emerged as a real contender to the majors after it acquired Summit Entertainment and released the hugely successful *The Hunger Games* in 2012. But lacking the deep pockets of a Time Warner or a Disney, an expensive flop or two could have dire consequences for the company.

Conclusion

At decade's end, the major film studios had survived the recession and restored their profitability, although the returns still represented a small fraction of their conglomerate parents' bottom lines. The majors achieved these results by fleeing to safety in production and reducing overheads. Most of the revenue was generated by tentpoles, long favoured by young men aged sixteen to twenty-four with disposable income, and family films. Big-budget franchises played well in all the world's markets and could be exploited by all divisions of the studio. And they could easily spin off sequels. Modestly budgeted pictures, the type favoured by mature adults that won awards and critical honours, were either ignored by the studios or foisted on outside investors and speciality divisions to produce. Like their conglomerate parents, the studios streamlined their operations and focused on content. To reduce overheads, studios cut back on production, shuttered poorly performing units, shed jobs and became tightfisted when it came to star salaries and contract negotiations with their unionised employees. The money saved was invested in blockbusters. Hollywood's rank-and-file artisans bore the brunt of these austerity measures, while those at the top of the studio hierarchies prospered. Hollywood's old ways of doing business would not likely return when the economy improved.

Box-office receipts increased over the decade, which seemed to imply that moviegoing was recession-proof. When adjusted for inflation, however, box-office receipts actually declined. The number of tickets sold declined as well. Responding to the growing popularity of home theatres, competition from Netflix and Redbox, and changes in consumer behaviour brought about by Google, Facebook and YouTube, exhibitors upgraded moviegoing by building high-end megaplexes and by going digital. Going digital made for the easy conversion to 3-D, which saved the market from further erosion, beginning in 2009 with the release of James Cameron's *Avatar*. The picture started a trend, as all the studios jumped on the bandwagon to enhance the value of their tentpoles. Exhibitors capitalised on the innovation by charging higher ticket prices for their 3-D versions. Starting in 2011, the novelty of 3-D began to wear off as audiences became more picky. The movie business is cyclical, and it's probably too soon to say anything definitive about declining admissions.

The time-honoured mass-marketing techniques Hollywood used to launch their pictures remained intact in the new millennium. The arrival of the internet and its ability to reach millions of movie fans instantaneously undermined Hollywood's strict control over publicity and promotion. Distributors were forced to add to their repertoire to retain a hold on their core audience. Embracing fan sites and social networks connected studios to their audience, but such efforts did not necessarily result in greater ticket sales, so major studios continue to rely heavily on television advertising to launch a new film. Perhaps the biggest challenge now facing Hollywood is how to make up for declining DVD sales, once a principal source of profit for most pictures. DVD and Blu-ray revenues are still substantial but the dropoff in sales, beginning in 2007, left studios scrambling to fill the void. Responding to perceived changes in consumer viewing habits, studios partnered with cable operators to enhance their VOD channels by offering them their new releases the same date they are released to home video rather than holding them back for eight weeks. In other words, the studios collapsed the PPV/VOD and home video windows hoping to capitalise on a growing revenue source.

Studios next experimented with a potentially more lucrative revenue source – premium VOD. The plan here was to offer consumers new releases at a premium price earlier in the distribution cycle, at a midway point during the theatrical run. The plan was immediately denounced by NATO, the exhibitor trade association, which claimed that any encroachment on the theatrical run would cannibalise the business. Major theatre chains refused to play such pictures. The studios relented, but the idea was far from dead. Studio chiefs vowed to find a way to continue the experiments in the future to prove that theatrical exhibition and PVOD can coexist and thrive.

If Netflix's gradual transition from DVDs by mail to online streaming was any guide, it appeared that consumers were losing interest in physically owning content, preferring instead to watch them online at an affordable set price. When Warner Home Entertainment introduced the cloud-based digital locker UltraViolet, the service allowed consumers to purchase or rent movies, which could be played on any device by streaming from the cloud. NATO wished the service every success so long as its offerings did not infringe on the theatrical window. Hollywood hopes that cloud technology will become the standard way to watch movies on mobile devices and in the home.

After a decade of prosperity and being at the centre of media attention, Indiewood hit the doldrums. In the era of tentpoles and franchises, speciality units of the majors could not carry their weight and were either closed or sold. Indie film-makers outside Hollywood's orb were especially hard hit by declining DVD sales, once a revenue mainstay, and, after the financial meltdown

beginning in 2008, private investors retreated. A theatrical release for almost any independent film could only be a dream. Relatively few art houses still book indie films; the best hope for reaching an audience for such fare is by VOD – that is, if a film has received some sort of festival recognition.

Among the mini-majors, Lionsgate Films is currently on a roll as a result of the runaway success of *The Hunger Games*. With this picture, Lionsgate had its second big franchise after the *Twilight* series, which it acquired in the merger with Summit Entertainment. The two franchises, along with Lionsgate's well-stocked film library and television holdings, have made the company a formidable player in Hollywood and give it a better than even chance of becoming the next major.

Overall, Hollywood has grown more cautious in the new millennium. Each of the major studios is now controlled by a large conglomerate, which means that each is but a relatively small part of a much bigger business. Earnings from the movie division often pale by comparison to profits made elsewhere. Chieftains at the top of the conglomerate therefore place relentless pressure on studio bosses to produce marketable movies that will generate substantial revenues across media platforms at home and abroad. Such pressures are combined with substantial anxieties about new technologies, piracy and the erosion of theatrical ticket sales. All of this has engendered significant changes in industry strategy, practice and output. Today the studios focus almost exclusively on tentpoles and franchises, leaving lower-budget productions to their partners and independents.

References and Further Reading

Acland, Charles R., *Screen Traffic: Movies, Multiplexes, and Global Culture* (Durham: Duke University Press, 2003).

_____, 'Theatrical Exhibition: Accelerated Cinema', in Paul McDonald and Janet Wasko (eds), *The Contemporary Hollywood Film Industry* (Malden, MA: Blackwell, 2008).

Adam, Thomas, et al., *US Electronic Media and Entertainment* (London: Informa, 2003).

'America's Sorcerer', *Economist*, 10 January 1998.

Arango, Tim, 'Holy Cash Cow, Batman! Content is Back', *New York Times*, 10 August 2008a.

_____, 'How the AOL–Time Warner Merger Went So Wrong', *New York Times*, 10 January 2010.

_____, 'How Social Networking Site Cools as Facebook Grows', *New York Times*, 11 January 2011.

_____, 'Time Warner Refocusing With Move to Spin off Cable', *New York Times*, 1 May 2008b.

Arango, Tim and Carr, David, 'Netflix's Move Onto the Web Stirs Rivalries', *New York Times*, 24 November 2010.

Arbitron Cinema Advertising Study 2007, http://www.arbitron.com/downloads/ cinema_study_2007.pdf

Austin, Bruce, *Hollywood, Hype and Audiences: Selling and Watching Popular Film in the 1990s* (Manchester: Manchester University Press, 2002).

Balio, Tino, 'Adjusting to the New Global Economy: Hollywood in the 1990s', in Albert Moran (ed.), *Film Policy: International, National and Regional Perspectives* (New York: Routledge, 1996).

_____, 'The Art Film Market in the New Hollywood', in Geoffrey Nowell-Smith and Steven Ricci (eds), *Hollywood & Europe: Economics, Culture, National Identity* (London: BFI, 1998).

_____, 'Hollywood Production Trends in the Era of Globalisation', in Steve Neale (ed.), *Genre and Contemporary Hollywood* (London: Routledge, 2000).

_____, '"A Major Presence in All the World's Important Markets": The Globalization of Hollywood in the 1990s', in Steve Neale and Murray Smith (eds), *Contemporary Hollywood Cinema* (London: Routledge, 1998).

_____, *United Artists: The Company That Changed the Film Industry* (Madison: University of Wisconsin Press, 1987).

Barker, Andrew, 'Fanboys to Men?', *Variety*, 18 December 2006.

Barnes, Brooks, 'A Bid to Get Film Lovers Not to Rent', *New York Times*, 11 November 2011a.

_____, 'At Disney, a Splintering of Power makes It Tough to Find a Chief', *New York Times*, 26 April 2012.

_____, 'Growing Conversion of Movies to 3-D Draws Mixed Reactions', *New York Times*, 3 April 2010a.

_____, 'A Hollywood Brawl: How Soon is Too Soon for Video on Demand?', *New York Times*, 19 December 2010b.

_____, 'Many Culprits in Fall of a Family Film', *New York Times*, 14 March 2011b.

_____, 'New Team Alters Disney Studios's Path', *New York Times*, 26 September 2010c.

_____, 'Screenvision to Revamp Preshow Ads at Cinemas', *New York Times*, 26 July 2010d.

_____, 'A Studio Head Slowly Alters the "Warner Way"', *New York Times*, 9 February 2010e.

Barnes, Brooks and Cieply, Michael, 'Film Chief at Disney Steps Down', *New York Times*, 19 September 2009.

_____, 'Movie Studios Reassess Comic-Con', *New York Times*, 12 June 2011.

Bart, Peter, 'After the Honeymoon's Over', *Daily Variety*, 8 February 2010a.

_____, 'Can H'w'd Nurture its 3D Skill Set?', *Variety*, 13–19 June 2011a.

_____, 'The Iger Sanction: Fix the Pix, Pronto', *Variety*, 22 April 2012.

_____, 'Lay Off the Layoffs in H'w'd', *Daily Variety*, 16 February 2010b.

_____, 'Mouse Gears for Mass Prod'n', *Variety*, 19 July 1993.

_____, 'At Par, Bottom Line's a Winner', *Variety*, 26 February 2011b.

_____, 'A Surprise Power Play', *Variety*, 2 June 2005.

Belton, John, 'Digital Cinema: A False Revolution', *October* no. 100 (Spring 2002), pp. 98–114.

Bing, Jonathan, 'Land of Hype and Glory', *Variety*, 3 May 2004.

Biskin, Peter, *Down and Dirty Pictures: Miramax, Sundance, and the Rise of Independent Cinema* (New York: Simon & Schuster, 2004).

Block, Alex Ben, 'It's Official: Lionsgate Buying "Twilight" Studio Summit Entertainment', *Hollywood Reporter*, 13 January 2012.

'Blockbuster to Introduce Streaming via Dish Network', *New York Times*, 23 September 2011.

Boddy, William, 'A Century of Electronic Cinema', *Screen* no. 143 (Summer 2008), pp. 142–56.

Bordwell, David, *Pandora's Digital Box: Films, Files and the Future of the Movies* (Madison: Irving Way Institute Press, 2012).

———, *The Way Hollywood Tells It: Story and Style in Modern Movies* (Berkeley: University of California Press, 2006). http://www.davidbordwell.net/books/pandora.php

Bordwell, David and Thompson, Kristin, *Minding Movies: Observations on the Art, Craft, and Business of Filmmaking* (Chicago: University of Chicago Press, 2011).

Brodie, John and Busch, Anita, 'H'Wood Pigs Out on Big Pix', *Variety*, 25 November–1 December 1996.

Brophy-Warren, James, 'A Producer of Superheroes', *Wall Street Journal*, 27 February 2009.

Chatfield, Tom, *Fun Inc.: Why Games are the 21st Century's Most Serious Business* (New York: Pegasus, 2010).

———, 'Videogames Now Outperform Hollywood Movies', *Observer*, 26 September 2008.

Chmielewski, Dawn, 'Alan Horn Could Revive Walt Disney Studios' Magic,' *Los Angeles Times*, 1 June 2012.

Cieply, Michael, 'Filmmakers Tread Softly on Early Release to Cable', *New York Times*, 17 May 2010a.

———, 'For Movie Stars, the Big Money is Now Deferred', *New York Times*, 4 March 2010b.

———, 'Independent Filmmakers Distribute on Their Own', *New York Times*, 13 August 2009a.

———, 'A Rebuilding Phase for Independent Film', *New York Times*, 25 April 2010c.

———, 'Shakeup in Film Festivals as a Familiar Face Moves', *New York Times*, 18 February 2009b.

Cieply, Michael and Barnes, Brooks, 'Universal Studios a Tortoise against Hollywood's Hares', *New York Times*, 16 July 2007.

'Comcast's Ripple Threat', *Variety*, 31 October 2010.

Compaine, Benjamin M. and Gomery, Douglas, *Who Owns the Media? Competition and Concentration in the Media Industries*, 3rd edn (New York: Routledge, 2000).

Corliss, Richard, 'Show Business: Master of the Movies', *Time*, 25 June 1988.

Crofts, Charlotte, 'Cinema Distribution in the Age of Digital Projection', *Post Script* no. 30 (Winter–Spring 2011), pp. 82–98.

Daly, David, *A Comparison of Exhibition and Distribution Patterns in Three Recent Feature Motion Pictures* (New York: Arno, 1980).

Dekom, Peter and Sealey, Peter, *Not on My Watch: Hollywood and the Future* (Beverly Hills: New Millennium Press, 2003).

De Vany, Arthur S. *Hollywood Economics: How Extreme Uncertainty Shapes the Film Industry* (New York: Routledge, 2003).

'Digital Movies Not Quite Yet Coming to a Theatre Near You', *Los Angeles Times*, 19 December 2000.

Dunn, Sheryl Wu, 'For Matsushita, Life Without MCA Probably Means a Return to Nuts and Bolts', *New York Times*, 8 April 1995.

Eller, Claudia, 'New Line, Old Story: A Small Studio Falls', *Los Angeles Times*, 29 February 2008.

_____, 'Warner Realigns its Top Execs', *Los Angeles Times*, 23 September 2010.

Eller, Claudia and Chmielewski, Dawn C., 'Disney Agrees to Sell Miramax Films to Investor Group Led by Ron Tutor', *Los Angeles Times*, 30 July 2010.

Epstein, Edward Jay, *The Big Picture: The New Logic of Money and Power in Hollywood* (New York: Random House, 2005a).

_____, 'How Did Michael Eisner Make Disney Profitable?', *Slate*, 18 April 2005b, http://www.edwardjayepstein.com/HE1.htm

Evans, Greg and Brodie, John, 'Miramax, Mouse Go for Seven More', *Variety*, 13–19 May 1996.

Fabrikant, Geraldine, 'At a Crossroads, MCA Plans A Meeting With Its Owners', *New York Times*, 13 October 1994.

_____, 'Battling for the Hearts and Minds at Time Warner', *New York Times*, 26 February 1995a.

_____, 'Blockbuster Seeks to Flex Its Muscles Abroad', *New York Times*, 23 October 1995b.

_____, 'Plenty of Seats Available', *New York Times*, 12 July 1999.

'Fanning Fanboy Flames', *Daily Variety*, 19 July 2010.

Fellman, Daniel R., 'Theatrical Distribution', in Jason E. Squire (ed.), *The Movies Business Book* (New York: Fireside, 2004).

Finkelstein, Sidney, 'The Worst CEOs of 2011', *New York Times*, 27 December 2011.

Fleming, Michael and Garett, Dianne, 'Deal Or No Deal', *Variety*, 11–17 August 2008.

Fleming, Michael and Klady, Leonard, 'Crying all the Way to the Bank', *Variety*, 22 March 1993.

Flint, Joe and Dempsey, John, 'Viacom, B'buster Tie $7.6 Bil Knot', *Variety*, 3–9 October 1994.

Friedman, Robert G., 'Motion Picture Marketing', in Jason E. Squire (ed.), *The Movies Business Book* (New York: Fireside, 2004).

Friedman, Wayne, 'Social Media Gains Virility', *Variety*, 5 October 2010.

Fritz, Ben, 'Fox Toons Soar with Blue Sky', *Variety*, 5–11 May 2008.

_____, 'Not Much Demand Yet for Premium Video-on-demand', *Los Angeles Times*, 8 July 2011.

_____, 'How Moviegoers at Different Ages Use Technology', *Los Angeles Times*, 30 September 2009.

Fulford, Robert, 'Synergy Another Word for Catastrophe', *Globe and Mail*, 16 August 1995.

Furman, Phyllis, 'NBC Gets Vivendi Universal', *New York Daily News*, 9 October 2003.

Glover, Tony, 'Video Games Set to Outgun Hollywood', *National*, 5 January 2011.

Gold, Richard, 'No Exit? Studios Itch to Ditch Exhib Biz', *Variety*, 8 October, 1990.

_____, 'Sony–CPE Union Reaffirms Changing Order of Intl. Showbiz', *Variety*, 27 September–3 October 1989.

Goldsmith, Jill, 'H'w'd Vexed by Plex Success', *Variety*, 16 May 2004.

_____, 'Movie Chain AMC Plans an IPO', *Variety*, 11 December 2006.

Goldstein, Patrick and Rainey, James, 'Hollywood Gets Tough on Talent', *Los Angeles Times*, 3 August 2009.

Gomery, Douglas, *Shared Pleasures: A History of Movie Presentation in the United States* (Madison: University of Wisconsin Press, 1992).

Goo, Sara Kehaulani, 'Google Gambles on Web Video', *Washington Post*, 10 October 2006.

Graser, Marc, 'A Fix of Formulas and Fragments', *Variety*, 21 December–3 January 2010a.

_____, 'As Studios Court Dweebs, Will Comic-Con Turn into a Faux Film Fest?', *Variety*, 14–20 July 2008.

_____, 'Chips & Blips, Anyone?', *Variety*, 6–17 December 2010b.

_____, 'Creatives Finding Fewer Riches in Pitches', *Variety*, 1 May 2010c.

_____, 'Disney Riding Franchise Plan', *Variety*, 18 February 2011a.

_____, 'Heavy Hitters Pick Up Slack as Studios Evolve', *Variety*, 27 February–4 March 2012.

_____, 'Information Please', *Variety*, 7–13 March 2011b.

_____, 'A New World Order', *Variety*, 18 October 2009.

_____, 'VOD gets Big Push', *Daily Variety*, 17 March 2010d.

Graser, Marc and Ault, Susanne, 'Bringing Any to the Many', *Variety*, 21 March 2010.

Graser, Marc and McNary, Dave, 'Indie Film Great Miramax Shutters,' *Variety*, 28 January 2010.

Greenberg, Joshua M., *From Betamax to Blockbuster: Video Stores and the Invention of Movies on Video* (Cambridge, MA: MIT Press, 2008).

Greenwald, Stephen R. and Landry, Paula, *This Business of Film: A Practical Guide to Achieving Success in the Film Industry* (New York: Lone Eagle, 2009).

Grimes, William, 'Is 3-D Imax the Future or Another Cinerama?', *New York Times*, 13 November 1994.

Gruenwedel, Erik, 'Kevin Tsujihara: Discs Key to Driving UltraViolet Adoption', *Home Media Magazine*, 29 February 2012.

Gunelius, Susan, *Harry Potter: The Story of a Global Business Phenomenon* (New York: Palgrave Macmillan, 2008).

'The Harry Potter Economy', *Economist*, 19 December 2009.

'Harry Potter and the Synergy Test', *Economist*, 10 November 2001.

'Harry's Magic Numbers', *Variety*, 18–24 July, 2011.

Hayes, Dade, 'Movie Theater Ads Reeling in Cash', *Variety*, 15 June 2008.

Hayes, Dade and Bing, Jonathan, *Open Wide: How Hollywood Box Office Became a National Obsession* (New York: Hyperion, 2004).

Hayes, Dade and McNary, Dave, 'New Line in Warner's Corner', *Variety*, 28 February 2008.

Hofmeister, Sallie and Eller, Claudia, 'Another Exec Quits Viacom in Shake-Up', *Los Angeles Times*, 3 June 2004.

Hofmeister, Sallie and Hall, Jane, 'Disney to Buy Cap Cities/ABC for $19 Billion', *Los Angeles Times*, 1 August 1995.

'Hollywood and the Internet', *Economist*, 21 February 2008.

'Hollywood Plays It Safe at Con', *Daily Variety*, 26 July 2010.

Holson, Laura M., 'For Disney and Pixar, a Deal Is a Game of "Chicken"', *New York Times*, 31 October 2005a.

_____, 'How the Tumultuous Marriage of Miramax and Disney Failed', *New York Times*, 6 March 2005b.

Holson, Laura M. and Lyman, Rick, 'In Warner Brothers' Strategy, A Movie Is Now a Product Line', *New York Times*, 11 February 2002.

Horn, John, 'The Living-room TV, not Cannes, May be Independent Film's Best Friend', *Los Angeles Times*, 12 May 2009a.

_____, '"Slumdog" Strikes It Rich with 8 Oscar Wins', *Los Angeles Times*, 23 February 2009b.

Hughes, David, *Tales from Development Hell: Hollywood Film-Making the Hard Way* (London: Titan, 2003).

Hurt, Harry, III, 'The Hunger of the Media Empire', *New York Times*, 17 October 2009.

Hutsko, Joe, 'Behind the Scenes Via Movie Web Sites', *New York Times*, 10 July 2003.

James, Caryn, 'Home Alone', *New York Times*, 16 November 1990.

Jardin, Xeni, 'The Cuban Revolution', *Wired*, April 2005.

'Jean-Marie Messier Himself: Where Did It All Go Wrong?', *Economist*, 12 June 2003.

Kaufman, Anthony, 'Extreme Subjects a Challenge for Marketers', *Variety*, 15 December 2008.

Kehr, Dave, '3-D's Quest to Move Beyond Gimmicks', *New York Times*, 10 January 2010.

Kennedy, Randy, 'At the Sundance Film Festival, A New Power Broker Is Born', *New York Times*, 25 January 2005.

Klady, Leonard, 'Toy Story', *Variety,* 20–26 November 1995.

Klinger, Barbara, *Beyond the Multiplex: Cinema, New Technologies, and the Home* (Berkeley: University of California Press, 2006).

Klinkenborg, Verlyn, 'The Vision Behind the CBS–Viacom Merger', *New York Times*, 9 September 1999.

Knee, Jonathan A., Greenwald, Bruce C. and Seave, Ava, *The Curse of the Mogul: What's Wrong With the World's Leading Media Companies* (New York: Portfolio, 2009).

Kroll, Justin, 'Pre-packaged Films Find Greenlight', *Variety*, 27 February–4 March 2012.

_____, 'Universal Adapts to Comcast Era', *Variety*, 16 May 2011.

Kunz, William M., *Culture Conglomerates: Consolidation in the Motion Picture and Television Industries* (Lanham, MD: Rowman & Littlefield, 2007).

La Porte, Nicole and Mohr, Ian, 'Do Croisette Pic Promos Pay Off?' *Variety*, 29 May–4 June 2006.

Learmouth, Michael, 'How YouTube Morphed into a Movie-Marketing Darling', *Advertising Age*, 22 February 2010.

Leydon, Joe, *Variety*, 15 March 2002.

Lieberman, David, 'Net Visionaries: Bad Execs or Victims of Bad Timing?', *USA Today*, 13 January 2003, http://www.usatoday.com/money/media/2003-01-13-aol-cover_x.htm, retrieved 2 February 2011.

Lohr, Steve, 'A New Power in Many Media', *New York Times*, 11 January 2000.

Lowry, Tom, 'Shattered Windows', *Variety*, 23–29 August 2010.

Lyman, Rick, 'Back From the Beach and Bound for Toronto', *New York Times*, 7 September 2000.

_____, 'Movie Marketing Wizardry', *New York Times*,11 January 2001.

Marich, Robert, 'Tube Ties Up Studio Bucks', *Variety*, 15–21 August 2011.

Markels, Alex, 'A Movie Theatre Revival, Aided by Teenagers', *New York Times*, 3 August 2003.

'The Market Research Issue', *Variety*, 7–13 March 2011.

Martin, Douglas, 'The X-Men Vanquish America', *New York Times*, 21 August 1994.

Maslin, Janet, 'Target: Boomers and Their Babies', *New York Times*, 24 November 1991.

McCarthy, Todd, 'The Flintstones', *Variety*, 23–9 May 1994.

_____, '101 Dalmatians', *Daily Variety*, 25 November 1996.

_____, 'Spider-Man 2', *Variety*, 23 June 2004.

McClintock, Pamela, 'Avatar Nabs $73 Million at Box Office', *Variety*, 20 December 2009a.

_____, 'Legendary Soups Up Pic Presence', *Daily Variety*, 31 October 2005.

_____, 'Specialty Biz: What Just Happened', *Variety*, 1 May 2009b.

McDonald, Paul and Wasko, Janet, *The Contemporary Hollywood Film Industry* (Malden, MA: Blackwell, 2008).

McNary, Dave, 'Lionsgate Buys Summit for $412.5 Million', *Variety*, 13 January 2012.

_____, 'Screenwriters Dancing the One-step', *Variety*, 24 April 2010.

_____, 'WB Layoffs Looming', *Daily Variety*, 21 January 2009.

McNary, Dave and Hayes, Dade, 'Picturehouse, WIP to Close Shop', *Variety*, 8 May 2008.

'The Meaning of "Indie"', *New York Times*, 29 May, 2005.

Miller, Winter, 'Sony Classics Plays by its Own Rules', *Variety*, 20 June 2008.

Mohr, Ian, 'Cuban Rhythm Shakes Up Pics', *Variety*, 7–13 May 2007a.

_____, '"Spider-Man 3" Snares $148 Million', *Variety*, 6 May 2007b.

MPAA (Motion Picture Association of America), *2010 Theatrical Market Statistics* (2010).

Natale, Richard, 'Family Films Ready for the Heat of Battle', *Los Angeles Times Calendar*, 6 November 1998.

Neale, Steve (ed.), *Genre and Contemporary Hollywood* (London: Routledge, 2000).

Neale, Steve and Smith, Murray (eds), *Contemporary Hollywood Cinema* (London: Routledge, 1998).

'New Media Can't Yet Carry the Day', *Variety*, 15 August 2011.

'Niche was Nice: New Plan – Expand', *Variety*, 10 August 1992.

Nowell-Smith, Geoffrey and Ricci, Steven (eds), *Hollywood & Europe: Economics, Culture, National Identity* (London: BFI, 1998).

'Old and New Media Part Ways', *Economist*, 16 June 2005.

'Paramount Cuts Ties with Tom Cruise's Studio', *New York Times*, 8 August 2006.

'Paramount's Rudin Jumps Ship for Disney', *Guardian*, 20 April 2005.

Pfanner, Eric, 'In London, Small Studio's Quirky Films Make Big Money', *International Herald Tribune*, 13 September 2004.

Piccalo, Gina, 'Girls Just Want to Be Plugged In – to Everything', *Los Angeles Times*, 11 August 2006.

Pollack, Andrew, 'At MCA's Parent, No Move to Let Go', *New York Times*, 14 October 1994.

Pollock, Dale, 'Epoch Filmmaker', *Daily Variety*, 9 June 2005.

Porter, Eduardo and Fabrikant, Geraldine, 'A Big Star May Not a Profitable Movie Make', *New York Times*, 28 August 2008.

Rabinowitz, Mark, 'Rejects Wreak Revenge', *Daily Variety*, 16 January 2009.

Rampell, Catherine, 'Unusual Film Gets Innovative Marketing', *New York Times*, 30 September 2010.

Redstone, Shari E., 'The Exhibition Business', in Jason E. Squire (ed.), *The Movies Business Book* (New York: Fireside, 2004).

Rendon, Jim, 'Sunday Money', *New York Times*, 10 October 2004.

Rotella, Carlo, 'The Professor of Small Movies', *New York Times*, 28 November 2010.

Russell, Jamie, *Generation Xbox: How Videogames Invaded Hollywood* (East Sussex: Yellow Ant, 2012).

Sanati, Cyrus, 'The Challenges Facing Icahn at Blockbuster', *New York Times*, 23 September 2010.

'Saved by the Box', *Economist*, 23 May 2009.

Saylor, Mark, 'Taking the Long View, He Changed the Way Independents Do Business', *Los Angeles Times*, 3 March 1998.

Schamus, James, 'To the Rear of the Back End: The Economics of Independent Cinema', in Steve Neale and Murray Smith (eds), *Contemporary Hollywood Cinema* (London: Routledge, 1998).

Scott, A. O., 'Adding a Dimension to the Frenzy', *New York Times*, 9 May 2010.

_____, 'Episode III – The Revenge of the Sith', *New York Times*, 16 May 2005a.

_____, 'A Golden Age of Foreign Films, Mostly Unseen', *New York Times*, 26 January 2011.

_____, 'The Invasion of the Midsize Movie', *New York Times*, 21 January 2005b.

_____, 'The Way We Live Now', *New York Times*, 25 January 2004.

Siegel, Tatiana, 'Relativity's Riches', *Daily Variety*, 8 January 2008.

_____, 'Tobey Maguire, Sam Raimi Out of "Spider-Man"', *Variety*, 11 January 2010.

Siegel, Tatiana and Thompson, Anne, 'D'works Split from Par Turns Messy', *Daily Variety*, 22 September 2008.

Smith, Lynn, 'Hollywood Rediscovers Movies for the Family', *Toronto Star*, 16 April 2002.

Snyder, Gabriel, 'Don't Give Me an "R"', *Variety*, 20 February 2005.

Solman, Gregory, 'Gordon Paddison's Hollywood Adventure', *Adweek*, 8 October 2007.

'Sony Pictures Classics', *Hollywood Reporter*, 1 February 2011.

Sorkin, Andrew Ross, 'NBC–Comcast: A Big Deal, but Not a Good One', *New York Times*, 26 October 2009.

Spillman, Susan, 'Will Batman Fly?', *USA Today*, 19 June 1989.

Squire, Jason E. (ed.), *The Movies Business Book* (New York: Fireside, 2004).

Sragow, Michael, 'Sea Change Coming to Movie Business', *Baltimore Sun*, 26 January 2006.

Stelter, Brian, 'MySpace Might Have Friends, but It Wants Ad Money', *New York Times*, 16 June 2008.

Sterngold, James, 'For Sony's Studios, A New Mood', *New York Times*, 28 July 1997.

_____, 'Sony, Struggling, Takes a Huge Loss on Movie Studios', *New York Times*, 18 September 1994.

Swann, Christopher and Goldfarb, Jeffrey, 'Oil Prices Yawn at the Big Spill', *New York Times*, 9 June 2010.

Swanson, Tim, 'Regency's Risky Biz', *Variety*, 9 November 2001.

Tabuchi, Hiroko and Barnes, Brooks, 'Sony Chief Still in Search of a Turnaround', *New York Times*, 26 May 2011.

Thilk, Chris, 'Rating the Ratings', *Advertising Age*, 9 November 2010.

Thompson, Anne, 'Elizabeth Gabler guides Fox 2000', *Variety*, 8 January 2009.

_____, 'Hollywood's A-list Losing Star Power', *Variety*, 16 October 2008a.

_____, 'Mark Gill on Indie Film Crisis', *The Film Department*, 21 June 2008b, http://www.filmdept.com/press/press_article.php?id=6

_____, 'Slow Burn Keeps "Old Men" Simmering', *Variety*, 31 January 2008c.

_____, 'Trying to Bring Big-Media Ideas Into the World of Art Theatres', *New York Times*, 19 July 2004.

Thompson, Kristin, *The Frodo Franchise: The Lord of the Rings and Modern Hollywood* (Berkeley: University of California Press, 2007).

Time Warner Inc., *1989 Annual Report* (1989).

Tinic, Serra, *On Location: Canada's Television Industry in a Global Market* (Toronto: Toronto University Press, 2005).

Triplett, William, 'Redstone: Content's King', *Daily Variety*, 23 August 2006.

Turan, Kenneth ,'The Prequel has Landed', *Los Angeles Times Calendar*, 18 May 1999.

Ulin, Jeffrey C., *The Business of Media Distribution: Monetizing Film. TV and Video Content in an Online World* (New York: Focal Press, 2010).

'Unkind Unwind', *Economist*, 17 May 2011.

Verma, Kamal Kishore, 'TheAOL/Time Warner Merger: Where Traditional Media Met New Media', http://archipelle.com/Business/AOLTimeWarner.pdf (n.d.).

'Virgin Territory', *Variety*, 18–22 April 2012.

Vogel, Harold, 'Entertainment Industry', *Merrill Lynch*, 14 March 1989.

Wallenstein, Andrew, 'Studios' Viral Marketing Campaigns are Vexing', *Reuters/ Hollywood Reporter*, 30 April 2008, http://uk.reuters.com/article/2008/04/30/uk-virals-idUKN3036810320080430

Warner Communications, *1980 Annual Report* (1980).

Wasko, Janet, *Hollywood in the Information Age: Beyond the Silver Screen* (Cambridge: Polity Press, 1994).

Wasser, Frederick, *Veni, Vidi, Video: The Hollywood Empire and the VCR* (Austin: University of Texas Press, 2001).

Waterman, David, *Hollywood's Road to Riches* (Cambridge, MA: Harvard University Press, 2005).

Waxman, Sharon, 'Chairwoman of Universal Seems Poised to Leave', *New York Times*, 25 February 2006.

_____, 'Paramount Fires Leaders of Classics Unit', *New York Times*, 7 October 2005.

_____, 'With Acquisition, Lions Gate Is Now Largest Indie', *New York Times*, 16 December 2003.

Webber, Bruce, 'Like the Movie, Loved the Megaplex', *New York Times*, 17 August 2005.

Weinraub, Bernard, 'Art, Hype and Hollywood at Sundance', *New York Times*, 18 January 1998.

_____, '"The Full Monty" is by Far the Biggest Film Success at Fox Searchlight Pictures', *New York Times*, 15 September 1997a.

_____, 'Mogul in Love ... With Winning', *New York Times*, 23 March 1999a.

_____, 'Sony Pictures Rumored to Plan a Big Shake-Up', *New York Times*, 7 August 1996.

_____, 'The Two Hollywoods; Harry Knowles is Always Listening', *New York Times*, 16 November 1997b.

_____, 'A Witch's Caldron of Success Boils Over', *New York Times*, 26 July 1999b.

'Who Gets the "King's" Ransom?', *Variety*, 14 March 2011.

Wilmington, Michael, 'The Mighty Ducks', *Los Angeles Times Calendar*, 2 October 1992.

Wong, Cindy Hing-Yuk, *Film Festivals: Culture, People, and Power on the Global Screen* (Rutgers, NJ: Rutgers University Press, 2011).

Wyatt, Justin, *High Concept: Movies and Marketing in Hollywood* (Austin: University of Texas Press, 1994).

Yarrow, Andrew L., 'The Studios Move on Theaters', *New York Times*, 25 December 1987.

Yiannopoulos, Milo, 'MySpace: Still Plenty of Room', *Telegraph*, 9 April 2009.

Index

LIST OF ILLUSTRATIONS

While considerable effort has been made to correctly identify the copyright holders, this has not been possible in all cases. We apologise for any apparent negligence and any omissions or corrections brought to our attention will be remedied in any future editions.

Toy Story, © Walt Disney Pictures; *Harry Potter and the Deathly Hallows: Part 2*, © Warner Bros. Entertainment Inc.; *Spider-Man 2*, © Columbia Pictures Industries Inc.; *Shrek*, © DreamWorks LLC; *Avatar*, © Twentieth Century-Fox Film Corporation/Dune Entertainment III LLC; *X-Men Origins: Wolverine*, © Twentieth Century-Fox Film Corporation/Dune Entertainment III LLC; *Jaws*, © Universal Pictures; *Crouching Tiger, Hidden Dragon*, © United China Vision Incorporated/© UVC LLC; *The King's Speech*, © UK Film Council/© Speaking Film Productions Ltd; *Slumdog Millionaire*, © Celador Films Ltd/© Channel Four Television Corporation; *Brokeback Mountain*, © Focus Features LLC; *The Hunger Games*, © Lions Gate Films Inc.